ILLUSION WORKS

OPTICAL ILLUSIONS

The Science of Visual Perception

AL SECKEL

FIREFLY BOOKS

To Laura and Elizabeth

Published by Firefly Books Ltd. 2006

Second Printing 2006

Publisher Cataloging-in-Publication Data (U.S.)
Seckel, Al
Optical illusions : the science of visual perception / Al Seckel.
[312] p. : ill. (some col.) ; cm.
Summary: Selection of more than 275 optical illusions from historical and modern sources.
ISBN-13: 978-1-55407-172-2
ISBN-10: 1-55407-172-0
ISBN-13: 978-1-55407-151-7 (pbk.)
ISBN-10: 1-55407-151-8 (pbk.)
1. Optical illusions. I. Title.
152.14/8 dc22 QP495.S435 2006

Library and Archives Canada Cataloguing in Publication
Seckel, Al
Optical illusions : the science of visual perception / Al Seckel.
Includes index.
ISBN-13: 978-1-55407-172-2 (bound)
ISBN-13: 978-1-55407-151-7 (pbk.)
ISBN-10: 1-55407-172-0 (bound)
ISBN-10: 1-55407-151-8 (pbk.)
1. Optical illusions. I. Title.
QP495.S42 2006 152.14'8 C2005-907555-4

Published in the United States by
Firefly Books (U.S.) Inc.
P.O. Box 1338, Ellicott Station
Buffalo, New York 14205

Published in Canada by
Firefly Books Ltd.
66 Leek Crescent
Richmond Hill, Ontario L4B 1H1

Design and composition by Brian Lehen • Graphic Design Ltd.

Printed in China

The publisher gratefully acknowledges the financial support for our publishing program by the Government of Canada through the Book Publishing Industry Development Program.

Contents

Preface

PART OF THE FUN of this book will involve being tricked, fooled, and misled. Being fooled has nothing to do with how smart you are, how cultured you are, how artistic you are or how old. You will be tricked. Many of the illusions are so powerful that you will doubt the written description, and others are so convincing that you will perceive nothing wrong.

This volume is by far the most comprehensive collection of illusions ever published. A good number come from recent work in vision and perception laboratories and others come from a variety of modern artists who have deliberately incorporated an illusion into a drawing, photograph, or sculpture. There are also quite a few illusions that have been created specially for this book. I have tried to provide a variety of different perceptual experiences. Many of the illusions in this book appear here for the first time in print. Of course, you will find the familiar classics here too.

The chapter "Your Mind's Eye" puts the illusions into a framework of modern understanding. At the back of the book you will find a chapter "What's Going On?" that provides brief scientific explanations of our best guesses for why these effects occur and how they are consistent with the processes that mediate normal perception. It needs to be emphasized that our understanding of vision and perception is very far from complete and the explanations provided in this volume are tentative and should be regarded with some degree of skepticism. Even the most current and up-to-date explanations will likely be revised further. Many explanations are still generating considerable scientific controversy. It is hoped that the examples in this volume will stimulate further thoughts in the reader about how these effects occur.

This book would not be possible without the help of numerous colleagues and friends who have provided me with examples and valuable discussions. In this regard, I would like to thank Jerry Andrus, Stuart Anstis, Ted Adelson, Chris Banta, Irving Biederman, Paola Bressan, Ken Brescher, Monika Buch, Patrick Cavanagh, Vicky Cobb, Francis Crick, James Dalgety, Jos De Mey, Sandro Del-Prete, Jerry Downs, David Eagleman, Bruno Ernst, Thomas Farkas, Jonathan Frakes, Martin Gardner, Richard Gregory, Lennart Green, Matheau Haemakers, Priscilla Heard, Elizabeth Ho, Donald Hoffman, Brad Honeycutt, Edward Horten, Keith Kay, Dan Kersten, Scot Kim, Akiyoshi Kitaoka, Alice Klarke, Ken Knowlton, Christof Koch, Lionel Koffler, Ken Landry, Michael Levenberg, George Levine, Bernd Lingelbach, R. B. Lotto, David MacDonald, Guido Moretti, Scott Morris, Ivan Moscovich, Victor Muniz, Octovio Ocampo, Istvan Orosz, Baingio Pinna, Jeffrey Price, Dale Purves, Vilaymur Ramachandran, Oscar Reutersvärd, Rusty Rust, Mark Setteducatti, Roger Shepard, Shin Shimojo, Pawah Sinha, Jerry Slocum, Dick Termes, Peter Thompson, Dejan Todorvovic, Peter Tse, Nicholas Wade, Walter Wick and Carol Yin.

Your Mind's Eye

YOU PROBABLY BELIEVE that you are in perfect mental control of what you think. After all, having control over your inner thoughts is without a doubt the most central part of what makes you who you are. Futhermore, an important part of your decision making process is your ability to distinguish between truth and falsehood. So, what would happen if you were suddenly unable to mentally override what you *know* to be false? You know that you are being tricked, but you can't stop yourself from being tricked, no matter how hard you try. This is a very odd experience indeed!

Luckily, this is not a normal experience. For the most part, how you perceive the world is fairly accurate, and what you perceive and what you know are in perfect harmony with each other. Yet, when you encounter an illusion it is just the opposite. There will be a mental split between *what you know* and *what you perceive*. What appears to be true is false and what appears to be false is true.

There is a common misperception that what you see in the world is exactly what you get. In fact, many books have misleadingly compared the human visual system to a camera, since photographs appear to convey the world accurately. However, this comparison greatly trivializes the enormous complexity of your visual/perceptual system. A camera *only* records incoming light. In contrast, your brain *interprets* the light that enters your eyes. That is a very big and qualitative difference. While your eyes are somewhat like a camera, it is *not* your eyes that process what you perceive, but your brain. When you look at a photograph, it is your brain interpreting the various relationships in the photograph, not the camera.

Perceiving images, objects and motion is a very complicated process. Only in the last hundred years, and especially in the last two decades, have scientists made some progress in understanding vision and perception. Illusions can be a very nice window into this process because they can reveal the hidden constraints that mediate vision and perception. How you "sort it out" is a truly wonderful process; however, this process mainly happens not in your eyes, but in your brain. Light waves enter each eye and form a two-dimensional image on the photoreceptive cells in the retina located at the back of each eye. These retinal images, whether from a two-dimensional image or from the real world, are semi-flat representations on two flat surfaces (one for each eye). The image on each eye provides a different point of view, which helps you to form a perception of depth. However, for any given single retinal image, there are an infinite variety of possible inputs that could give rise to the same image. For example, a straight line projected on your retina could have arisen from a physically straight line, or it could have arisen from a curved line, which happens to be at an angle at which it looks straight. The possibilities are endless. Your visual/perceptual system, however, usually settles for the correct interpretation, and it does this quickly and efficiently.

Your brain continually *interprets* the light that comes into your eyes according to hidden and subconscious "constraints" that relate to edges, brightness, contrast, color, motion, depth, direction of lighting, and so forth. In this way, your visual/perceptual system can quickly and efficiently *construct* a mental representation of your external world. These constraints are locked into the inner workings of your visual/perceptual system, and you cannot consciously stop your brain from using them. It is more important for your visual/perceptual system to consistently adhere to these constraints than to occasionally violate them, just because you have encountered something unusual, paradoxical, or inconsistent. This is why you can't stop yourself from being misled by many of the illusions in this book.

These perceptual constraints can also make mistakes, especially when there is not enough information, or the information appears to be in conflict. When this happens you get an illusion. Normally, you don't encounter such impoverished or contradictory visual scenes and so it does not make a big difference. There is enough information contained in the image to resolve it accurately. Vision scientists deliberately create new illusions by leaving out critical information that your visual/perceptual

system relies on, or by deliberately incorporating conflicting information into the scene.

Normally, your perception of the world is a stable one, because there is usually enough incoming information from the world that allows you to perceive an unambiguous interpretation of your world. Your mind does not have difficulty deciding what is going on in the scene. Scenes just do not flip back and forth. It would be very disconcerting if your interpretation of the world became unstable. It would be very difficult for you to move about.

It is possible to remove enough information from a scene so that you brain does not have enough information one way or another to decide between two or more different interpretations. Without enough information, some of the hidden perceptual rules that your visual/perceptual system relies on can come into conflict with each other, and your brain is unable to resolve the conflict. When this happens, the scene will appear to "flip-flop" between two or more meaningful interpretations. An image that has more than one possible interpretation is called an ambiguous figure. You will find many of these figures in this volume.

Ambiguous figures are a classic way that scientists demonstrate that your brain interprets the world that it sees. The image that enters your eye is perfectly stable, yet you can interpret it in more than one way. Although you can perceive these ambiguous images in more than one way, it is extremely difficult, if not impossible, for you to see both interpretations simultaneously. Either one or another set of perceptual constraints will dominate at one time when they are in conflict. By staring at the picture long enough, your brain may settle on the other interpretation.

Some of these types of illusions involve a perceptual shift between what constitutes a figure (the object) and its background (ground). It is usually the object that gives "meaning" to the scene as opposed to the scene's background. Ordinarily, figures are easily distinguished from their backgrounds by your visual/perceptual system. If you were unable to distinguish between an object and its background, then you would be unable to see the object. This is such an important perceptual process that your visual system has developed quite a number of rules to distinguish a figure from its background. In these types of illusions both the figure (object) and the ground (background) will have meaningful interpretations. This means that when your visual system interchanges figure and ground, you will have another interpretation of the meaning of the scene, which causes a perceptual "flip-flop."

It is also possible to create meaningful perceptual shifts in scenes by deliberately creating ambiguous edges of a figure so that different parts of a scene will be grouped together differently by your perceptual system. This is not so much an interchange of figure and ground as much as a re-organization and re-identification of the various parts of an image.

You will also come across images where the figure and ground have been deliberately obscured. This means that it is very difficult for your visual system to be able to discern the object (the meaningful part of the image) from the ground (background). This is the basis of camouflage, both natural and artificial. Camouflage involves deliberately obscuring the distinction between figure and ground. Animals use natural camouflage to blend into the background so that predators will not be able to see them. Sometimes, not only does this involve matching the background, but also the movement of the background.

In some of these images, initially it will be very hard to perceive the object; however, once your visual system locks on to it, then it will perceptually reorganize the image in your brain, and you will be forever locked into that one perception. This is in contrast to perceptually ambiguous illusions, where the image will perceptually "flip-flop" between two interpretations. In this case, you will initially have a "meaningless" interpretation, and then suddenly (it may take some effort) the "meaningful" interpretation will "pop" into your awareness. Once this does, you can never perceive the image in its meaningless state again. The primary focus of your visual/perceptual system is to determine meaning in images. Once it does this, it will always prefer a meaningful state to a meaningless one. Your perceptual reorganization of this image will last for years.

You will also encounter illusions that distort your perception of reality, so what appears to be true is false and what appears to be false is true. This is why it is so important to read the captions of every illusion in this book, because many of the illusions are so powerful that you won't know that you are being tricked until *after* you have read and checked the explanation. After you check the caption, knowledge informs you that your perception has been being misled. Interestingly, knowledge of the "Truth" does not cause your false perception to change. Nor does successive viewing experience help. Those areas of your brain that contain conceptual knowledge about the world rarely affect the rules that relate to creating your basic interpretation of images.

Your perceptual system can cause you to perceive images, colors, and effects that don't exist in the first place. This is a quite surprising aspect of your perceptual system. However, there is nothing to worry about, as these effects are extremely rare in nature. Vision scientists have created these effects to help them understand the underlying and hidden mechanisms of your perceptual system.

You will even encounter motion where there is no motion, and also perceive objects moving in ways that are entirely different from their true movement. As you explore the relative motion illusions in this volume, you will be surprised at how you can interpret motion in strange ways. Some of these illusions rely on either moving the image or the head to cause a perceived movement of the figure in a direction that is different from its true motion. With other images, even though both the head and the image may be steady, eye movements alone may induce the effect of relative motion.

Your visual/perceptual system has evolved a complex process for the detection of motion. Most of the time, your eyes, head, and body are in motion, which makes it very difficult to equate object motion directly with image motion. It is also overly simplistic to think that all one has to do is process a change of an object's position over a period of time. Some objects move too quickly (such as a fast-moving bicycle wheel's spokes), and others move too slowly (such as the motion of the planets and stars). Indeed, you can perceive motion when there is no motion. In a movie, for example, we have a very vivid sensation of watching moving objects, but what is physically appearing on the screen is a rapid succession of still images. Despite the existence of a number of successful examples, there are still conflicting theories of why these motion illusions occur.

So far, we have discussed a variety of illusions that produce images that are not really there or that distort your perception of reality. There is also a class of illusions that suggests objects that can't possibly physically exist! These illusions are known as impossible figures.

As you ponder each one of these impossible figures, carefully note how the different parts physically relate to each other. Do these drawings suggest "structures" that make sense with what you know and have experienced? Are there any problems? Do you see inconsistencies when you look at the parts of the image or do you see a problem *only* when you see the picture as a "whole"?

Some problems you will spot right away, and in other impossible figures, the problems will not be so obvious. The picture will appear perfectly normal. Only after you read the caption will you understand why that figure is physically impossible. Yet, once again, knowledge will not stop your brain from interpreting these images in a normal way even though you know that they are impossible.

In impossible figures, however, it is not the picture itself that is impossible, but only your three-dimensional interpretation of it as a real physical object. After all, there is nothing impossible about a flat drawing. You brain looks at these drawings and applies the same rules that it does to normal perspective drawings. Therefore, it will interpret these figures for you as normal three-dimensional figures, even though they can't exist in the real world. You have spent your entire life interpreting two-dimensional flat images into three-dimensional physical scenes incorporating depth. You can't stop doing this now even though you are faced with something that is impossible.

Although impossible figures can't exist, some clever people have utilized some optical tricks to create them as physical objects. It's lots of fun to try to make the impossible possible. However, all of these objects will work only from one well-defined viewing angle. After examining these works, you might want

to create some impossible figures or objects yourself. See what variations you can come up with.

If this isn't confusing enough, this volume will present illusions that will deliberately confuse you! They are designed to mix you up and lead you to an answer that is wrong. Getting mixed up is lots of fun, and these illusions are especially fun to try on your family and friends. Follow the instructions as well as you can. You can consciously avoid having these illusions work if you try, but it is more fun to have the effect work, so let yourself go.

So, why is it possible to "mix you up"? Psychologists have known for a long time that it is possible to "prime" a person's perception in a particular direction. Priming occurs when you engage in an activity that you are so familiar doing that you don't have to think about it, and then you are asked to do a very slight variation of this activity, which sends you down your original familiar path, and an error occurs. Sometimes, the familiar and the unfamiliar activities can work against each other, and the brain gets confused. For example, many people who drive the same way to work all the time often make a mistake when driving to a new location near their familiar destination.

A scene's context and what you expect to happen can dramatically influence your perception in many fundamental ways. Over the years, there have been numerous classic studies demonstrating how a person's perception of an event can be dramatically controlled through priming and context. This is why witness testimony has been so notoriously unreliable. It is well known that a crime scene or a dramatic sudden event can be witnessed by scores of people who give wildly different accounts.

Priming is also related to the notion that suggestion can influence judgments, and there is a whole marketing industry that tries to influence what you buy through advertising. Although we can describe the different accounts of perceptual priming, we really have no understanding at any level of why these perceptions occur.

There are also some fun illusions that are playful and surprising, like topsy-turvy images, which are a subset of perceptually ambiguous figures. In topsy-turvy figures, you need to either invert the figure or rotate it to see a different interpretation. No one knows when inverted images were first created, but they started to become popular during the Reformation in the 1500s. These early types of topsy-turvy images typically contained hidden political and religious messages. In the nineteenth century, they took on a more amusing character, and were very popular in advertisements and on puzzle cards.

Many of the illusions in this volume come from the creative minds of vision scientists, but many illusions also come from the inspired minds of artists. Incorporating obvious optical illusions in art has always been popular, and recently, there have been a growing number of artists, illustrators, and designers who have deliberately incorporated optical tricks into their artwork in order to evoke a feeling of surprise, delight, or even humor. We hope that you will enjoy many of their works presented here.

Architecture, too, has its share of illusions. When you look at a building, you don't expect to be tricked. However, illusions have been used in architecture for well over 1500 years to counter the effects of natural distortion. For example, when a series of columns extends farther away from the viewer, the columns appear to grow shorter and closer together as they approach a vanishing point. To create a counter-perspective illusion in such a case, the columns are spaced farther apart as they recede and their height increased so that from the given viewpoint (which must be controlled) they all appear to be the same height and distance apart. So, architects use illusions to make a building not look distorted. Of course, obvious illusions have also been incorporated into architectural details to cause delight and surprise in visitors.

There are many natural illusions, and if you know how to look for them, you can find them almost everywhere. Natural illusions, such as the rainbow and mirages, have caused wonder and admiration as well as religious awe; other natural illusions, such as the Moon illusion, have evoked decades of scientific controversy, and some natural illusions, such as anti-gravity hills and the "face" on Mars, have created cottage industries of crackpot theories.

Have fun with the illusions in this volume. Just remember, what you see is not necessarily what you get. Nor, in some cases, is seeing believing.

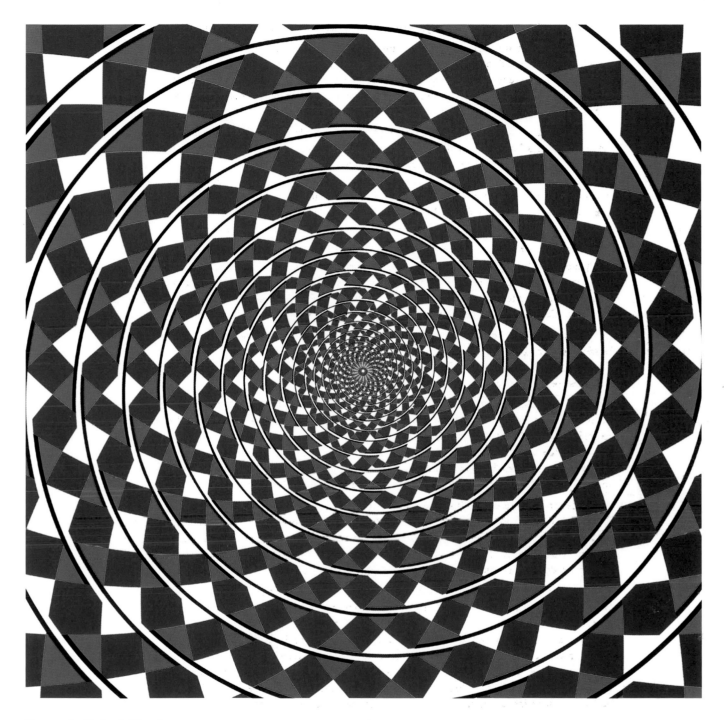

Fraser's Spiral Illusion

Do you perceive a spiral? Cover up any half of the image. What happens to your perception of the spiral's shape? Do you now perceive a series of concentric circles? What does this image really represent – a spiral or a series of concentric circles?

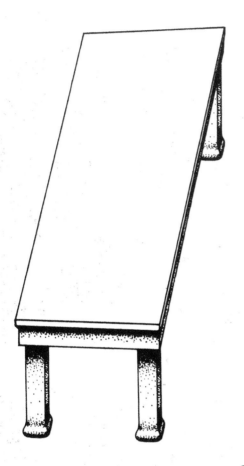

Shepard's Tabletop Illusion

Examine the two tabletops. Do they appear different in size and shape?
As unbelievable as it may seem, the two tabletops are identical in size. If you
don't believe it, trace *only* the tabletops and see for yourself.

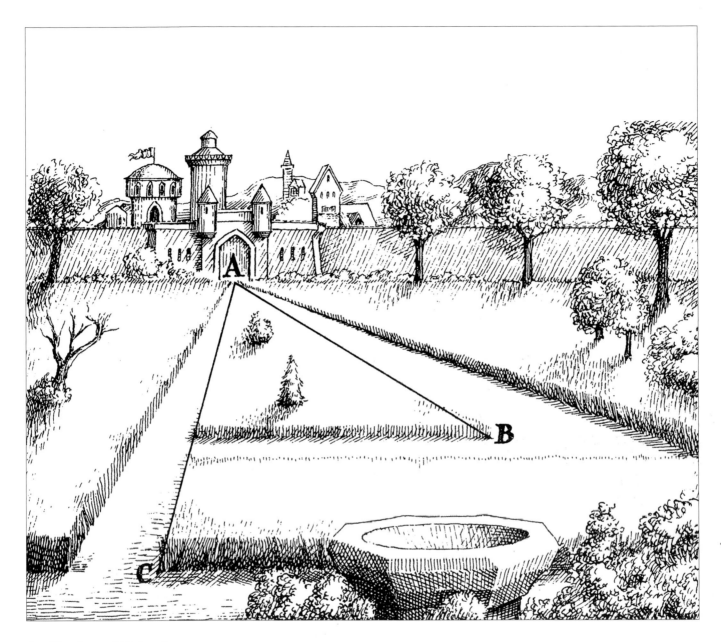

An Illusion of Extent

Does the length of line AC appear greater than the length of line AB? Measure them.

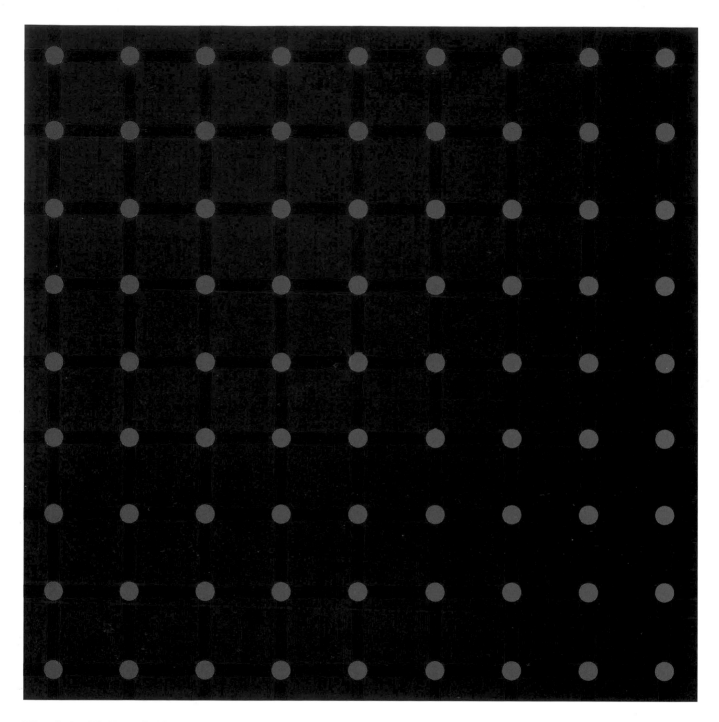

The Scintillating Grid Illusion

If you move your eyes around this image, you will see dots that appear to scintillate. If you stare at any one of the ghostly dots, it will disappear.

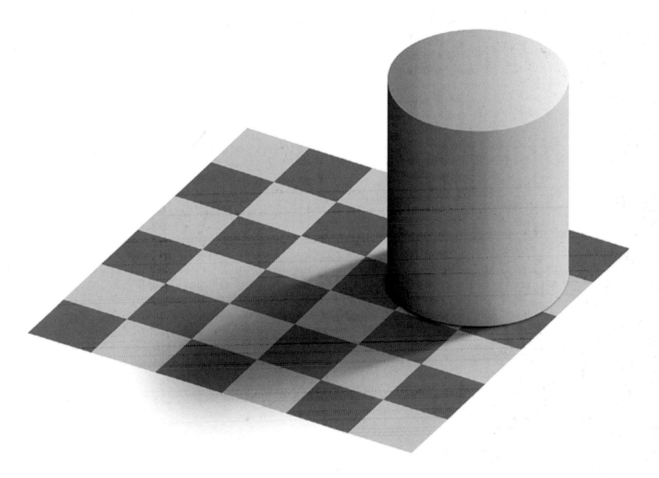

Adelson's Checkered Shadow Illusion

The light check inside the shadow of the cylinder is an identical shade of gray to the dark check outside of the shadow. If you don't believe it, cut out two peepholes exactly the size of each square and compare them.

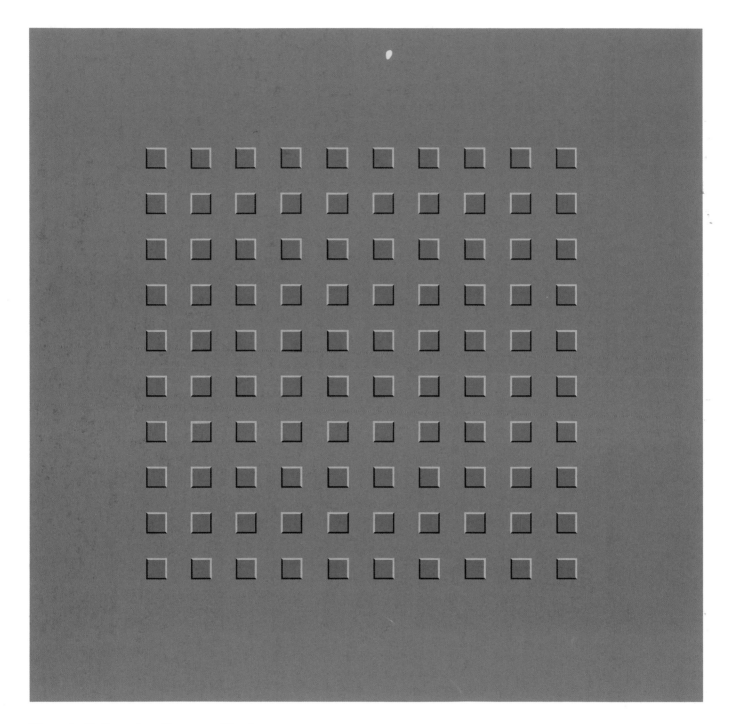

Pinna's Deforming Squares Illusion

Slowly move this image in an irregular manner and the squares will appear to deform.

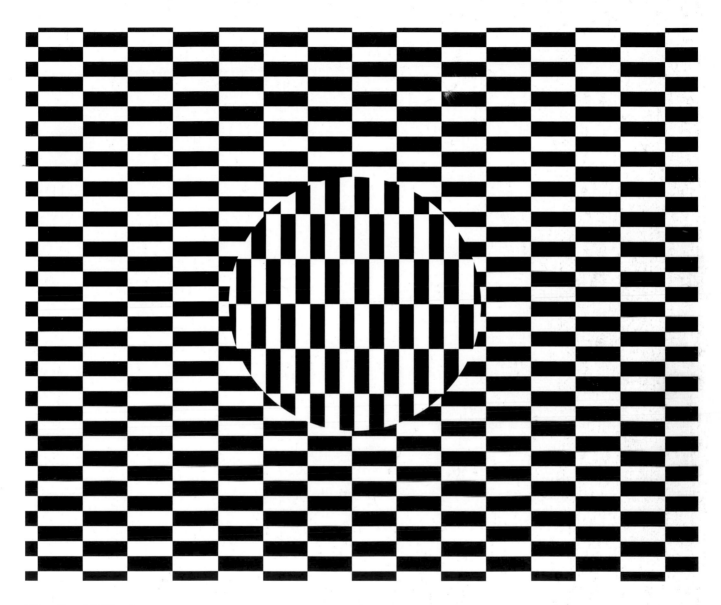

The Ouchi Illusion

If you move your eyes across this image or slowly shake it, the center section will appear to separate in depth and move slightly in a direction opposite to its true motion.

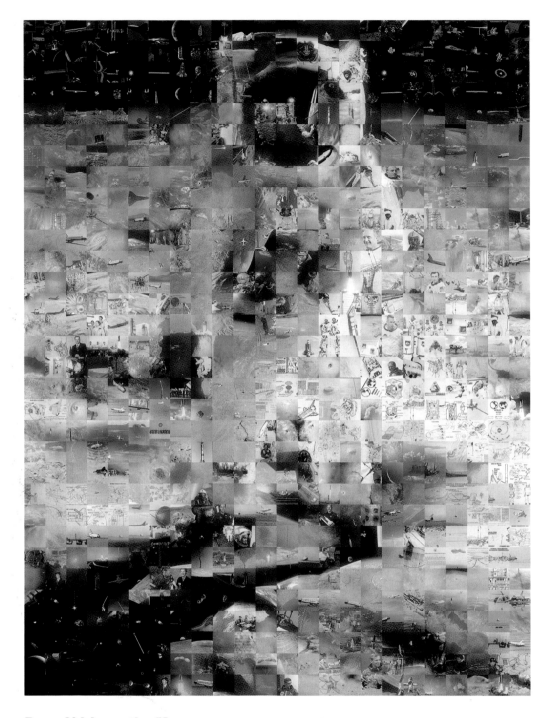

Buzz Aldrin on the Moon

This famous image of Buzz Aldrin on the Moon is made entirely out of hundreds of NASA images. If you view this image from a distance, it will be remarkably well defined. If you examine it closely, you can make out the individual photographs.

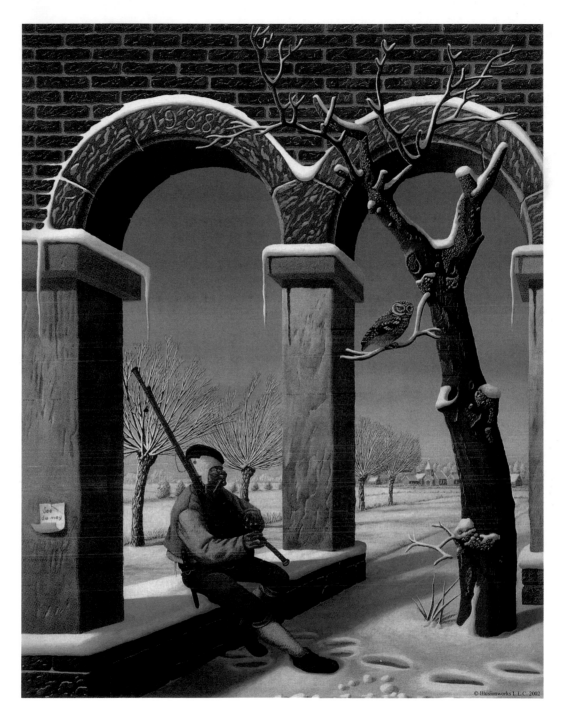

Melancholy Tunes on a Flemish Winter's Day

Is the left column coming forward?

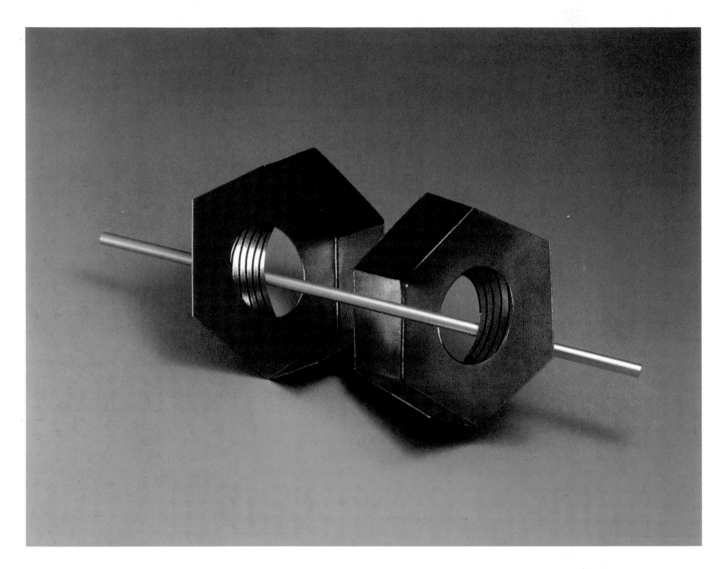

Crazy Nuts

This is a real physical object. Can you figure out how the straight steel rod passes through the seemingly perpendicular holes?

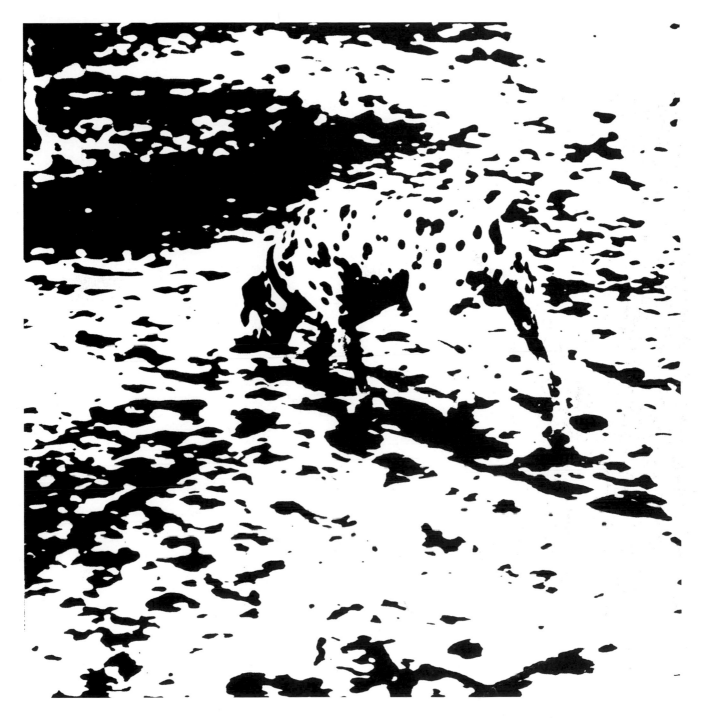

Can You Spot What Is Hiding Here?

What is hiding here? Before you check the answer, search carefully, because once you perceive the hidden image, you will never be able to see this image in its meaningless state again.

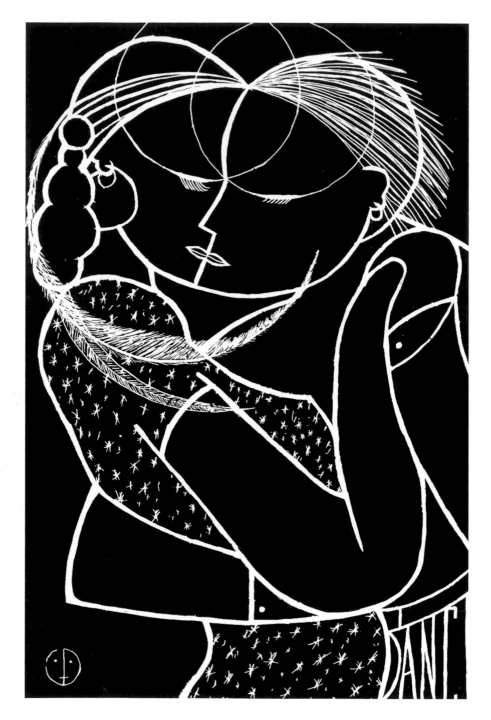

Soulmates

Do you perceive one head or two heads kissing in profile? They really appear to be soulmates.

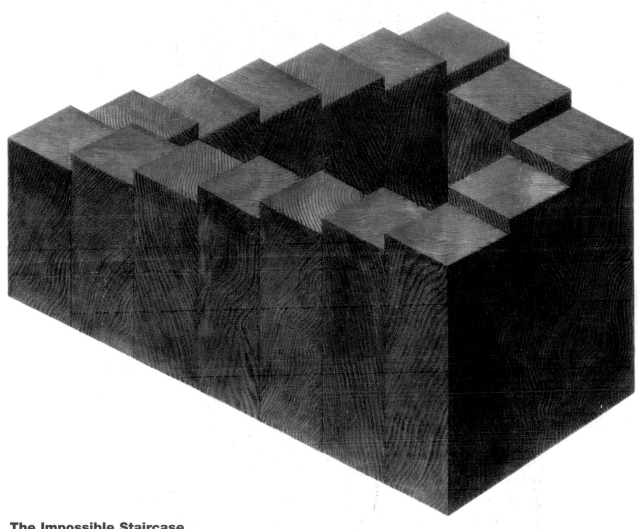

The Impossible Staircase

What happens when you walk around this peculiar staircase? Where is the bottom or top step located? Can such a staircase really exist?

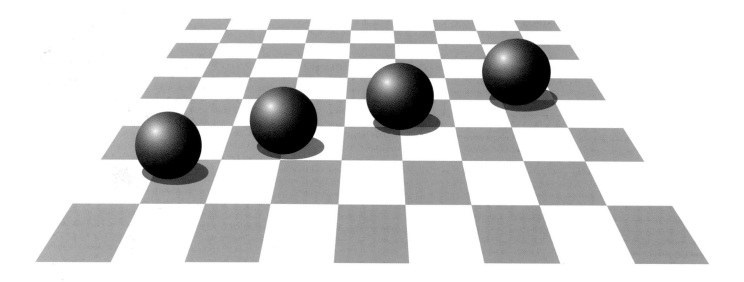

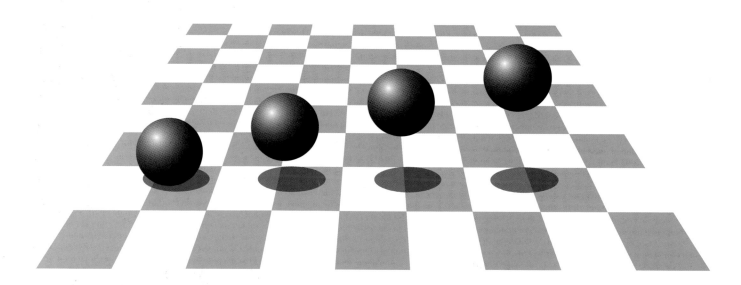

Kersten's Ball and Shadow Illusion

In the top illustration, the balls appear to be resting on the surface of the checkerboard floor. In the bottom illustration, the balls appear to be rising off the floor. Are the balls in the two illustrations truly in different positions relative to the background?

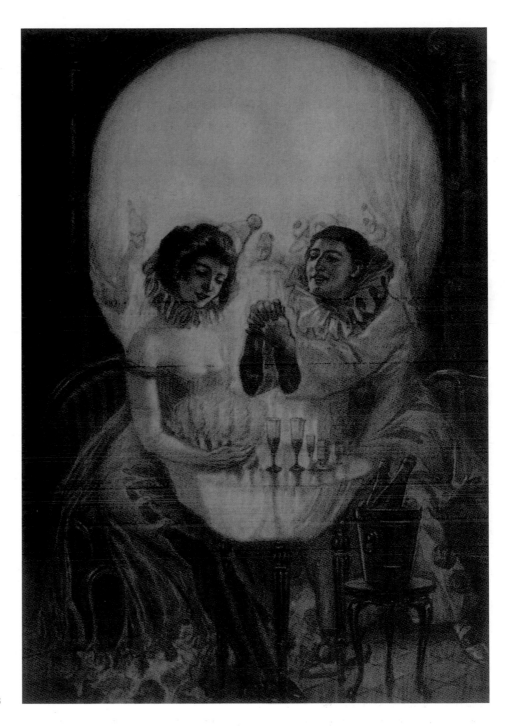

Is Danger Lurking
for this Couple?

Can you perceive the skull as well as
the couple?

Mackay's Effect

Move this figure slowly either right or left and you will perceive blurred "figure-eights" moving perpendicular to the true direction of motion. If you stare steadily at the center, while moving the figure, you should see a rotation pattern. You can get the direction of rotation to change by fixating on a point left or right of the image.

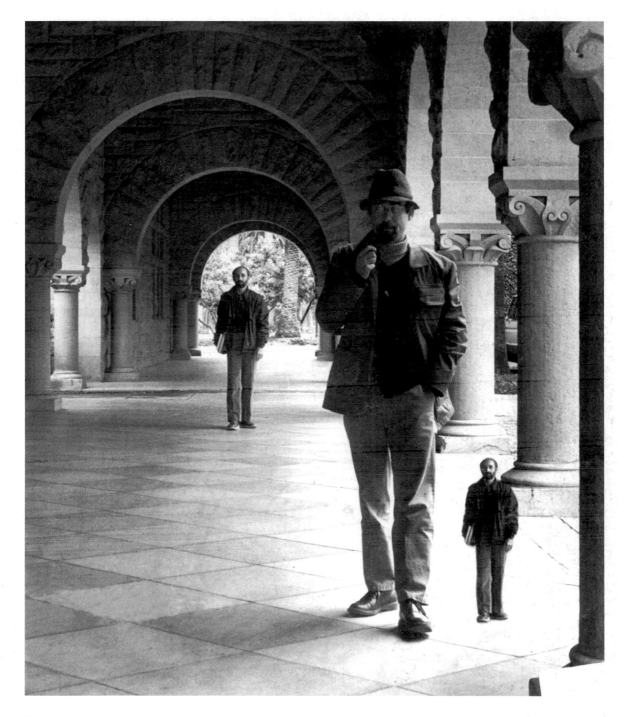

Hallway Illusion

Look at the man in the background and the little man standing in the foreground on the far right. Does either man appear normal? Does one man appear smaller than the other?

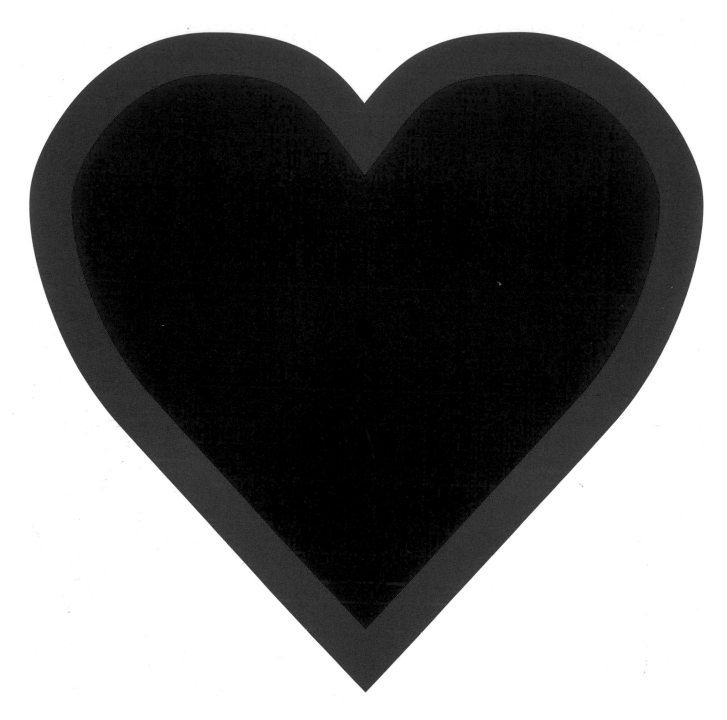

A Glowing Heart

Fixate on the black dot in the middle of the heart for 30 seconds or more without moving your eyes. Then quickly stare at a blank sheet of solid white or gray paper. You will see a faint, glowing red heart.

The Poggendorf Illusion

Which colored line is co-linear with the white line?

The Mysterious Lips that Appeared on the Back of My Nurse

Do you perceive a face or a landscape?

A Line of Squares

These squares may look perfect and separate, but they are formed by one continuous line.

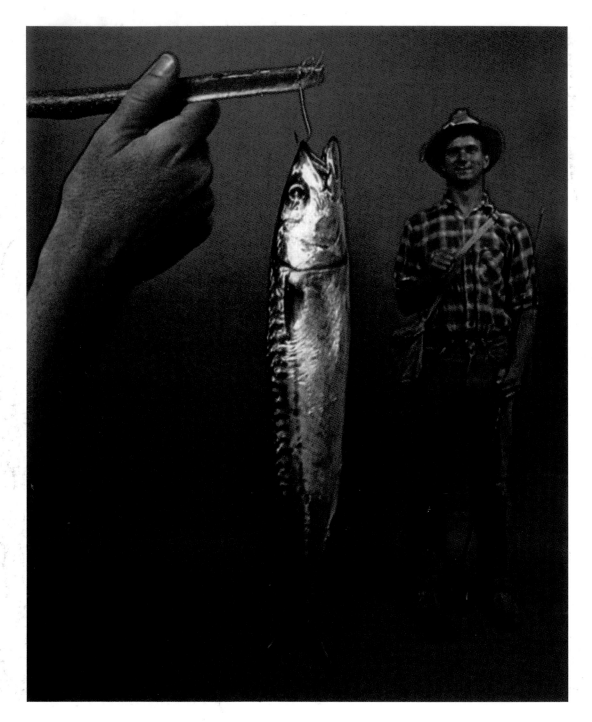

A Fish Tale in Context

Cover the man and the fish appears to be of normal size. Cover the hand and the fish is a rather remarkable catch.

Morellet's Tirets Illusion

Move your eyes around this image and it will appear to scintillate.

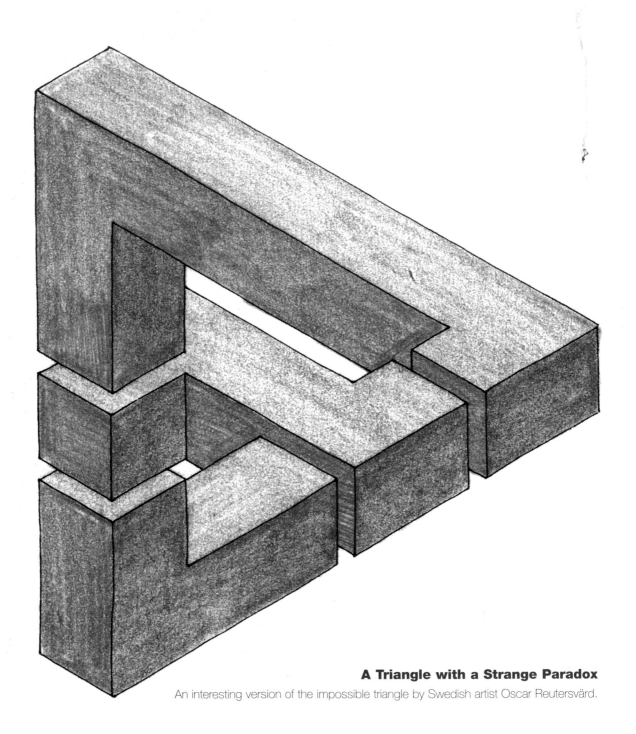

A Triangle with a Strange Paradox
An interesting version of the impossible triangle by Swedish artist Oscar Reutersvärd.

Color Assimilation

You will perceive two colored spirals, one dark red and one orange. In fact, both spirals are identical in color. Check this by making a very small peephole in a piece of paper and then compare the different areas.

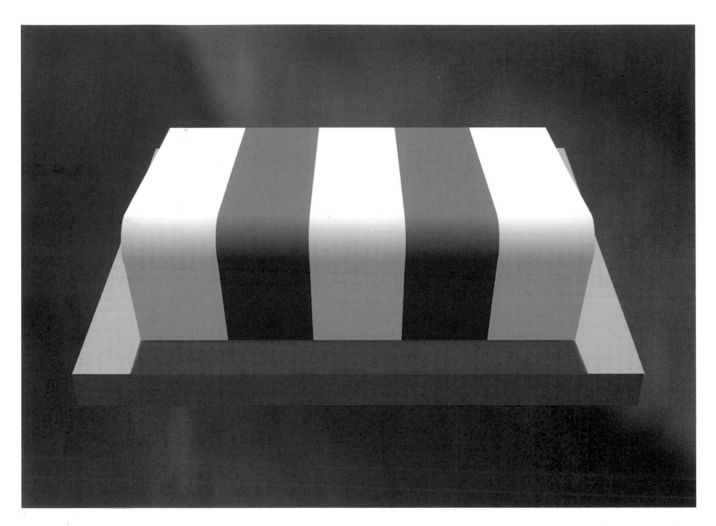

Brightness Illusion

Look at the striped object. It appears that two gray stripes lie in between three white stripes. Yet, what you see is not what you get! The two gray stripes on the top of the object are the identical shade of gray as the three shadowed "white" stripes on the front of the object.

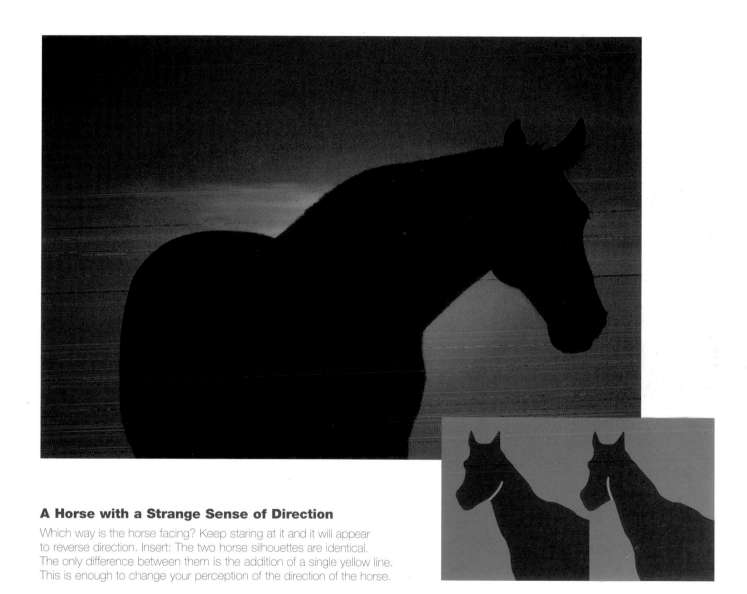

A Horse with a Strange Sense of Direction

Which way is the horse facing? Keep staring at it and it will appear to reverse direction. Insert: The two horse silhouettes are identical. The only difference between them is the addition of a single yellow line. This is enough to change your perception of the direction of the horse.

The Wundt Illusion

Do the different segments appear to be different sizes?

$$
\begin{array}{r}
1000 \\
20 \\
30 \\
1000 \\
1030 \\
1000 \\
+ \quad 20 \\
\hline
? \, ? \, ? \, ?
\end{array}
$$

This Just Does Not Add Up

As fast as you can, add up the column of numbers in groups out loud. What is your answer? Do it again. Have a friend try it. Most people get the wrong answer. Only look at the correct answer after you have tried it.

Three Line Illusion

Hold the illustration so that it is just below both eyes and the image lies flat and perpendicular to your face. Look at the two lines with both eyes and a third line will appear to rise out of the page.

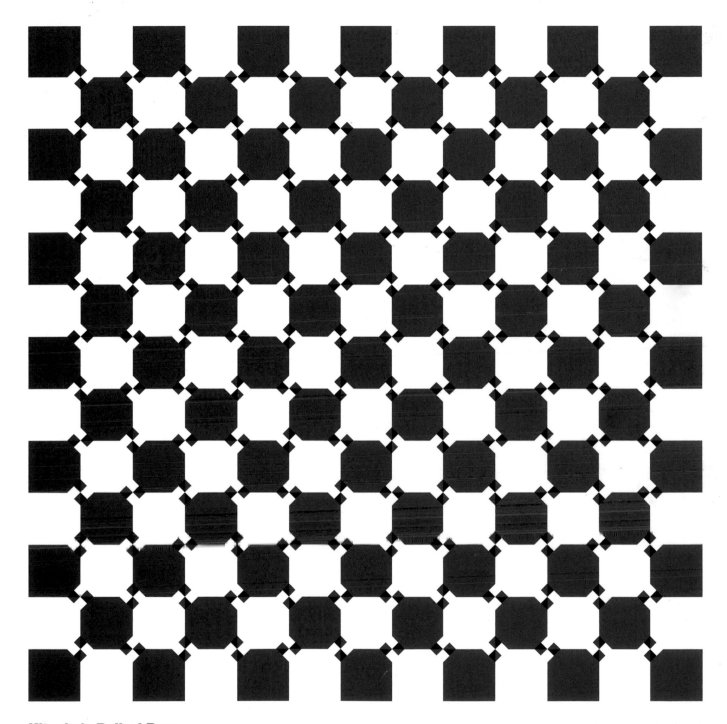

Kitaoka's Boli of Bugs

Do the vertical and horizontal lines appear to be wavy? Check them with a ruler.

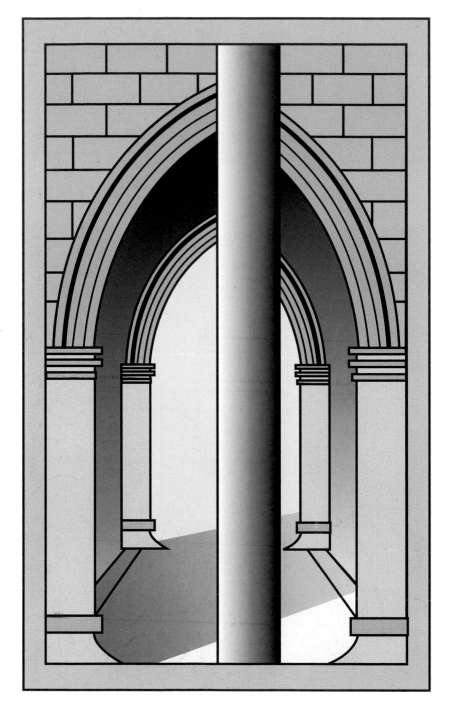

Pillar Illusion

Are the arches behind the pillar built incorrectly or is the pillar causing an illusion?

Hidden Star

Can you find the five-pointed star hidden in the pattern? Search carefully before you check the answer.

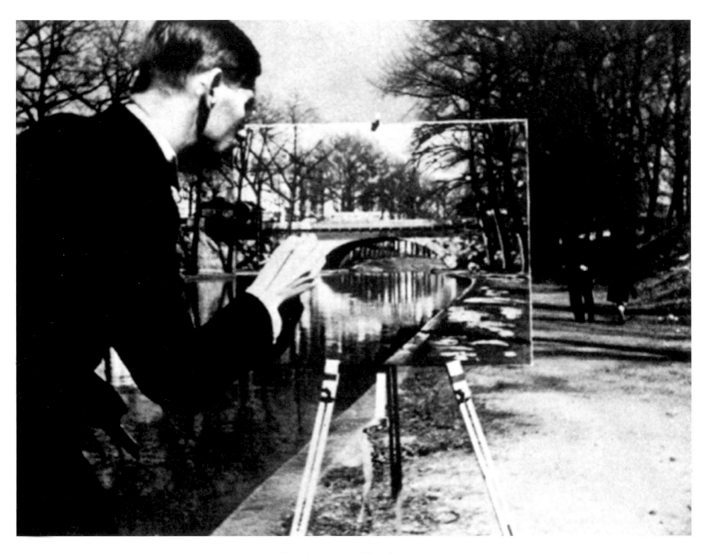

An Artist Paints a Fine Line Between Illusion and Reality

There is something unusual about this painting. What is it?

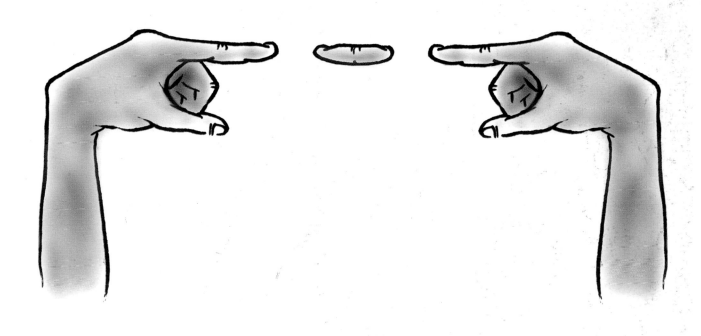

The Floating Finger Illusion

You can make a finger float right before your eyes in this fun illusion. Hold two opposing fingers in front of your face at eye level. Keep the tips of your index fingers at eye level. Focus on a wall several feet beyond your fingers. You should see a floating finger. Try moving your fingers closer to your face. What happens? If you focus on your fingers instead of the wall, the illusion vanishes.

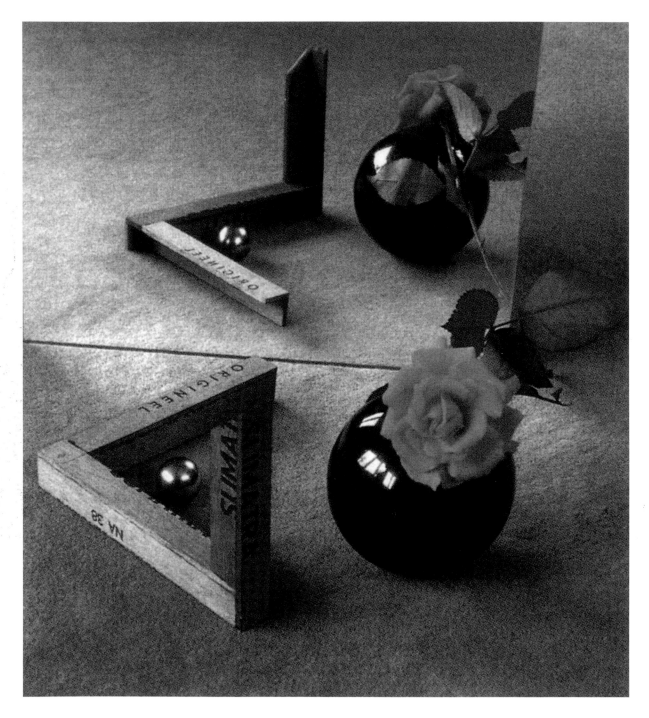

Reflections on an Impossible Triangle

In the foreground is an impossible triangle. Its true shape is revealed in the mirror.

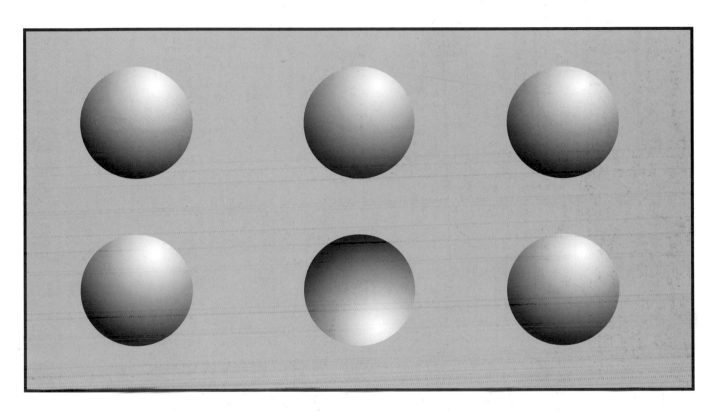

Shape from Shading Illusion

How many concave circles are there? One? Turn the image over and count again!

Flip-Flop Cube

Stare at this figure and it will invert in depth.

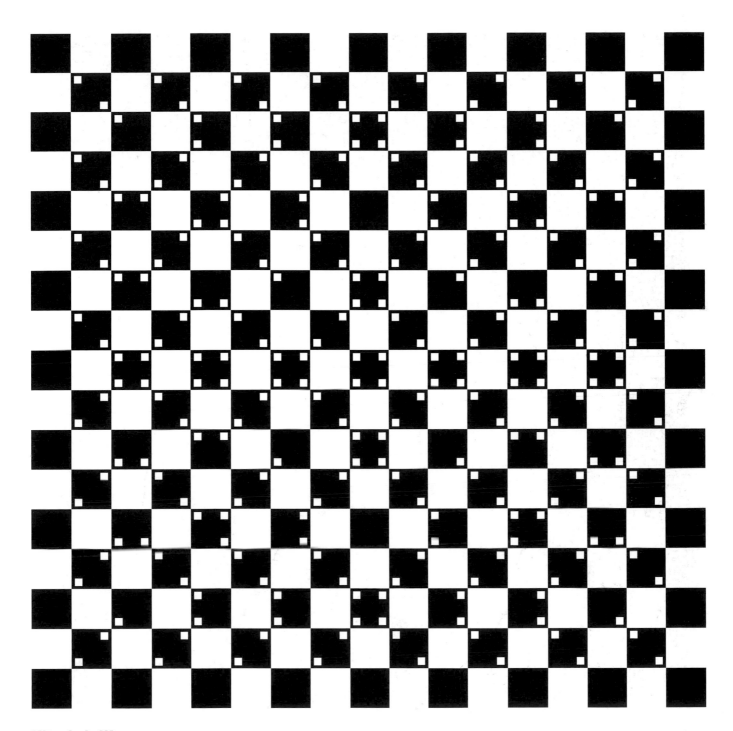

Kitaoka's Waves

Are the lines straight and parallel or are they bent? Check them with a straightedge.

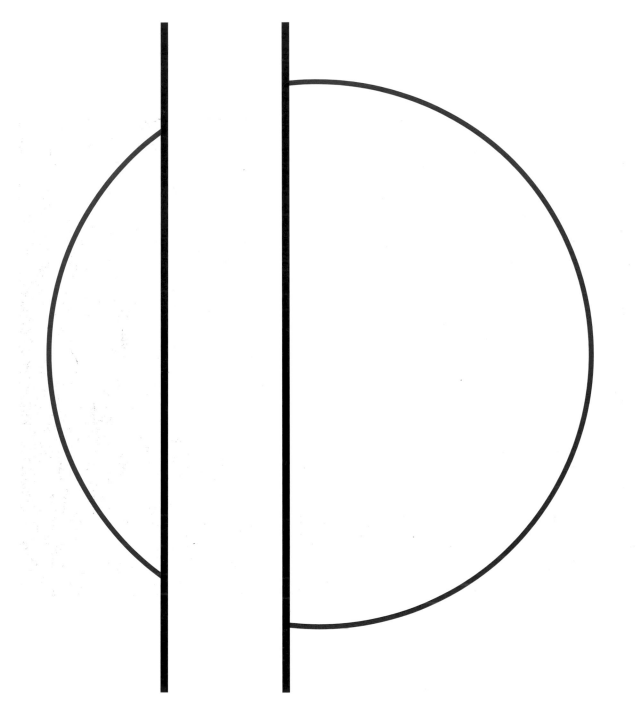

Circular Poggendorf Illusion

Are the ends of the two circular segments perfectly aligned?

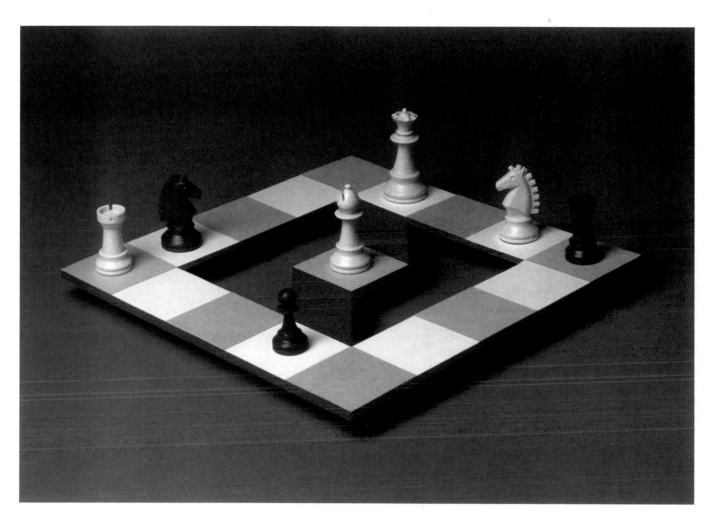

Level, but Rising Chess Set

How is this possible?

God Does Not Play Dice with the Universe

Do you see an array of dice or a famous face? Try looking at it from a distance.

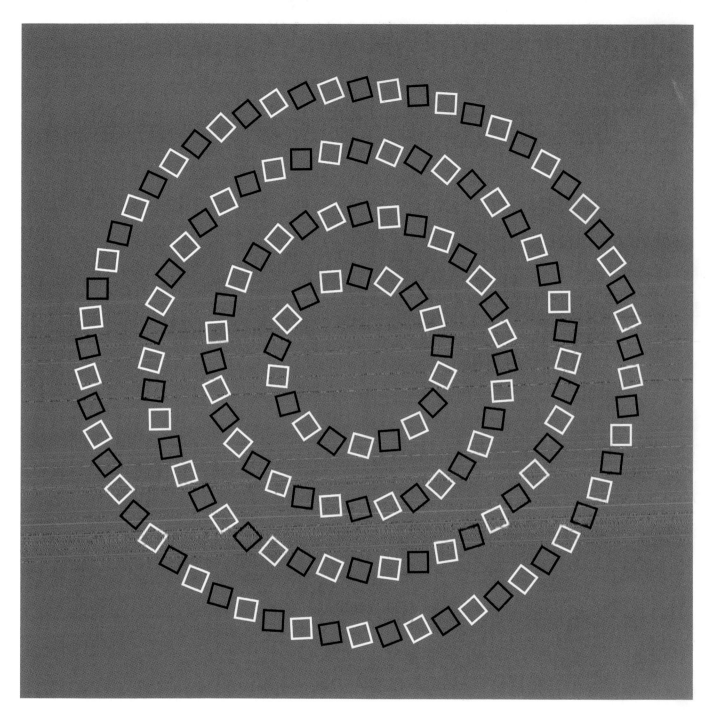

Pinna's Intertwining Circles Illusion

Do these circles appear to intersect and cross over each other?

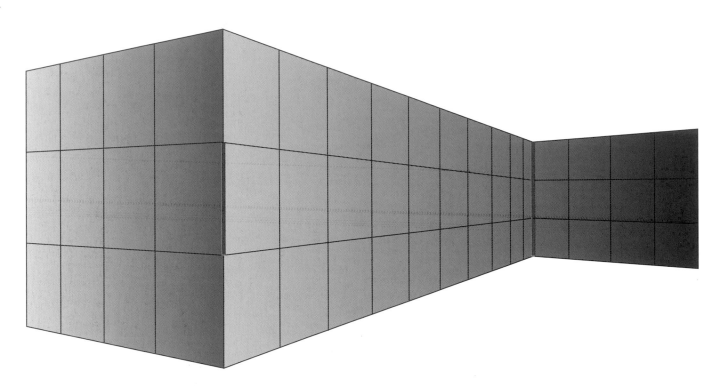

Variation on the Hallway Illusion

Believe it or not, both red lines are exactly the same length.

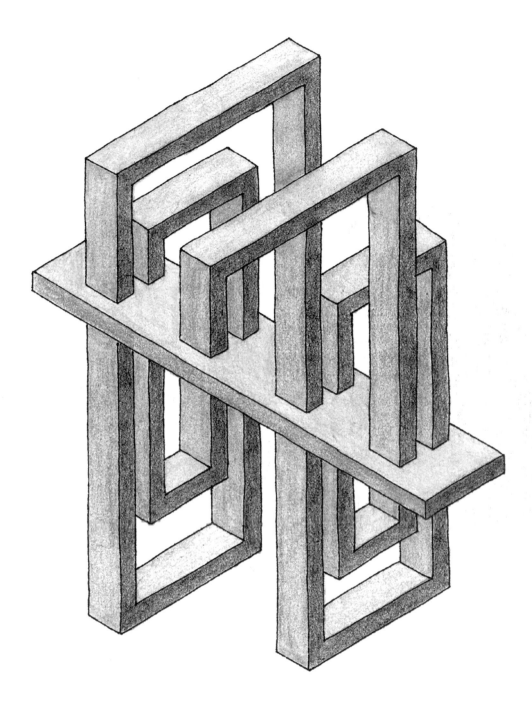

Reutersvärd's Impossible Meander

What is going on in this drawing?

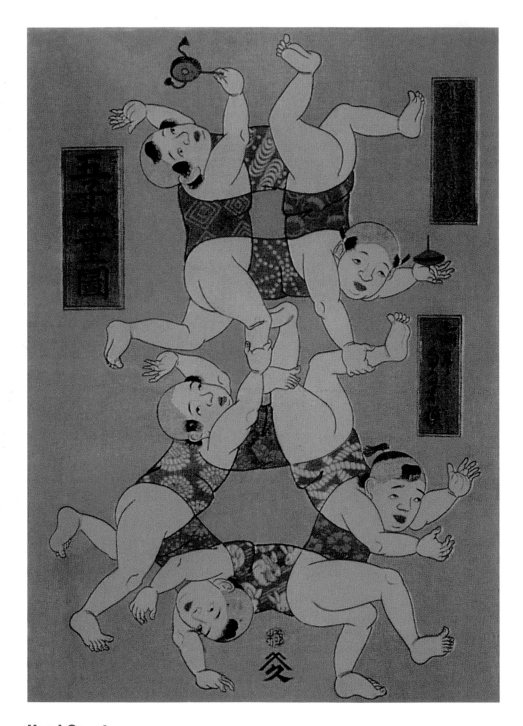

Head Count

There are only 5 heads, but one can count 10 children!

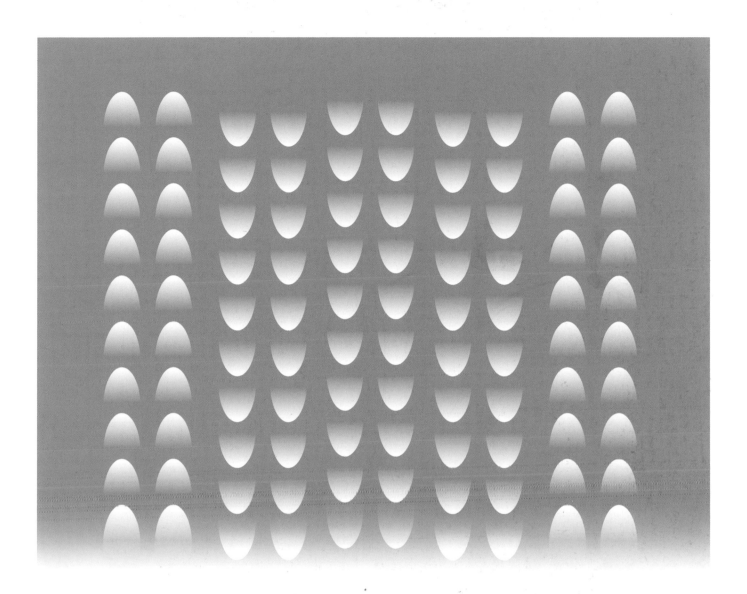

Kitaoka's Falls

If you look at this image, the middle section will appear to slowly drift downward and the outer sections will appear to drift slowly upward.

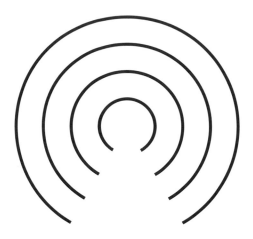

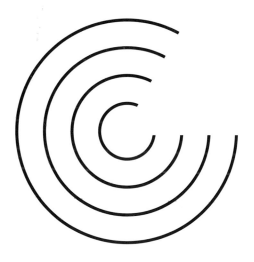

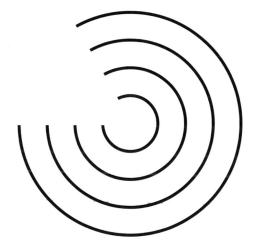

Kaniza Triangle

Do you perceive a white triangle even though there are no edges to define it? Does the triangle appear whiter than the background?

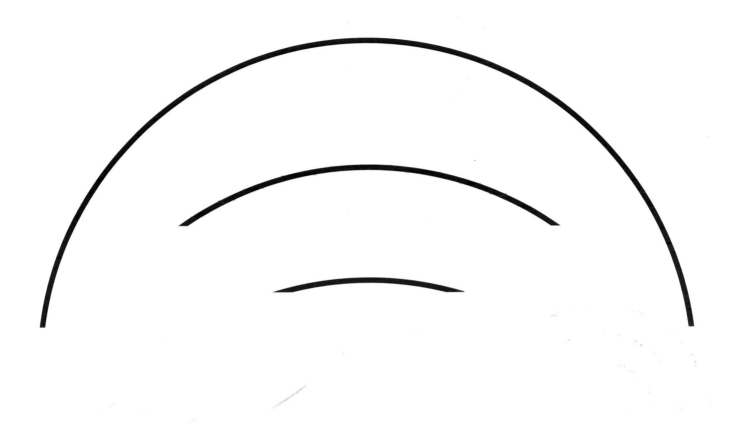

Tolansky's Curvature Illusion

Which line segment has the greatest radius of curvature?

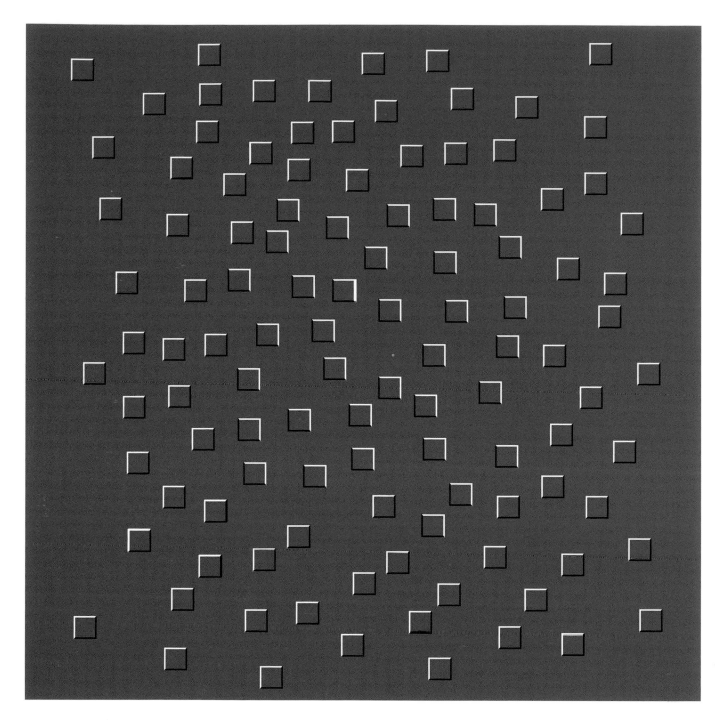

Pinna's Separating Squares Illusion

Move this image in an irregular manner and the center squares will appear to move in a different direction.

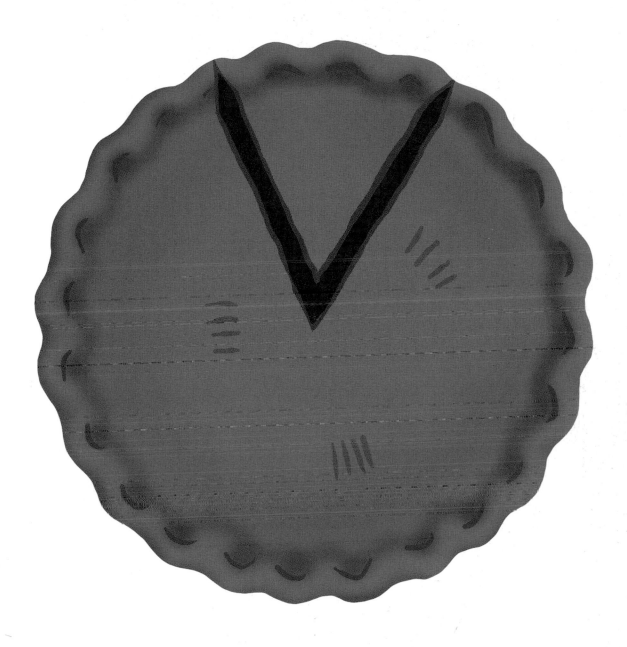

Where's the Pie?

This scrumptious pie has the amazing ability to appear and disappear right before your eyes! Can you make it transform from a single pie piece to a whole pie with a single piece missing?

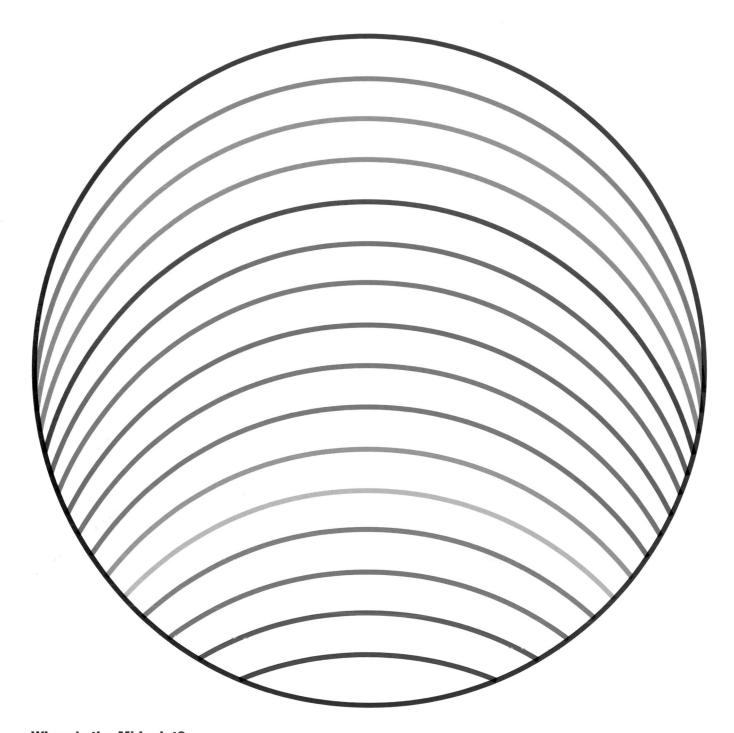

Where's the Midpoint?

One of the arcs within the circle passes through the center of the circle. Which colored line is it? Without measuring, can you determine the correct colored arc? Check your estimate with a ruler.

Rising Line Illusion

Can you make these lines rise out of the page? Tilt the page and look at the image with one eye from the bottom right side.

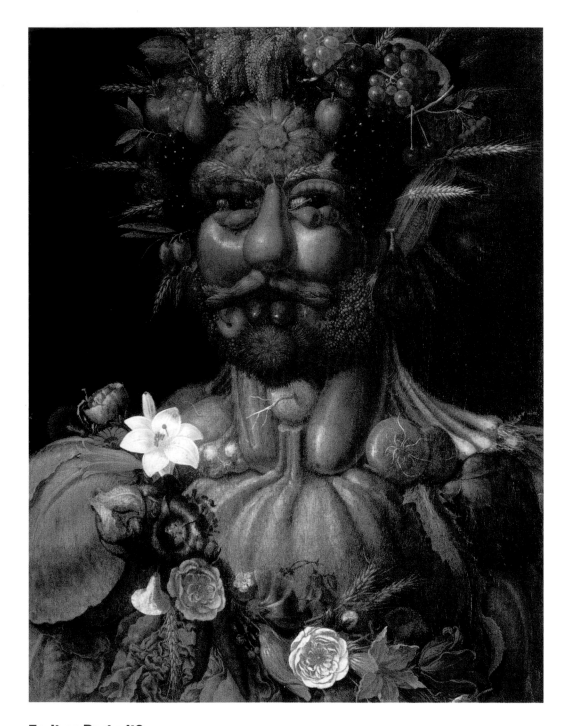

Fruit or Portrait?

Do you see a collection of fruit or a portrait of Emperor Rudolph II?

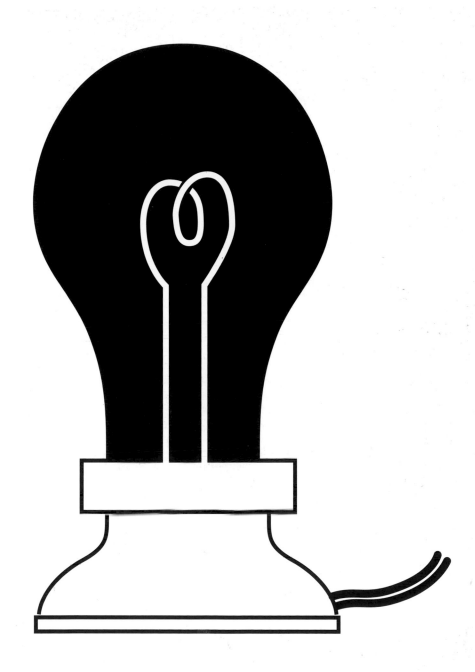

Make the Lightbulb Glow!

Stare at the black lightbulb for 30 seconds or more without moving your gaze. Quickly transfer your gaze to a blank sheet of white or gray paper. You will see a glowing lightbulb! Try it again, but this time look at a distant wall. What happens to the size of the glowing lightbulb?

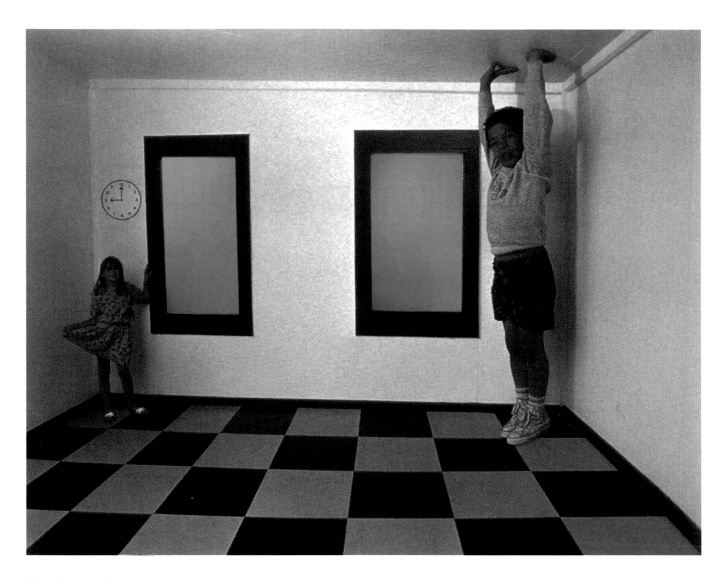

The Ames Room

Although the boy and the girl appear to be dramatically different in height, they are actually the same height. Additionally, although the room appears to be cubic, its true shape is quite different.

Camouflage

What do these strange symbols signify? Can you figure out what is the next pattern in the series?

Time-Saving Suggestion

Can you perceive both the arrows and the figures in this illusion?

Illusory Sphere

Can you perceive a sphere even though there are no edges or shadows to define it?

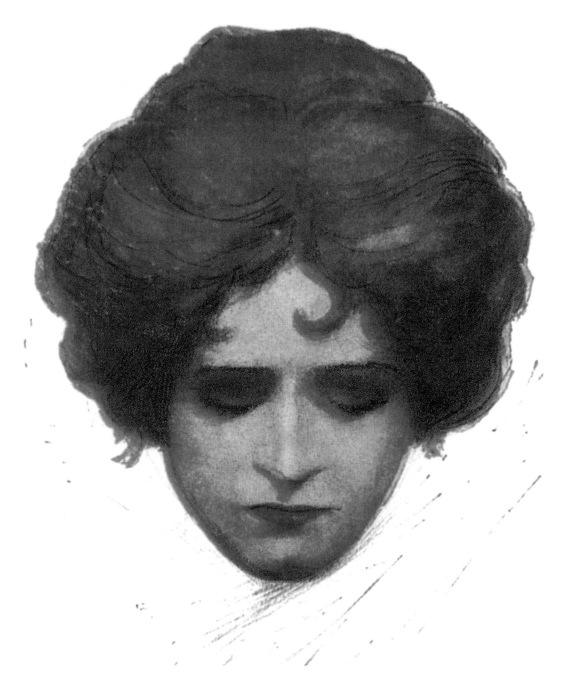

The Woman with Closed Eyes

Stare at this woman and her eyes will suddenly open!

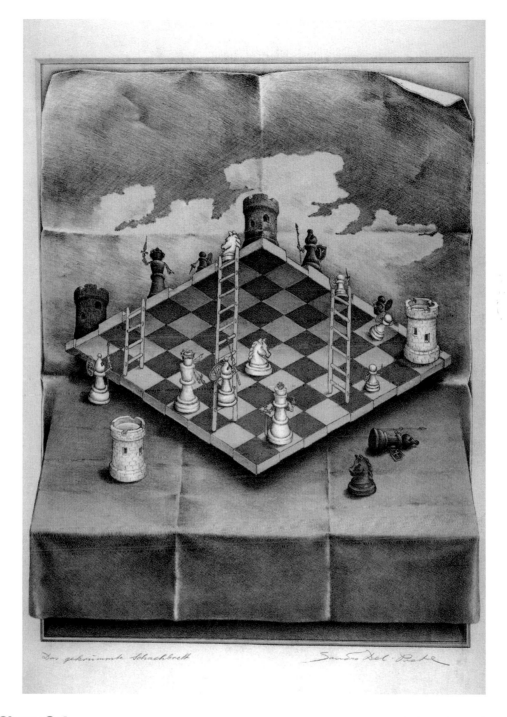

Das gekrümmte Schachbrett

The Folded Chess Set

Are you looking at this chessboard from the bottom or the top? The ladders also twist in strange ways.

The Müller-Lyer Illusion

Which line segment appears longer: the segment where the arrows are pointing in, or the segment where the arrows are pointing out?

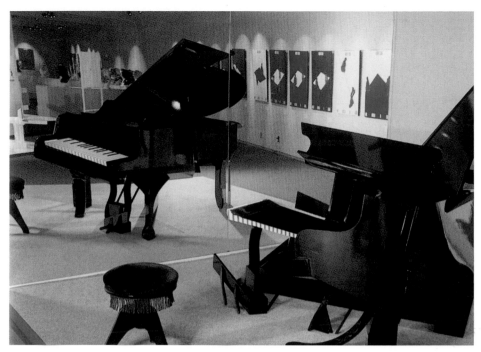

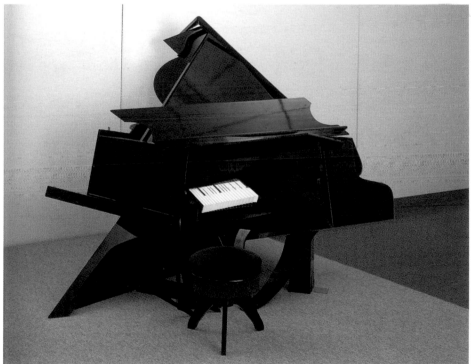

Fukuda's Underground Piano

The distorted structure seen in these two images creates the illusion of a perfect piano when reflected by the mirror in the top photo.

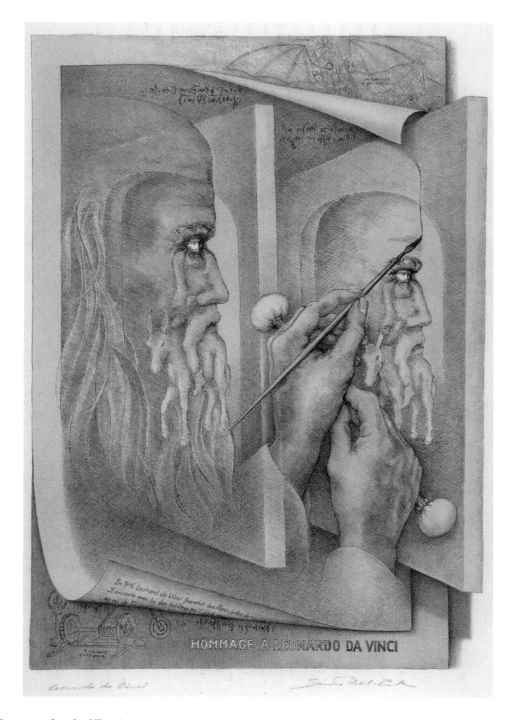

Homage to Leonardo da Vinci

From where is Leonardo da Vinci obtaining his inspiration for his portrait of a mule and rider? Look closely at his face and then closely at the mule and rider!

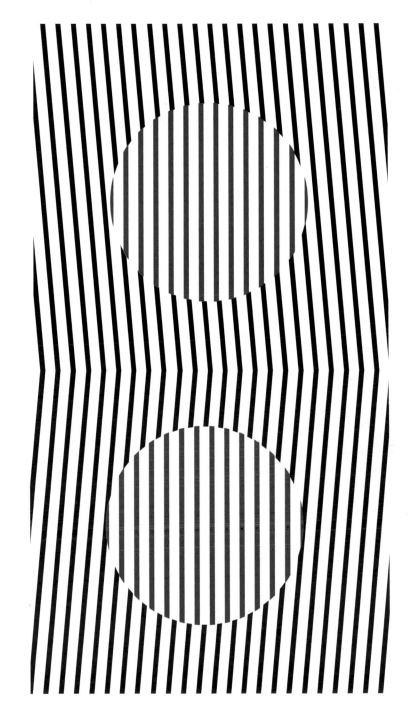

Blakemore's Tilt Orientation Illusion

Do the red vertical lines in the two center sections appear tilted?

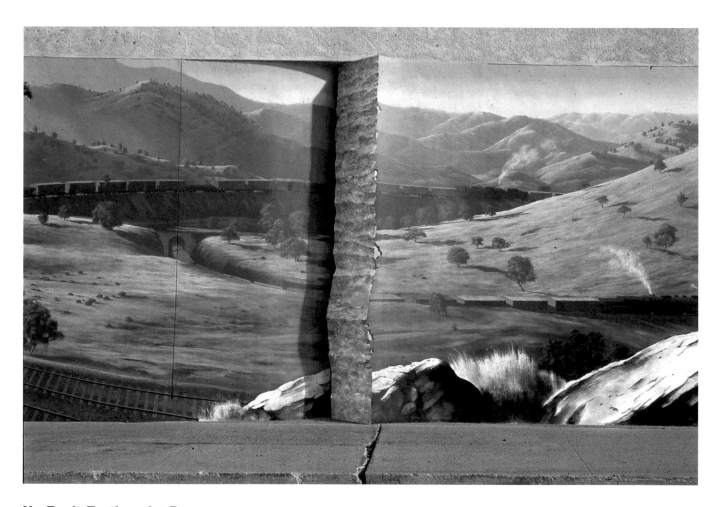

No-Fault Earthquake Damage

This California building appears to have significant earthquake damage. Can it be repaired? In truth, the large fissure in the wall does not need to be repaired, because it is entirely painted on a flat surface. This illusion is so convincing that it is almost impossible to view it as a continuous flat surface.

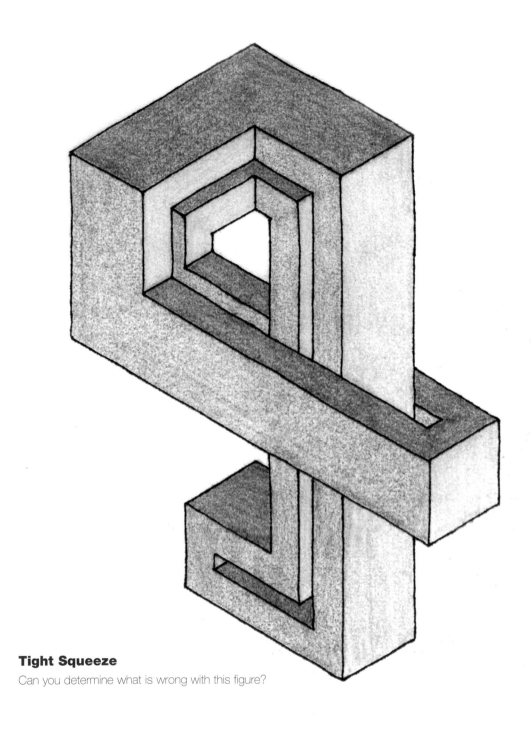

Tight Squeeze

Can you determine what is wrong with this figure?

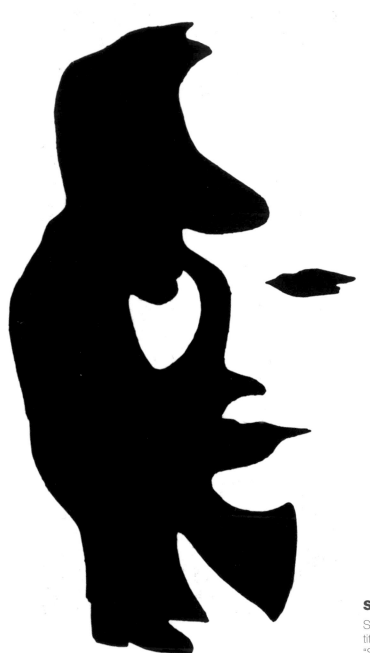

Sara Nader

Stanford psychologist Roger Shepard aptly titled this ambiguous figure/ground illusion, "Sara Nader." Can you tell why?

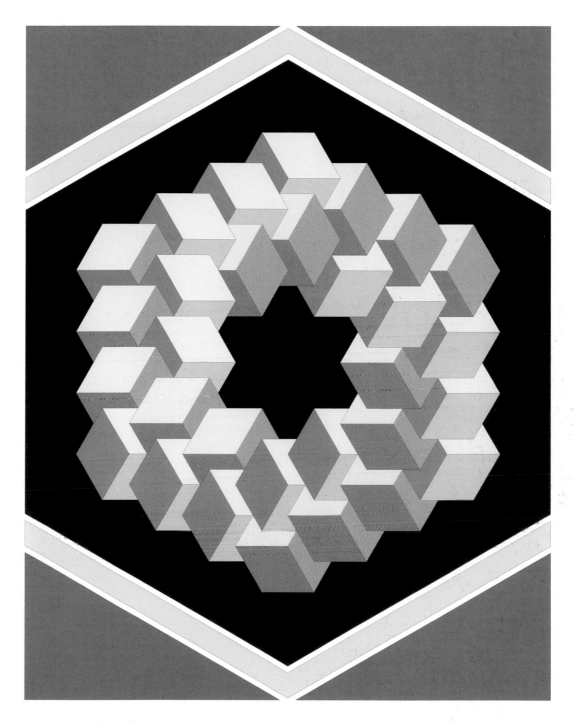

An Impossible Configuration of Cubes

Is this configuration of cubes possible?

Hidden Figure

What do you perceive here? Whatever it is, it is staring right at you! Try really hard to make sense of this image before you look up the answer in the back.

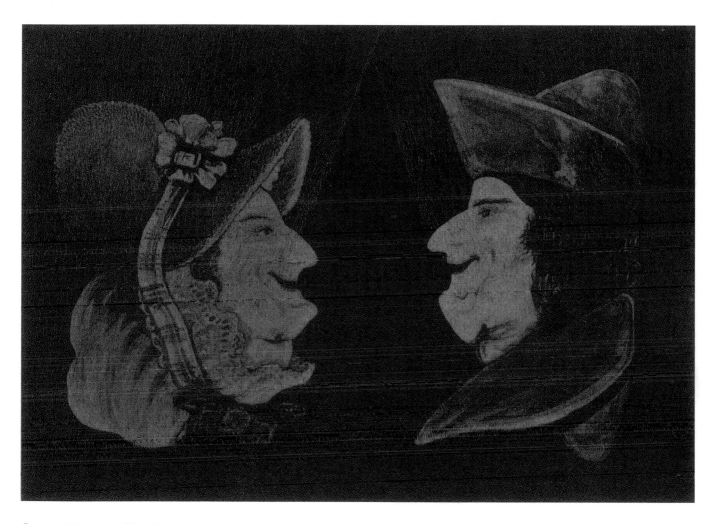

Courtship and Matrimony

This German 19th century topsy-turvy illusion was obviously created by a disgruntled husband or wife. The couple is perceived as being happy in "courtship," but if you turn the image upside down, you will see that the couple is unhappy in "marriage."

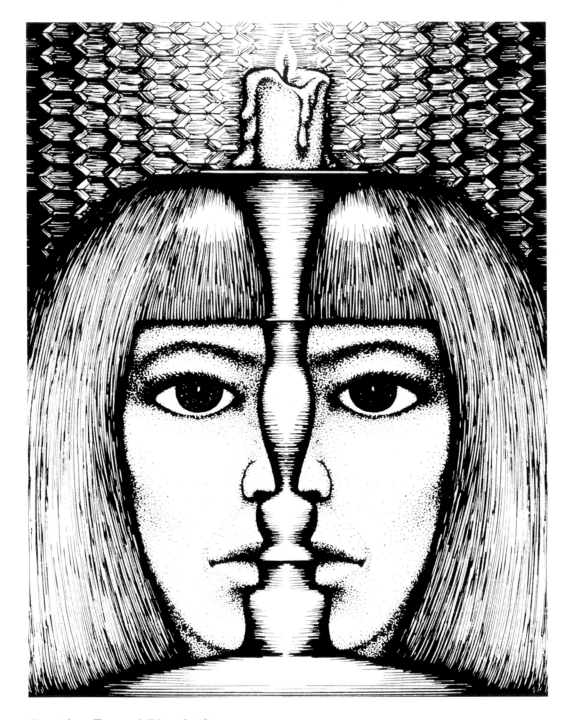

Egyptian-Eyezed Tête-à-tête

Which do you perceive: two heads in profile on either side of the candlestick, or one head behind the candlestick?

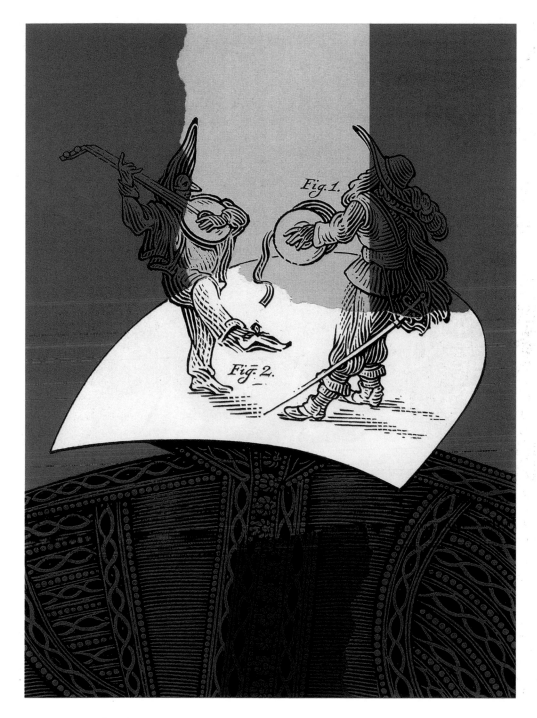

Portrait of Shakespeare

Do you see the two performing minstrels or the English playwright William Shakespeare?

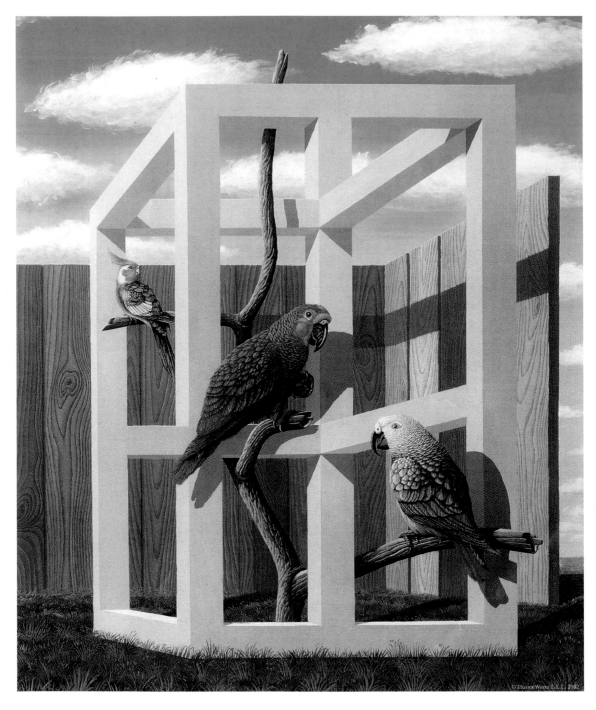

Strange Panopticon Construction for Parrots and Family

Can you see what is unusual about this birdcage?

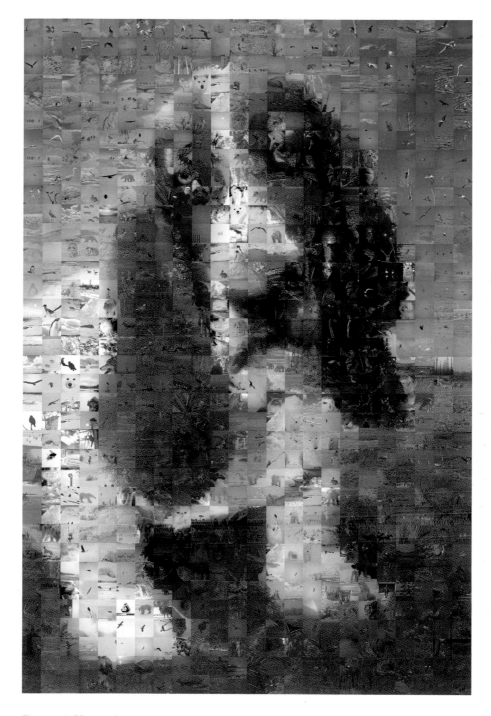

Basset Hound

This basset hound was created out of hundreds of small animal photographs. If you look closely at the picture you can see the individual images, and if you look at it from a distance it is easy to perceive the dog.

Filling-in Illusion

With one eye, steadily fixate on the center dot in the middle of the left smudge. After a few seconds the smudge will disappear. Try this again with the center of the smudge on the right. This time the smudge will not disappear.

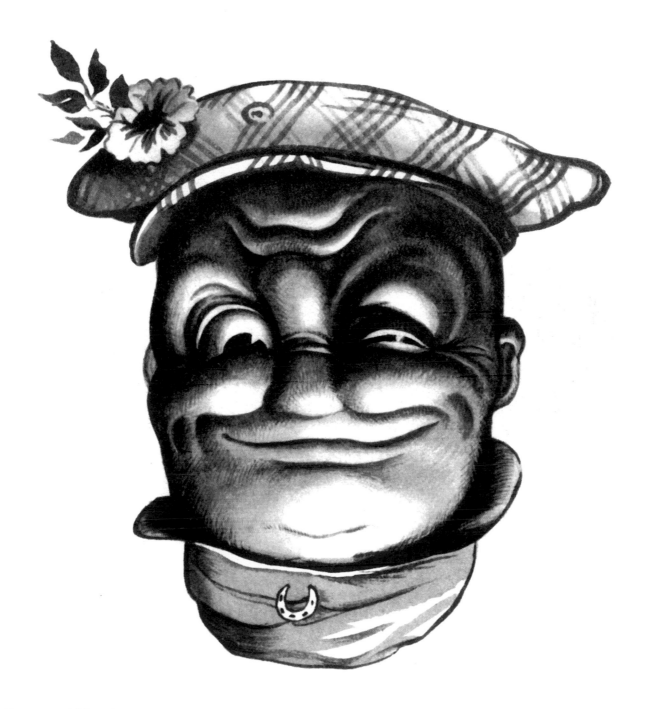

A Change of Mood

This man will change his mood if you turn him over.

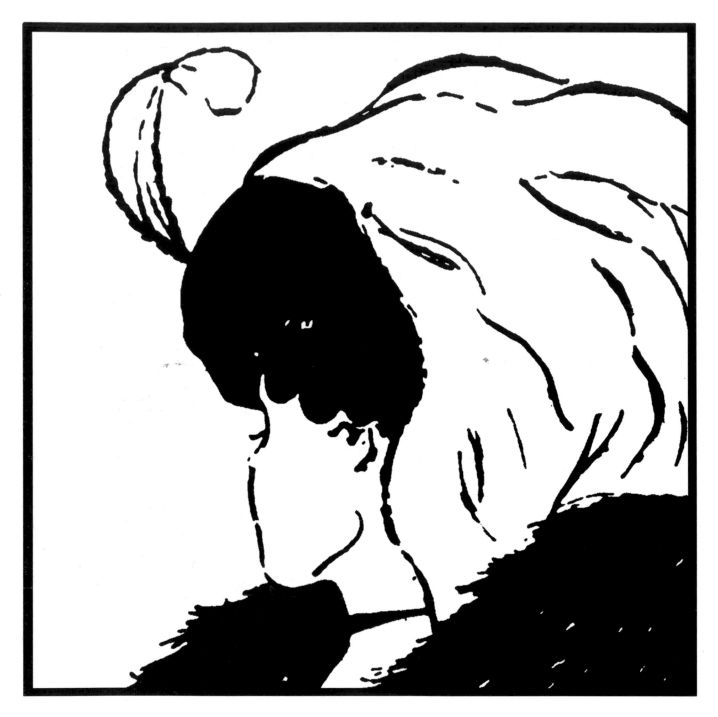

My Wife and Mother-in-Law

Do you see the profile of a young or old woman? If you stare at this image long enough, your perception will "switch" from one to the other. Once you have seen both the young woman and the old woman, see if you can perceive both simultaneously. You will find that it is almost impossible.

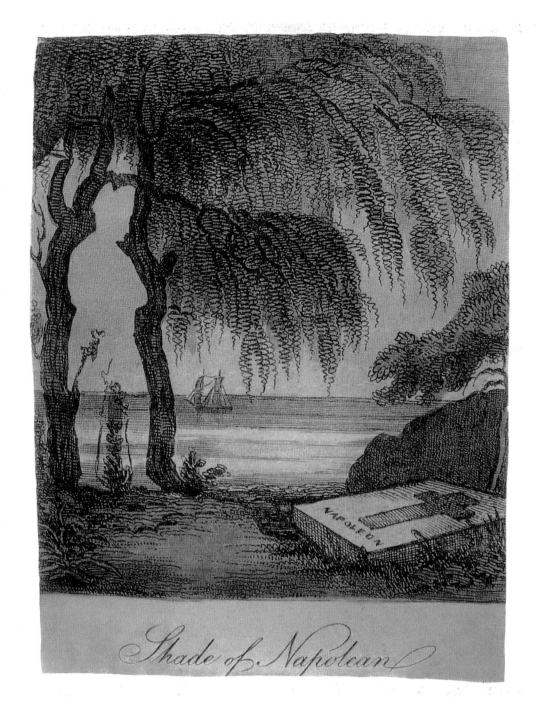

Shade of Napolean

Shade of Napoleon

Can you find the standing figure of Napoleon? This figure/ground illusion appeared shortly after Napoleon's death.

An Illusion Causes Another Illusion

Do you see a series of concentric rings?

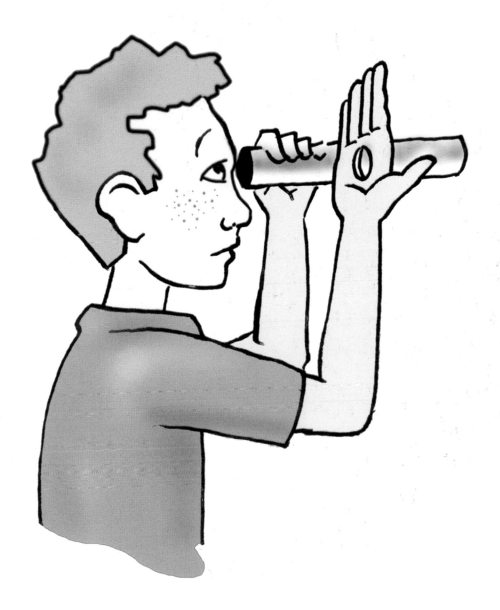

Hole in Your Hand

Create a hole in your hand! Hold a tube up to your eye. Look at something about 15 feet away with both eyes (one eye should be looking through the tube). Then bring your free hand up in front of the eye that is not looking through the tube. You will see the object through a round hole in the palm of your hand. For an interesting variation, place a dime in the center of your palm and it will appear to float!

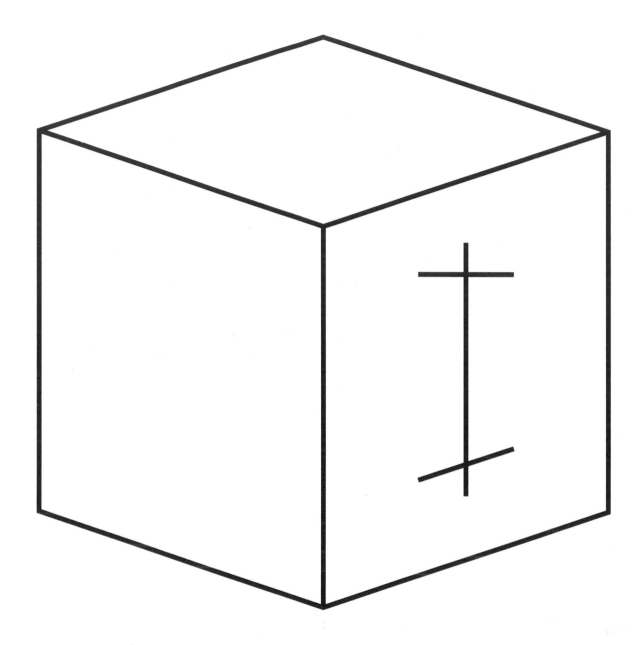

Perspective Box Illusion

Look at the figure on the outside of the cube. Which line is perpendicular to the vertical line and which line is at a slant? Cover just the outline of the cube and you will see your perception of the angles change.

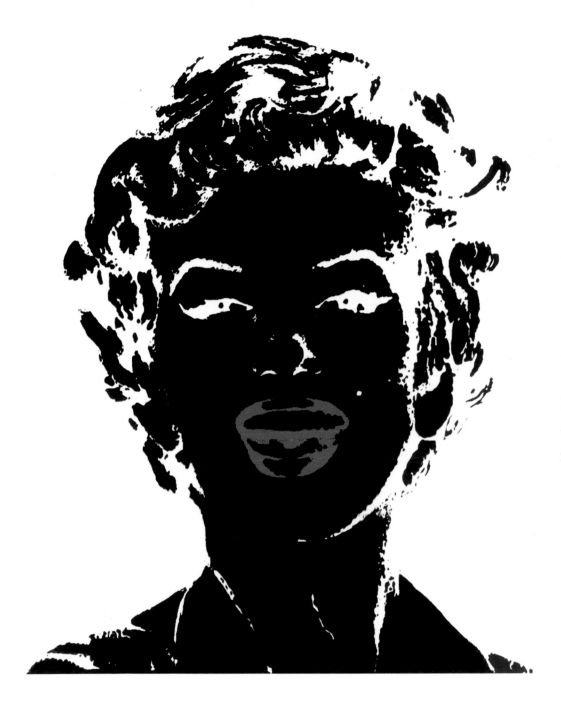

Marilyn's Red Lips

Stare at the figure of Marilyn Monroe for 30 seconds or more without shifting your gaze. Then quickly look at a solid white or gray background. You will see her lips glowing red!

Triangle Extent Illusion

Which line appears to be longer – the red line or the green line?

The Hermann Grid Illusion

You will see ghostly blue dots at the intersections. If you look directly at any dot it will disappear. This is a colored variation of the Hermann Grid Illusion. If the squares were black you would see ghostly gray dots at the intersections.

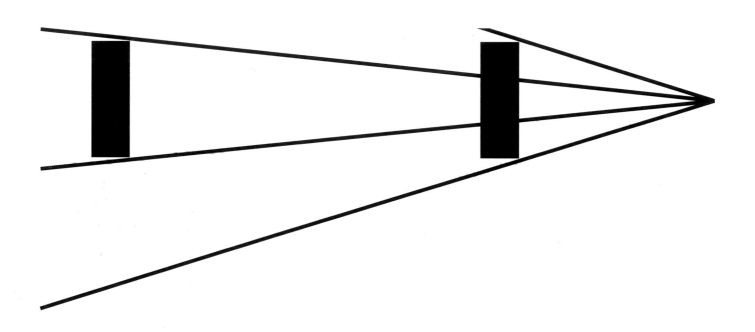

Ponzo Illusion

Which black bar appears larger? Measure them to check your answer.

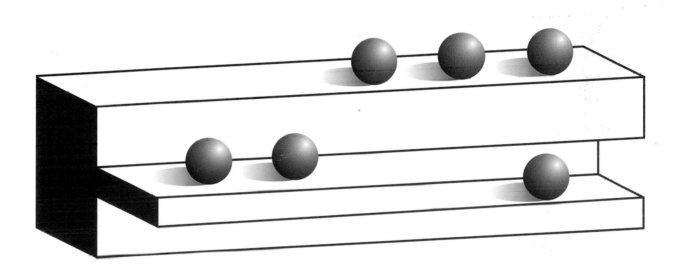

Impossible Shelf

Is this figure possible or impossible? Look closely at the shelves.

Terra Subterranea

Does the background figure appear larger than the foreground figure? Measure them to check your answer.

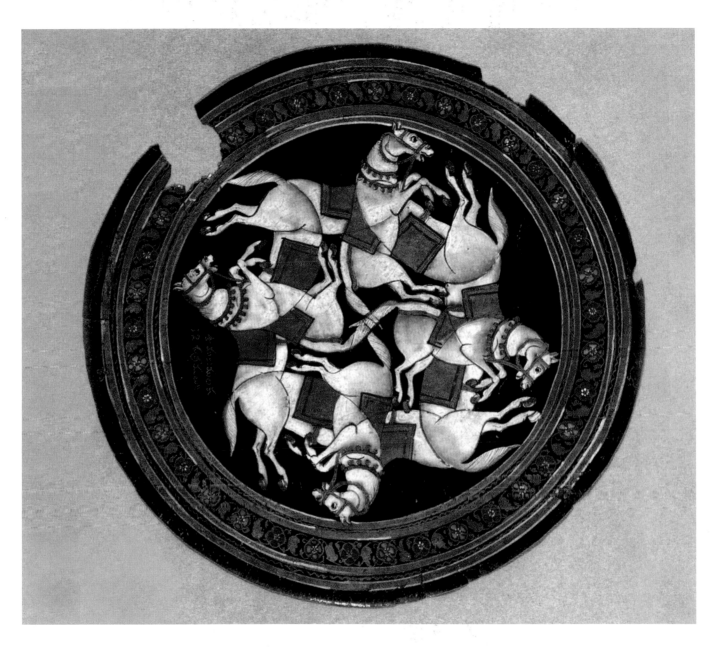

Persian Horses with Too Many Bodies

Count the heads and count the number of bodies.

The Cheshire Cat Illusion

This is a truly amazing illusion, but it requires two people to make it work! Sit facing a mirror, with a white wall on your right. Angle the mirror edge against your nose so that the reflecting surface faces the wall. The other person should sit directly across from you. Position yourself so that your right eye sees just the reflection of the wall, while your left eye looks forward at your partner's face. It is very important for both of you to remain very still. Keeping your head absolutely still, take an eraser and make a circular motion in front of the white wall. Your partner's face will disappear leaving only their mouth and eyes - just like the Cheshire Cat in *Alice in Wonderland*!

You might need to try this illusion several times, but don't give up. Allow some time to see the effect, as it is quite startling! The erasure can last for as long as five seconds if your eyes are kept stationary and there is no motion in the erased field of view. If your eyes move, the missing scene immediately reappears. If your eyes follow the moving object, erasure does not occur.

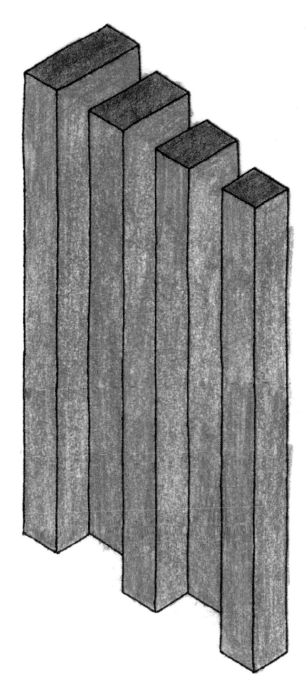

Impossible Paradox

How many paradoxes can you find in this figure?

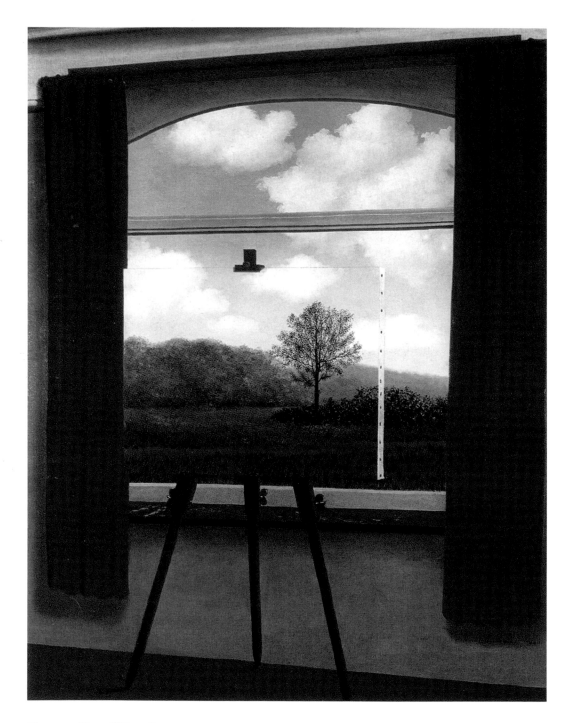

Human Condition I

Is the tree outside or inside the room?

Zöllner Illusion

Do the purple lines appear straight and parallel? Measure them with a ruler.

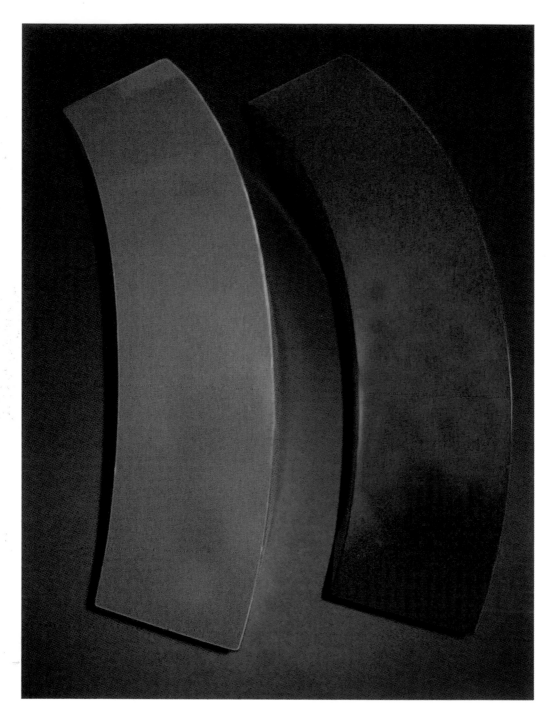

Wundt Blocks

Which colored block is larger?

Kitaoka's Tapes

Do the edges of the colored stripes appear wavy? Check them with a straightedge.

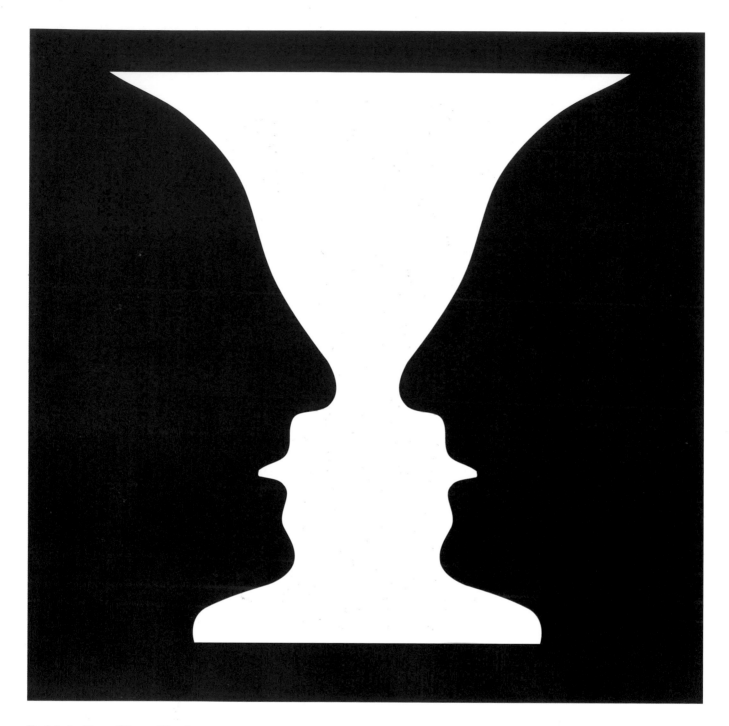

Rubin's Face/Vase Illusion

Do you perceive a white vase or two green heads in profile?

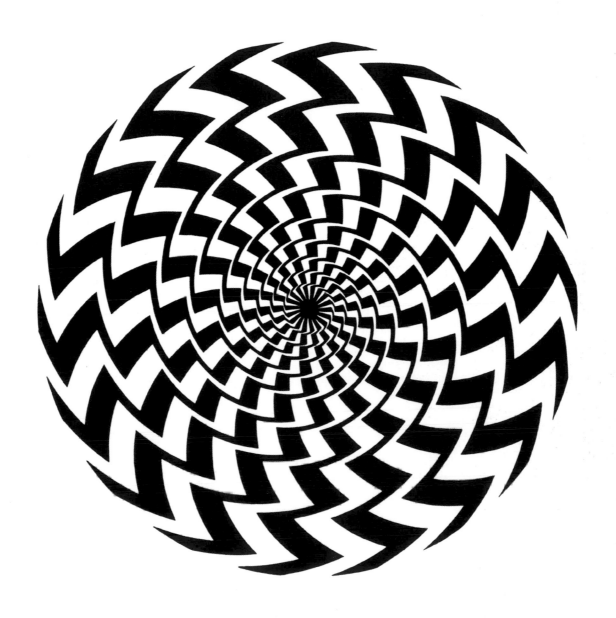

Wade's Spiral

Is this really a spiral?

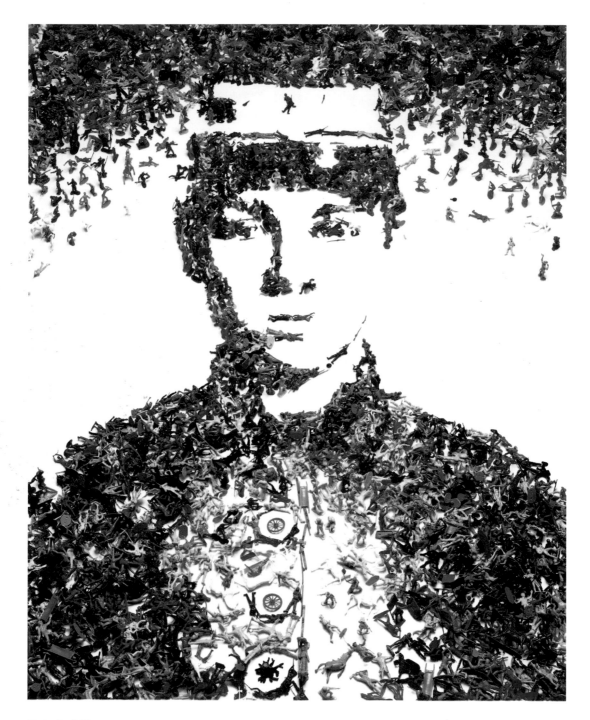

Toy Soldier

Look closely at this soldier. What is he made of?

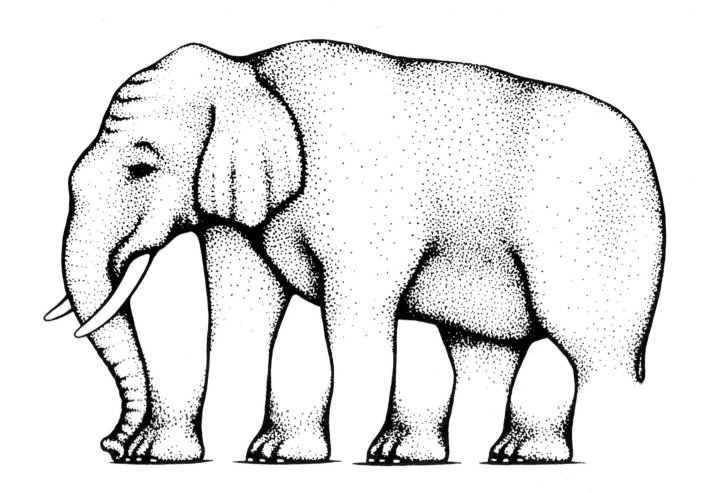

L'egs-istential Quandary

This elephant will have trouble walking!

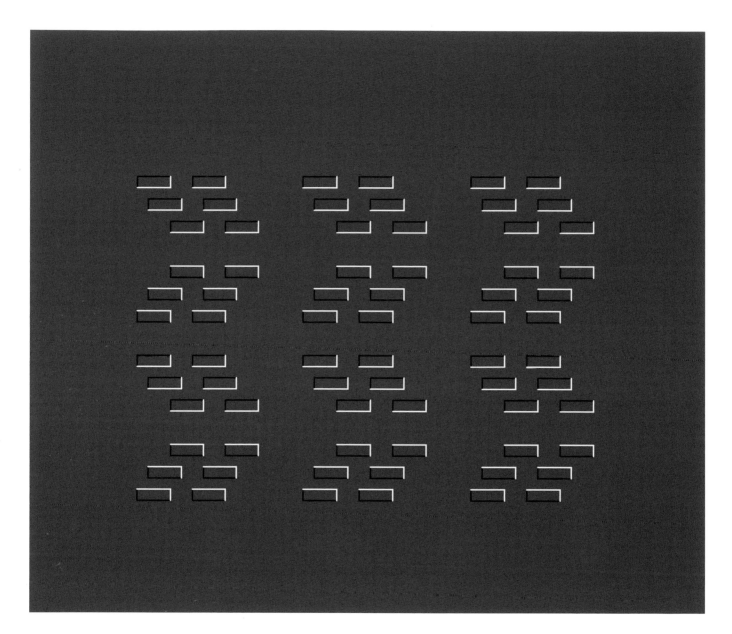

Spa

Move this image slowly up and down, and you will perceive motion perpendicular to its true motion.

The Garden Fence

What is odd about the slats on this fence? Cover up either end of the fence to see something strange.

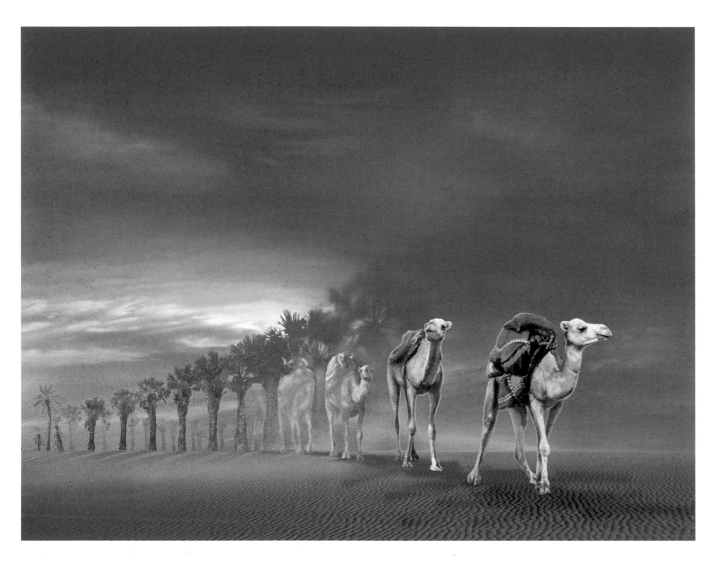

Desert Mirage

This is certainly a strange mirage to see in the desert.

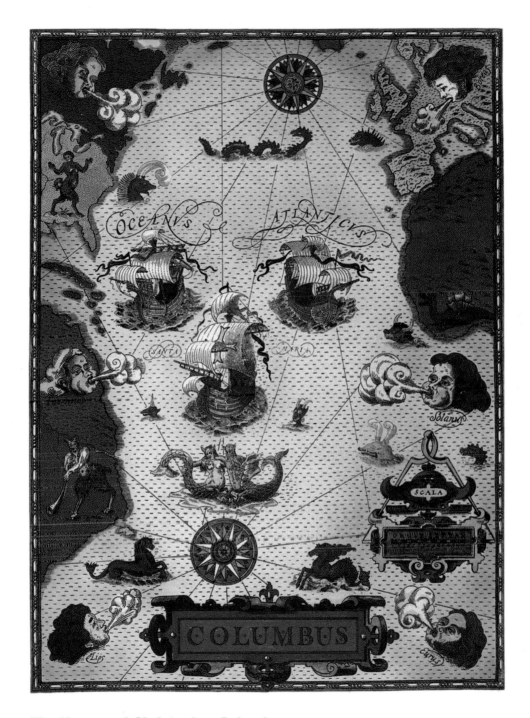

The Voyage of Christopher Columbus

This map celebrates the voyage of Christopher Columbus.

Illusory Torus

Do you see a white donut even though there are no edges, shadows or contours to define it?

Hidden Figure

A bearded man is staring right at you! Can you see him?

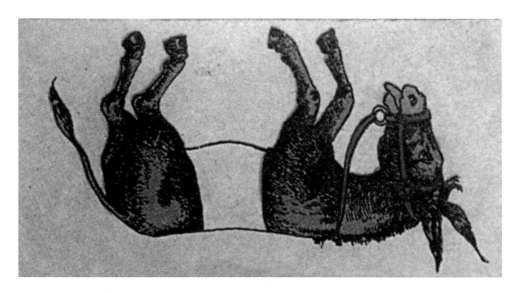
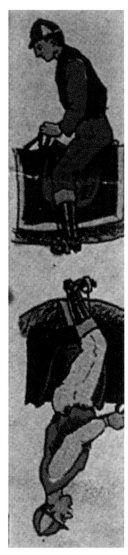
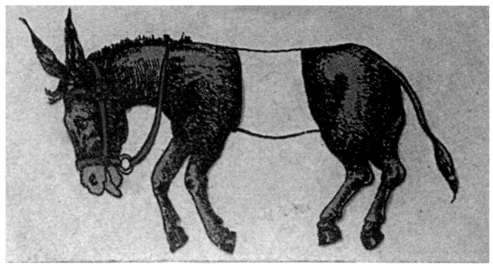

Ride that Mule!

This is one of the best puzzles of all time. Photocopy and carefully cut out the three pieces. The trick is to get the rider to mount both animals at the same time without overlapping the two larger pieces. The mules should break into a gallop when it is correctly assembled. Do not look at the answer until you have really tried hard at solving this one, as the solution is elegant and very gratifying.

Corporal Violet

Can you find the profiles of Napoleon, his wife and son?

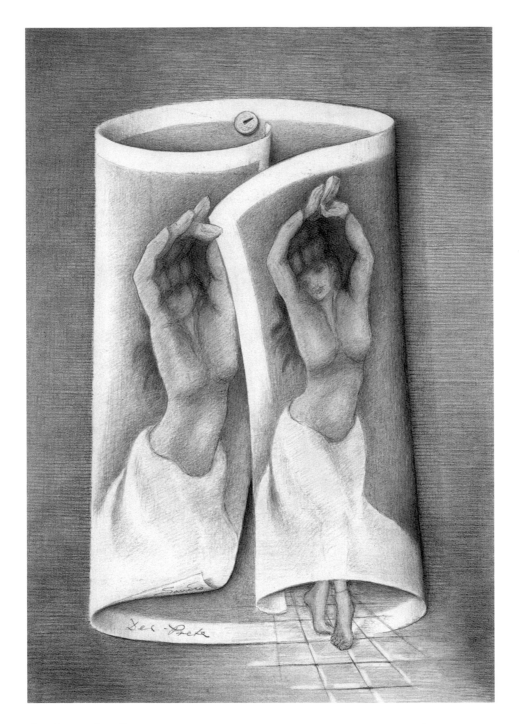

Gesture of a Dancer

The hand and the dancer are quite similar. Can you see why?

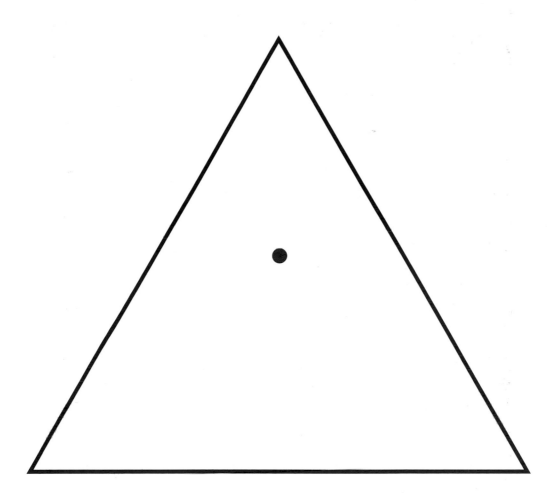

Estimation Illusion

How far up the triangle does the red dot appear?

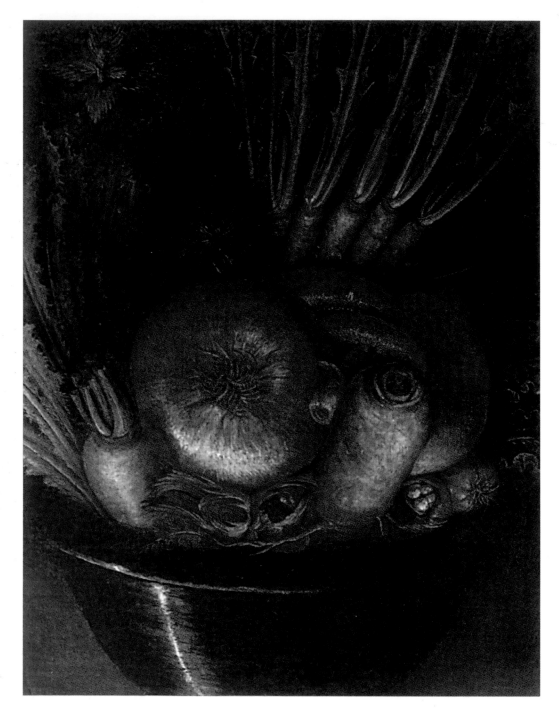

The Vegetable Gardener

If you invert the bowl of vegetables, you will see the gardener.

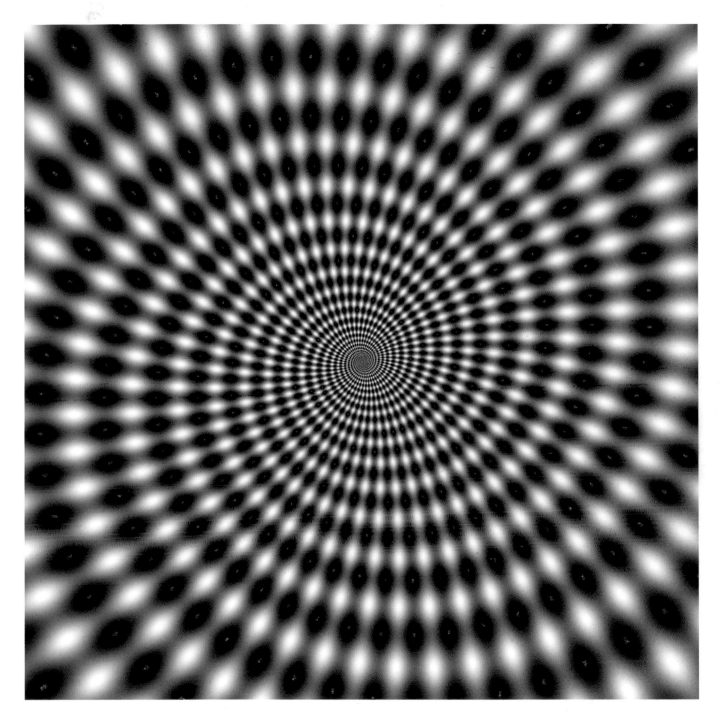

Warp

Move your head slowly toward and away from this image, and it should slowly appear to loom. The dots will also scintillate.

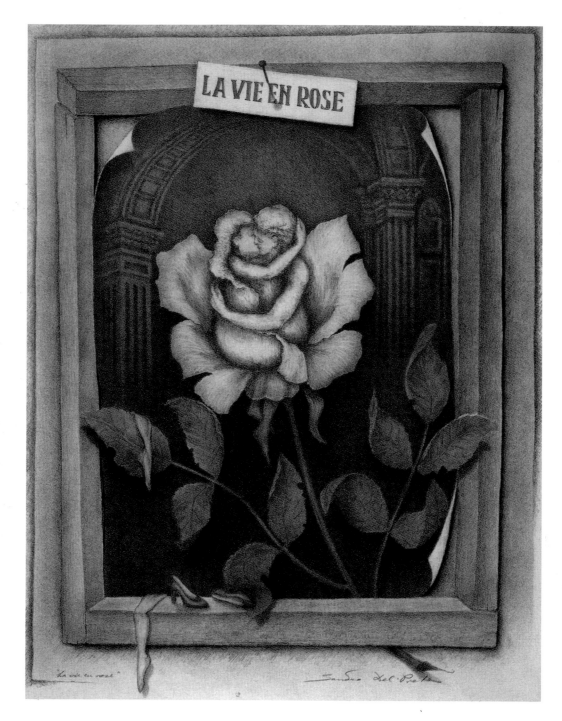

The Flowering of Love

Can you find the couple kissing in the petals of the rose?

Arcturus Brightness Illusion

Do you perceive a white cross within each of the four colored squares? The white crosses are illusory.

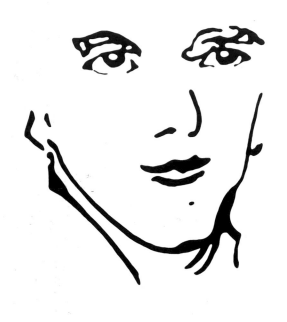
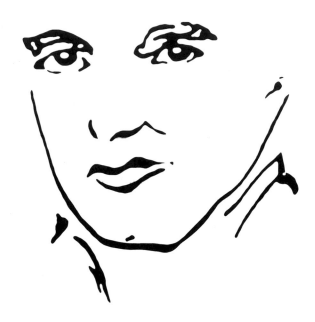

Perceived Gaze Illusion

Do the two men appear to be gazing in different directions?

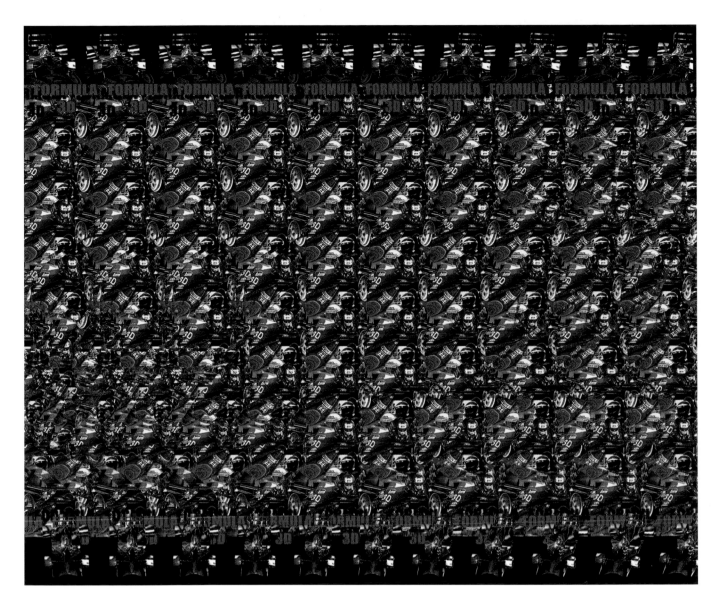

3D Grand Prix

Find the hidden race car. This image appears completely flat. When it is viewed properly (according to the instructions given in the explanation on page 298), the hidden race car will suddenly be resolved and appear in depth. It is quite a remarkable illusion and worth the effort to see.

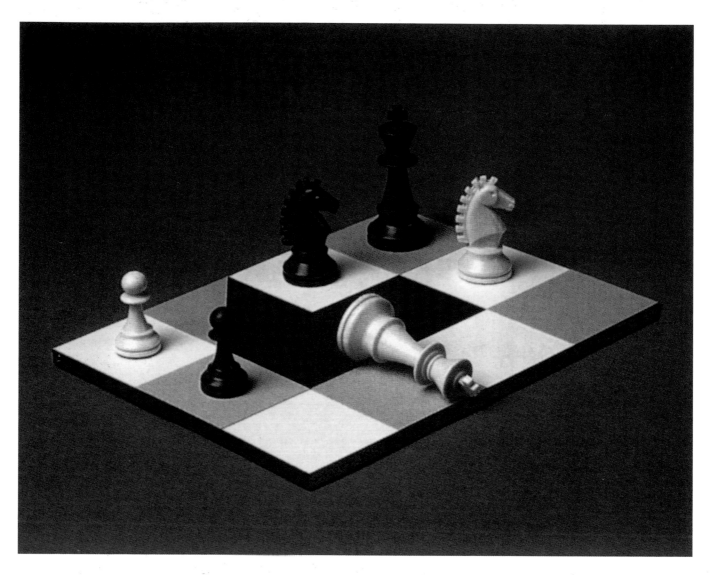

Ernst's Chess Set

How is this chess set possible? Can you tell how it was made?

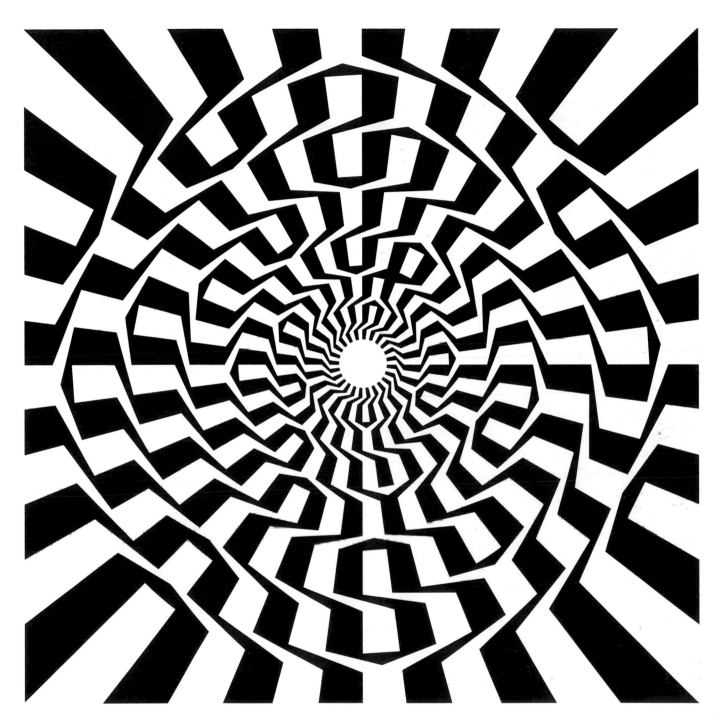

Wilcox's Twisted Circle Illusion

These don't appear to be perfect circles. But are they?

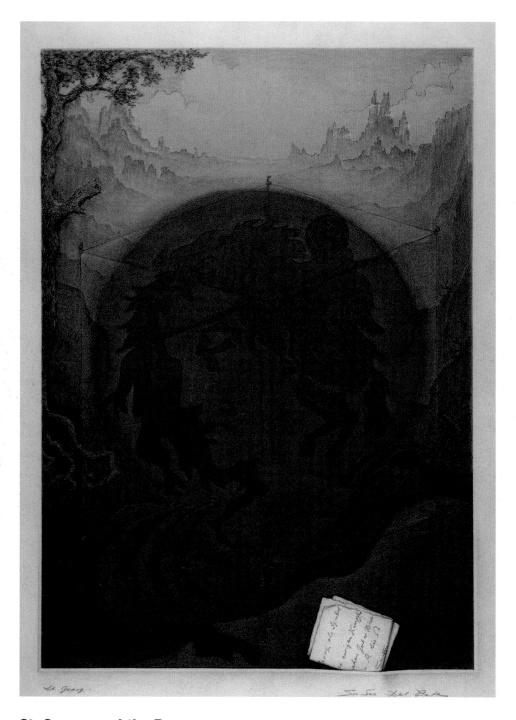

St. George and the Dragon

Can you find both a portrait of St. George and a depiction of him slaying the dragon?

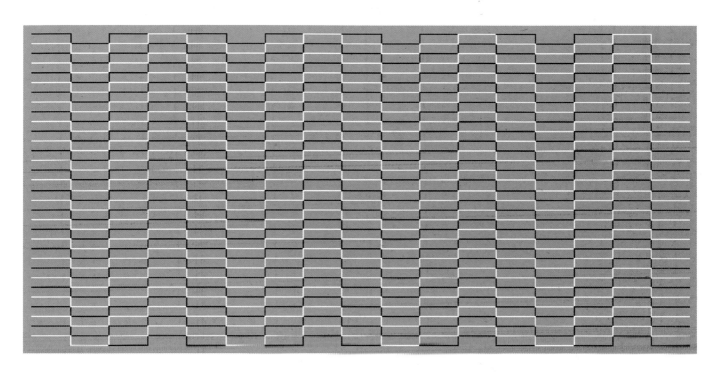

Heat Devil

Stare at this image and it will appear to pulsate and fluctuate, very much like the movement of air known as a heat devil that you see over a heated surface.

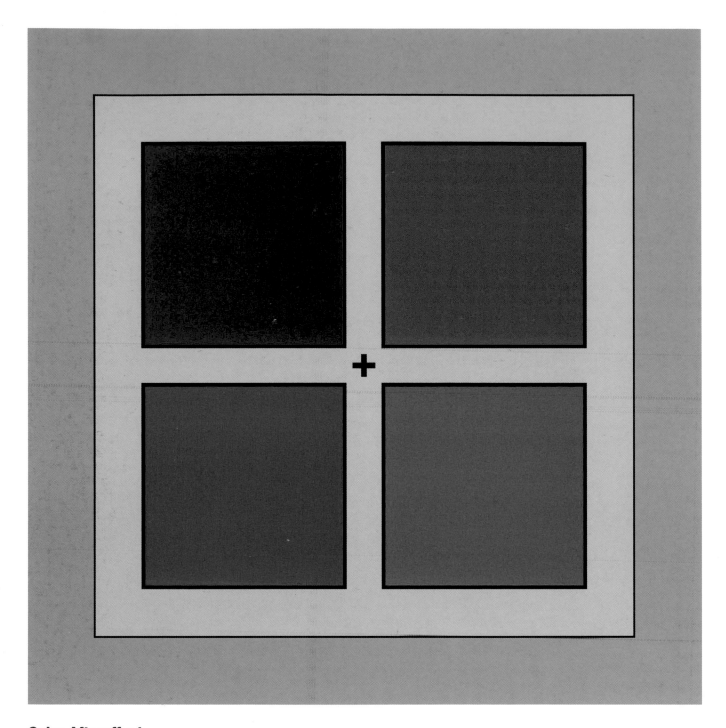

Color Aftereffect

Stare at this image continuously for at least 30 seconds without averting your eyes and then look at a blank sheet of paper. You will see the faint complementary colors of this image.

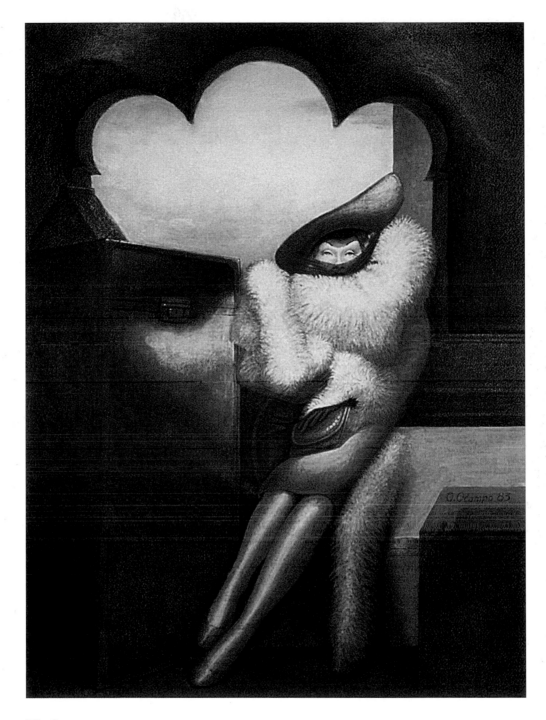

Marlene

Can you find both the head and the sitting figure of 1940's film star Marlene Dietrich?

The Hering Illusion

Do the red lines appear bent?

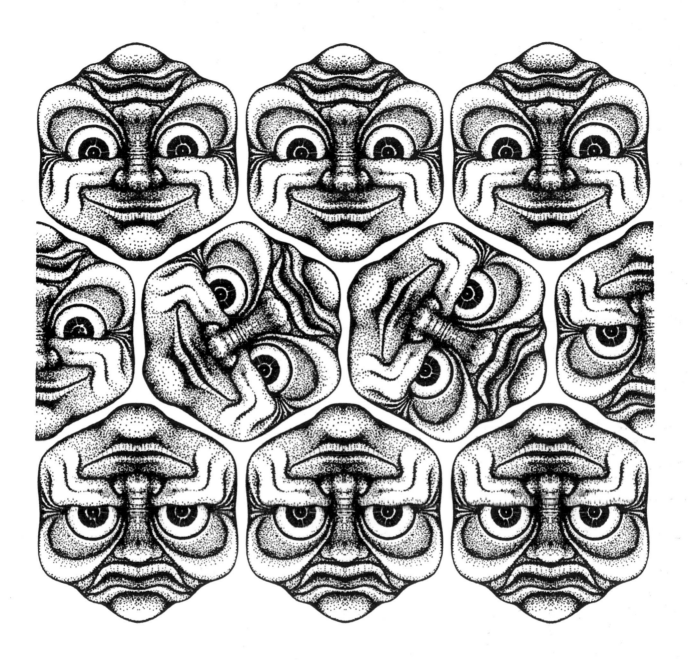

Glee Turns Glum

As the heads rotate, they change their mood from happy to sad.

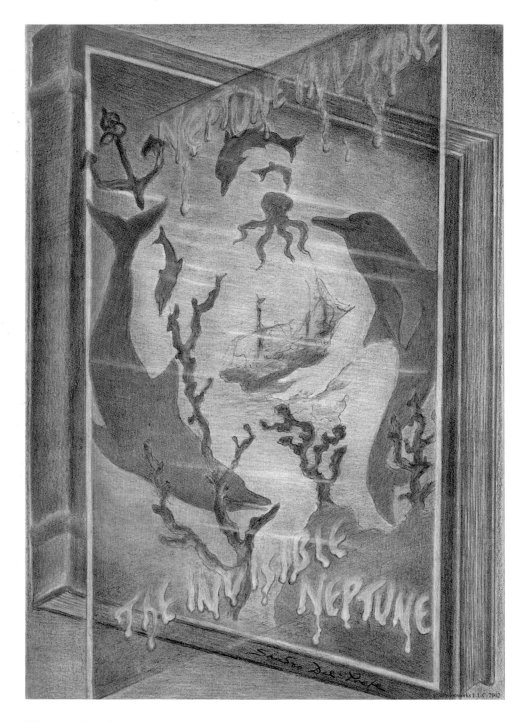

King of the Sea

Can you find the invisible figure of Neptune guarding the sea?

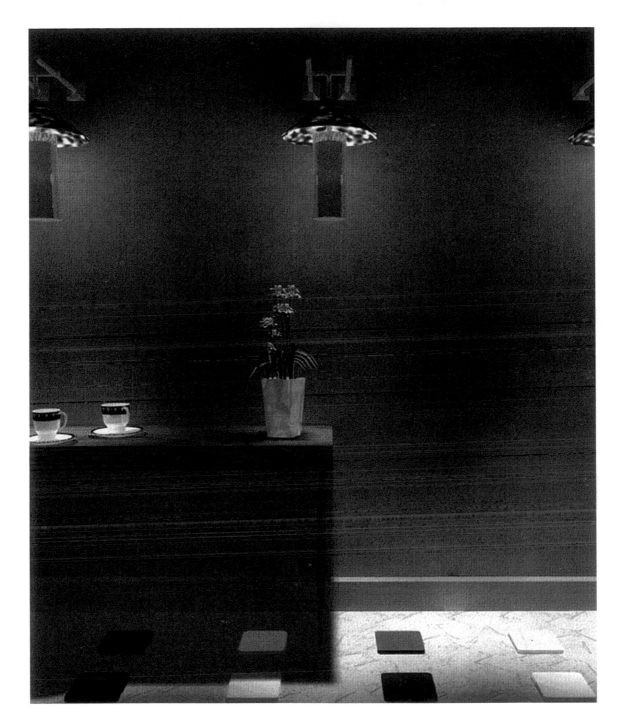

Brightness Illusion

The light square in the table's shadow is the same shade of gray as the dark square outside the table's shadow.

Visual Vibrations

Slowly shake this page and the image will appear to vibrate.

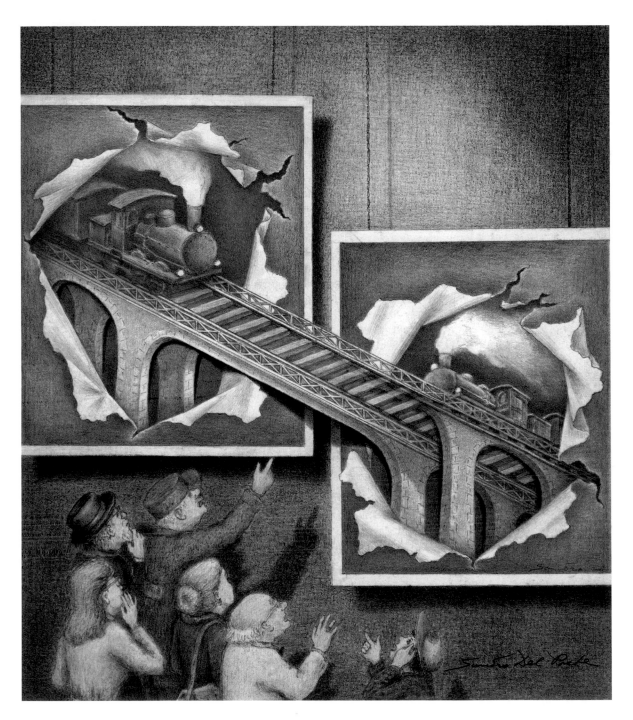

A Strange Incident on a Railway Bridge

Are these trains going to collide?

Two Cars for the Price of One

There are two cars here. Can you perceive them both? One car is seen from the side and the other from the front.

Wallpaper Stereo Illusion

This image appears completely flat. When it is viewed properly (according to the viewing instructions given in the explanation for illusion #125), the image will suddenly appear in depth. It is quite a remarkable illusion and worth the effort to see it.

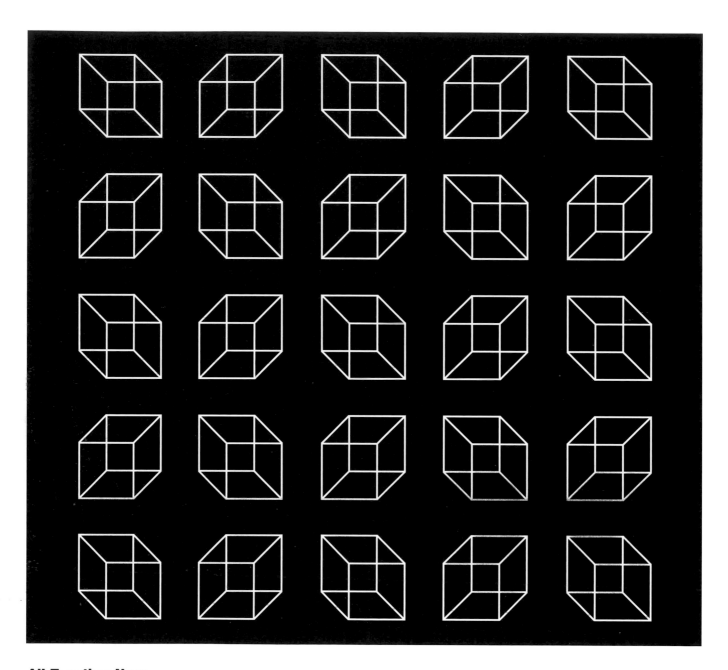

All Together Now

If you stare at this image all the boxes will simultaneously reorientate themselves in depth.

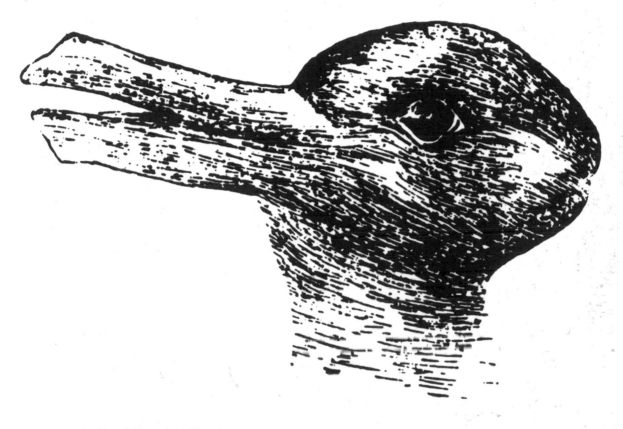

Jastrow's Duck/Rabbit Illusion
Do you perceive a rabbit or a duck?

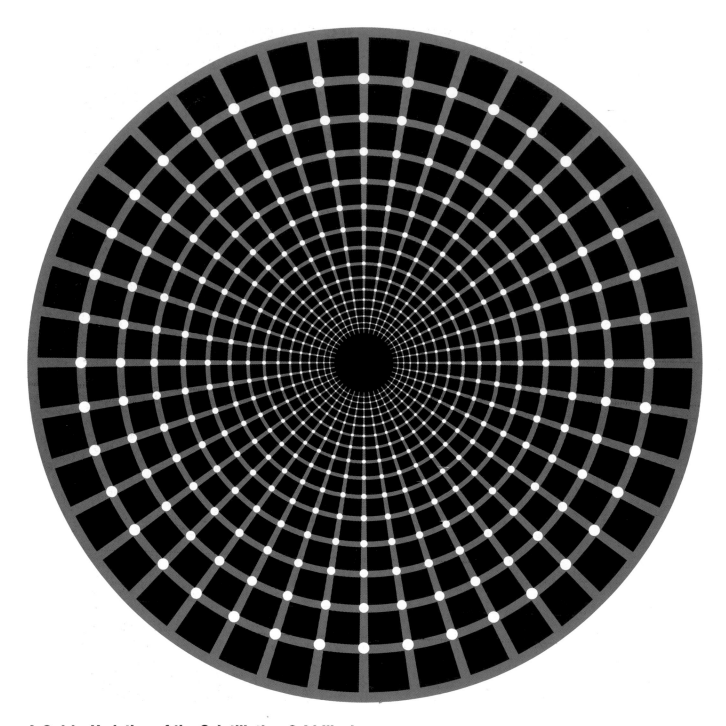

A Quirky Variation of the Scintillating Grid Illusion

In this variation of the scintillating grid illusion, illusory black dots abruptly appear or disappear in the white circles when you move your eyes around the image. If you fixate on any one dot it will disappear, and if you fixate on the center, all the dots will disappear.

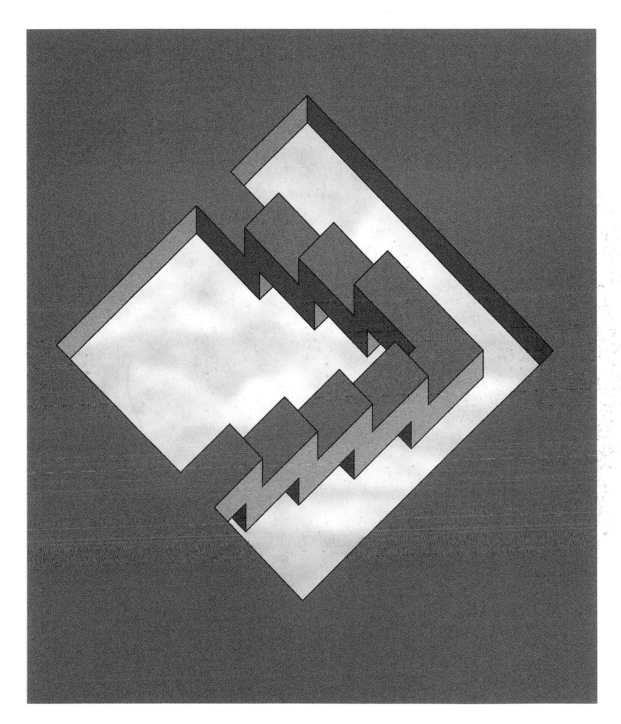

Level, but Descending

This is a most peculiar staircase. Each step that goes down stays on the same level as the surrounding floor.

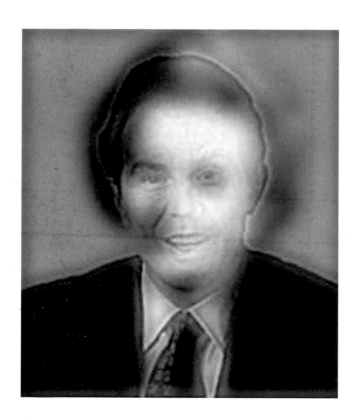 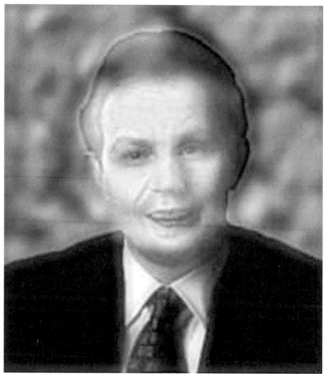

Spatial Frequency Facial Effect

If you squint, blink or defocus your eyes while looking at the pictures, the former English Prime Minister Margaret Thatcher should change to English Prime Minister Tony Blair. If this does not work, view these images from a distance until your perception changes.

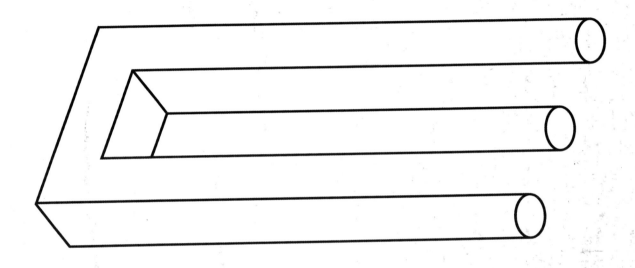

The Impossible Fork

This is another classic impossible figure - the impossible fork. How many prongs can you count? Observe the whole length of the middle prong. What happens?

red blue black yellow red

green orange blue gray pink

The Stroop Effect

Look at the list of colored words and name the color of each word, but don't name the word itself. Try to do this as fast as you can. You will find it is not so easy. Do it with a partner, who can check your responses.

Natural Camouflage

Can you find what is hiding in this picture?

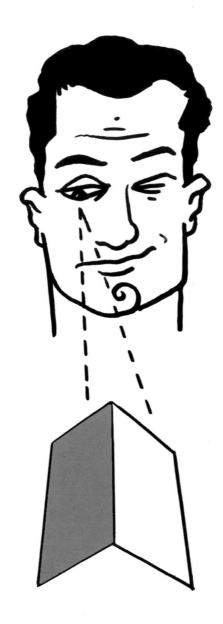

Mach Illusion

This is a fun illusion. Fold a piece of white paper as shown. Lay it down on a table and view it with only one eye from a distance above. Because of contradictory depth cues the paper will "invert." You should see the paper appear to stand upright. If you can hold this image stable and move from side to side the paper will appear to follow you. It is also interesting to note that the image appears to change in perceived brightness when inverted.

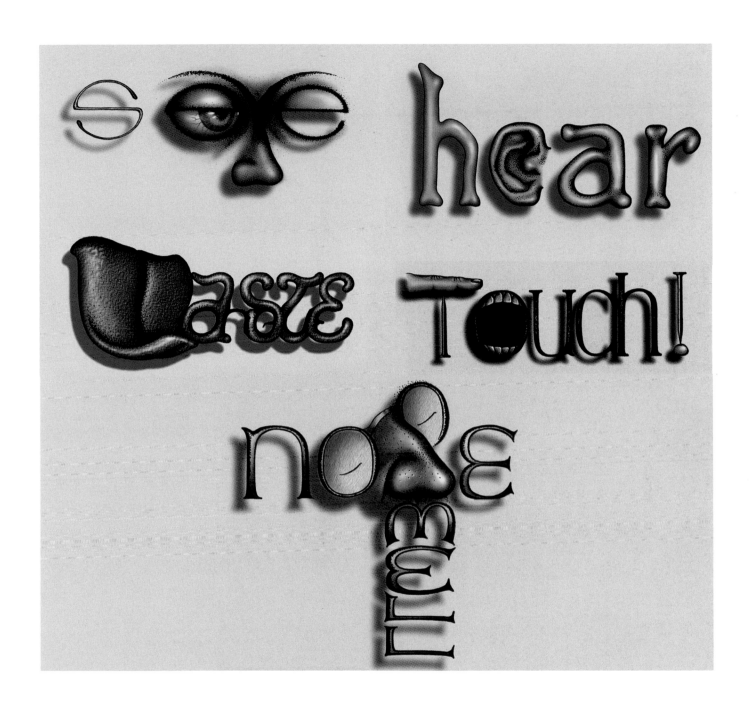

The Five Senses

Examine each one of these words that is related to one of the five senses. How does each word relate in a pictorial way to that particular sense? Also look for the related hidden word within each sensory word.

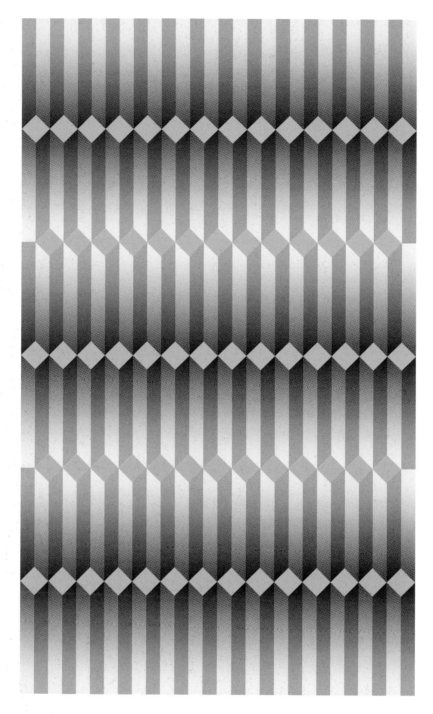

Logvinenko's Brightness Illusion

At the top of each row of blocks you will see either a row of light diamonds or dark diamonds. The light and dark rows of gray diamonds are identical shades of gray.

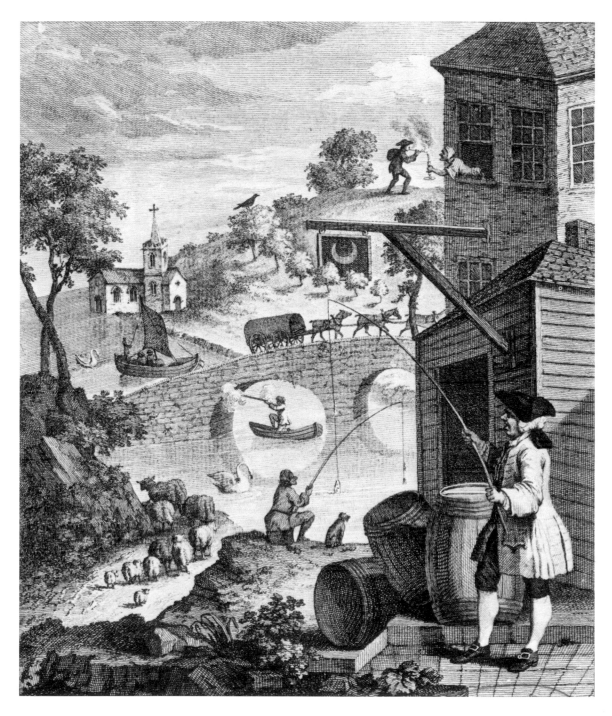

Mistakes of Perspective

There are quite a number of perspective mistakes in this 18th century engraving by William Hogarth. Can you find all of them?

Leviant's Enigma

Stare at the center yellow disk and you will see faint dots swirling around the blue circles. They can suddenly change direction, too.

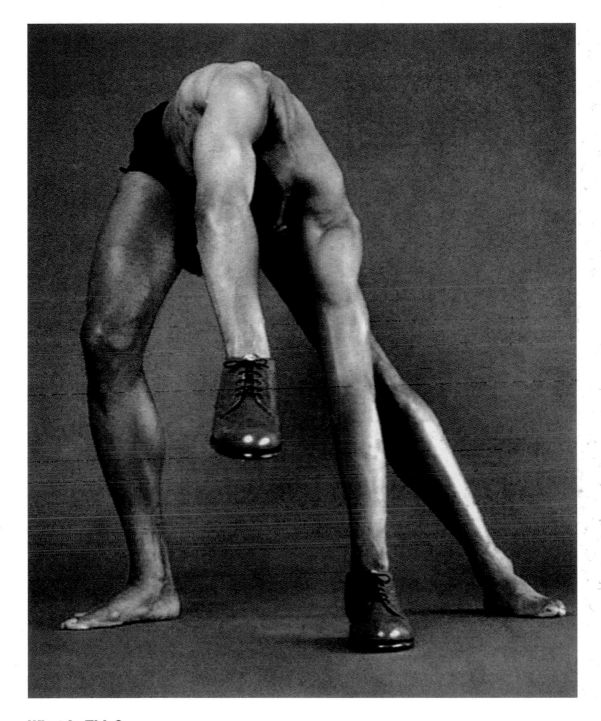

What Is This?

Can you make sense of this bizarre scene? The photograph has not been altered.

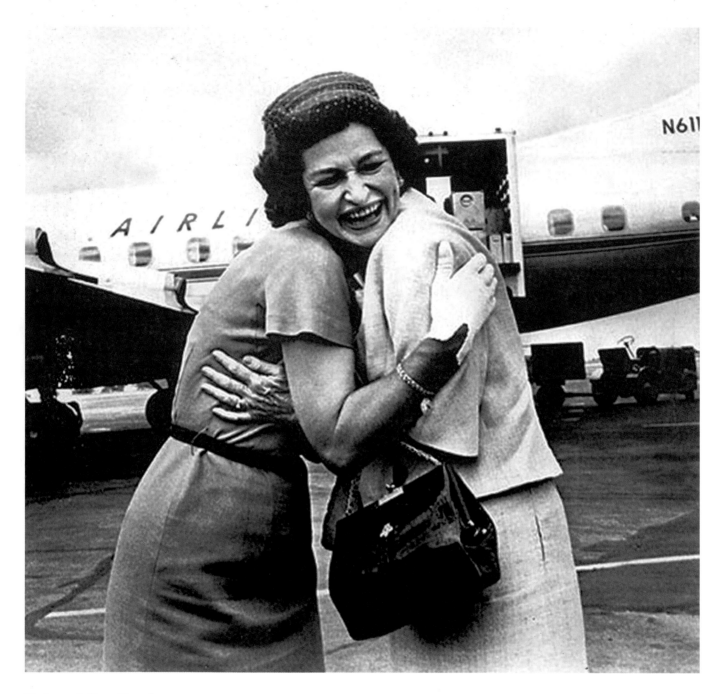

Being of One Head

Which body does Lady Bird Johnson's head belong to in this unaltered photograph? Can you imagine the magazine editor's consternation when attempting to match her head with the correct body?

The Café Escher Illusion

The horizontal and vertical lines appear to be bent, causing the squares to bulge at the center. All the vertical and horizontal lines are perfectly straight and parallel with each other, and therefore, the squares are not really distorted.

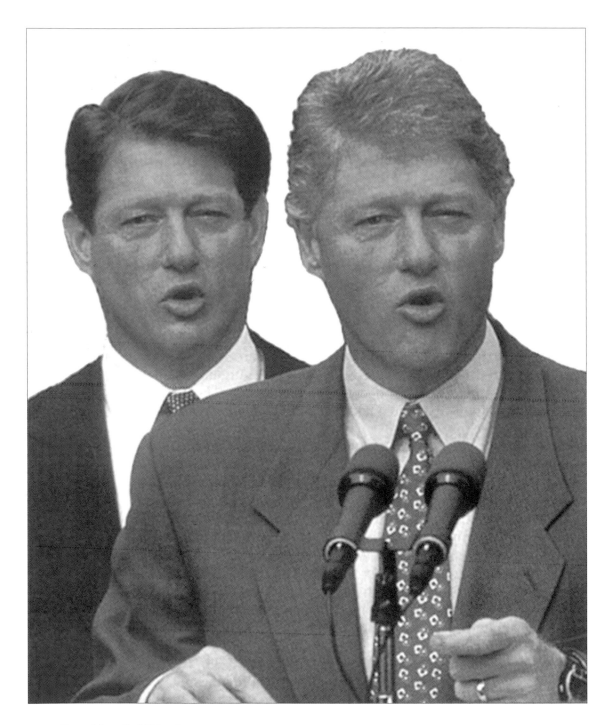

The Presidential Illusion

How quickly can you identify the famous politicians in this photograph? Carefully examine the picture again. You might be in for a surprise!

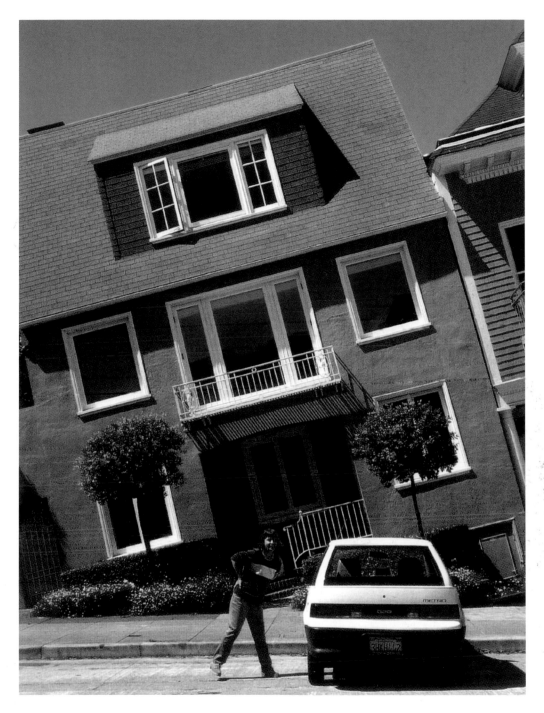

Tilted Houses

What happened to these houses?

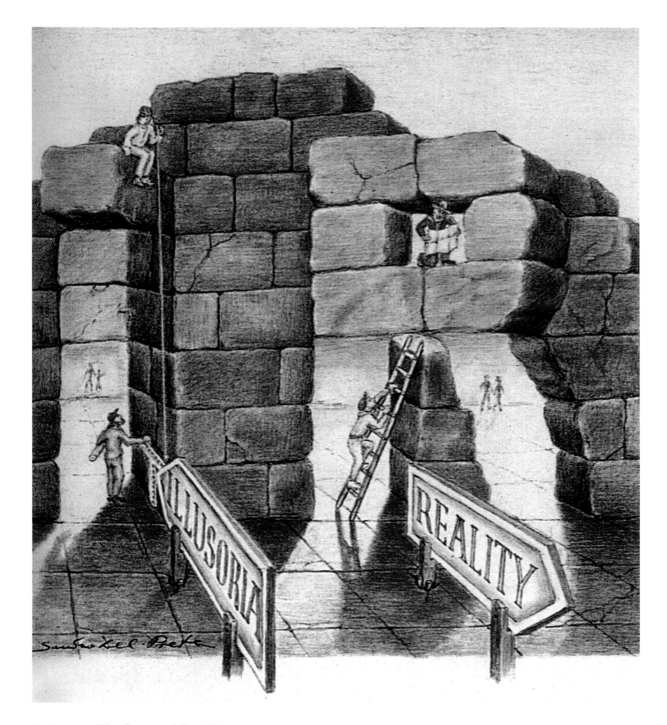

Between Illusion and Reality

Look carefully at the two openings. Is this construction physically possible? Try covering the top half of the illustration, examine it, and then separately cover the bottom half. What happens?

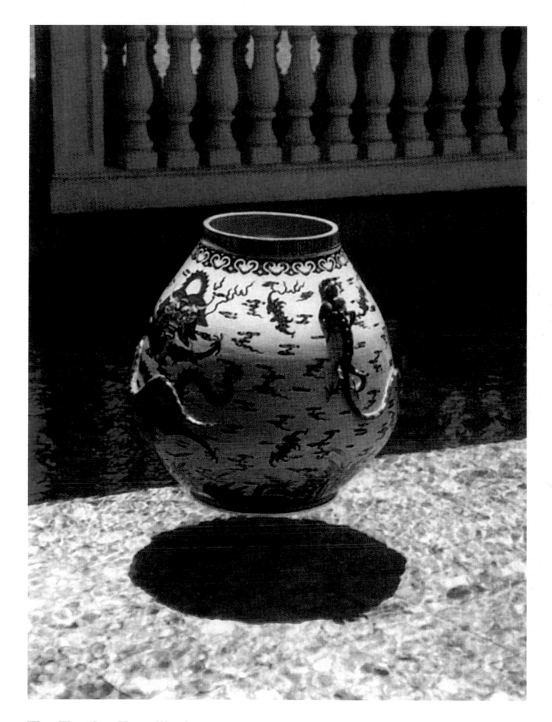

The Floating Vase Illusion

This vase appears to be floating above the ground, but it is really resting on the floor.

Misaligned Eyes

Do the eyes appear to be misaligned? Check them with a ruler.

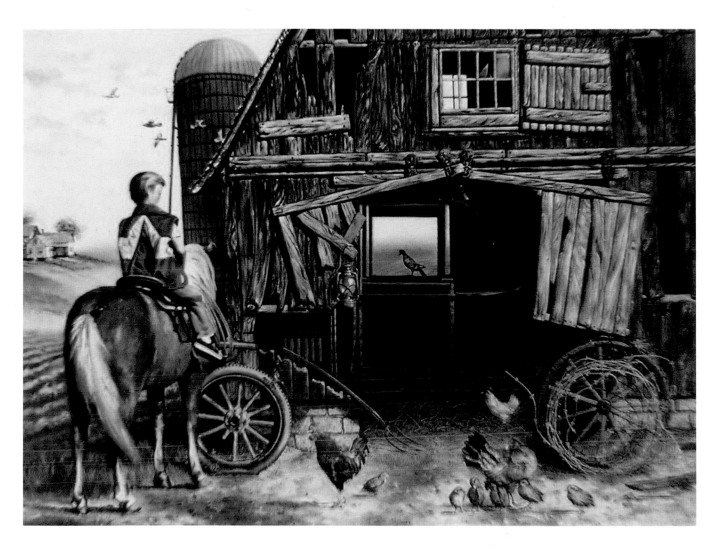

Hidden Car

There is something hidden in this image. Can you find it?

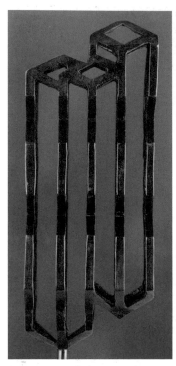 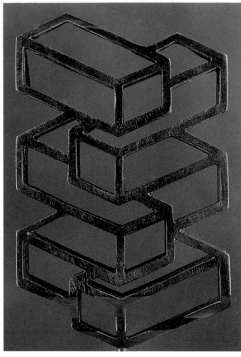 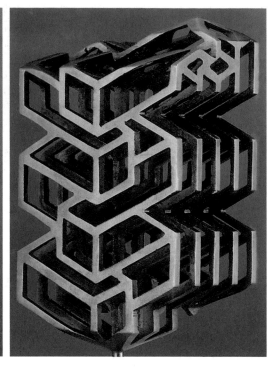

Moretti's Impossibly Transforming Blocks

Photo A

From this angle, you see a set of blocks based on a design by Swedish artist Oscar Reutersvärd - three vertically aligned blocks at the top, which somehow merge into two vertically aligned blocks on the bottom. This construction, of course, is impossible. It is also important to note that you are able to look through the sculpture to see the blue background.

Photo B

Turn the sculpture clockwise 90 degrees and you will see a set of several horizontally aligned impossible blocks, also based on a design by Oscar Reutersvärd. Again, you are able to look through the sculpture to see the blue background. But why don't you see the horizontal blocks from the previous view of this sculpture as seen in Photo A?

Photo C

The third view shows an intermediary angle, which reveals how the illusion was achieved. Italian artist Guido Moretti created this remarkable "impossible" transforming bronze sculpture. Believe it or not, these seemingly different sculptures are three different views of the same sculpture!

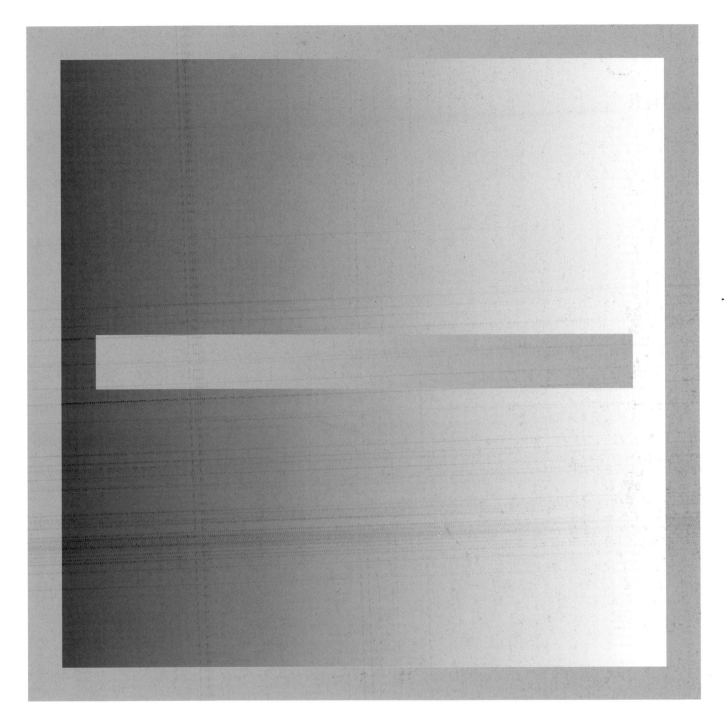

Simultaneous Contrast Illusion

Is the horizontal bar the same shade of gray throughout? Check your perception by covering everything except the horizontal gray bar.

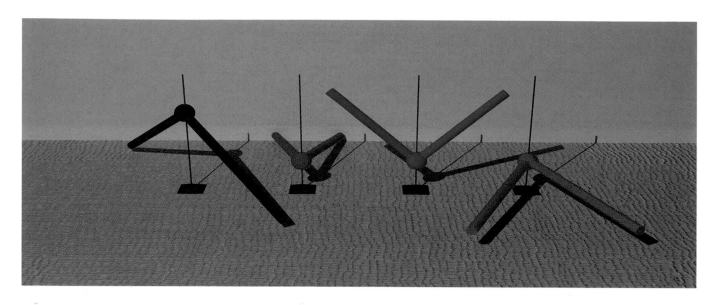

There's an Angle to This!

Without measuring, which angle appears to be the largest? Which angle appears to be the smallest?

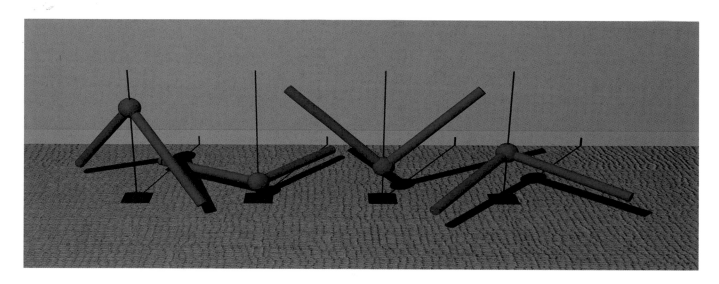

In this image, do all the objects appear to have the same sized angle?

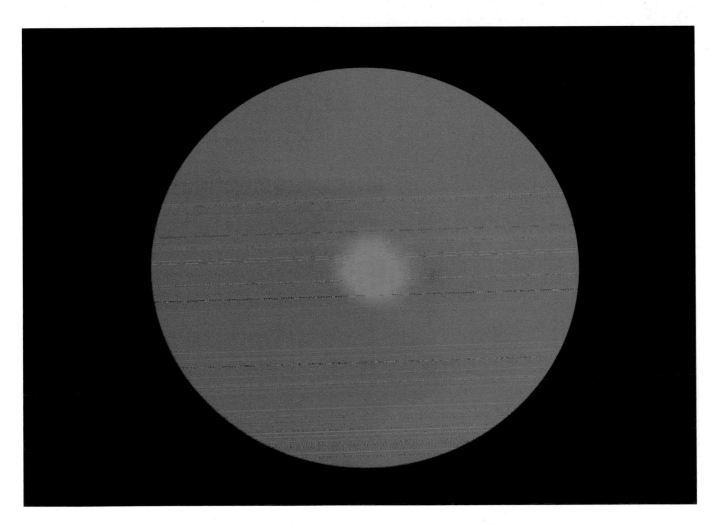

Filling-in Illusion

Stare at the blue dot in the center of the image without averting your gaze or attention and it will gradually fade out.

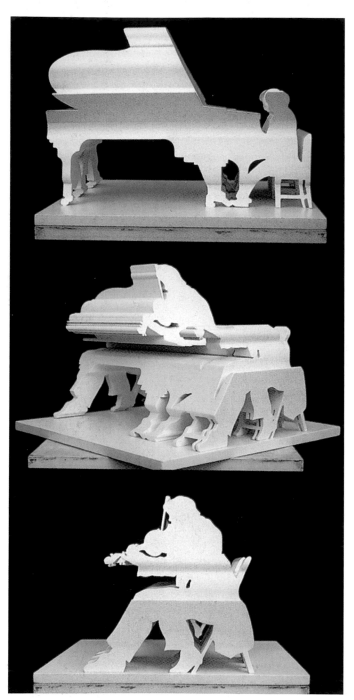

Encore

From one angle, this sculpture appears to be of a pianist. If you turn the sculpture 90 degrees you will see a violinist. The middle photo shows an intermediate point of view, where you can see how the pianist transforms into the violinist.

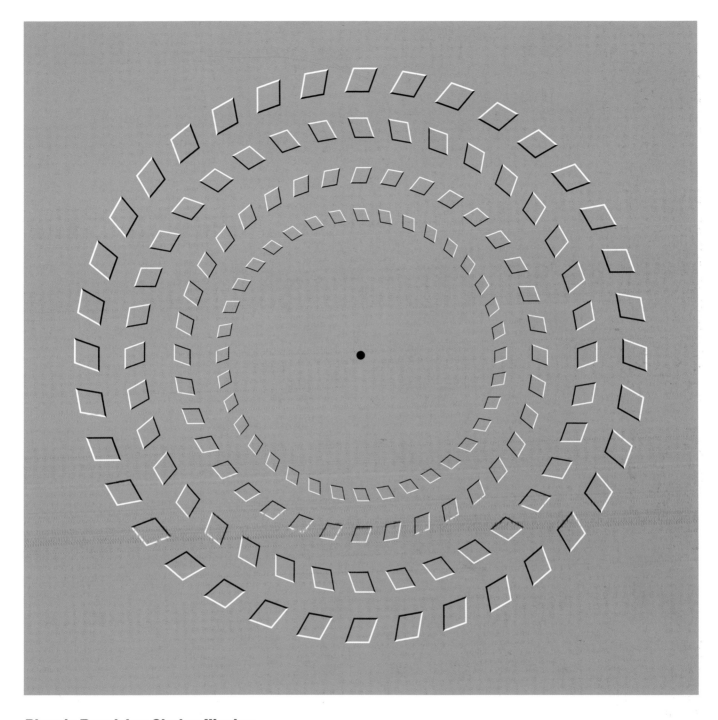

Pinna's Revolving Circles Illusion

Focus on the dot in the center and move your head backward and forward. Each wheel should rotate in an opposite direction to its adjacent wheel.

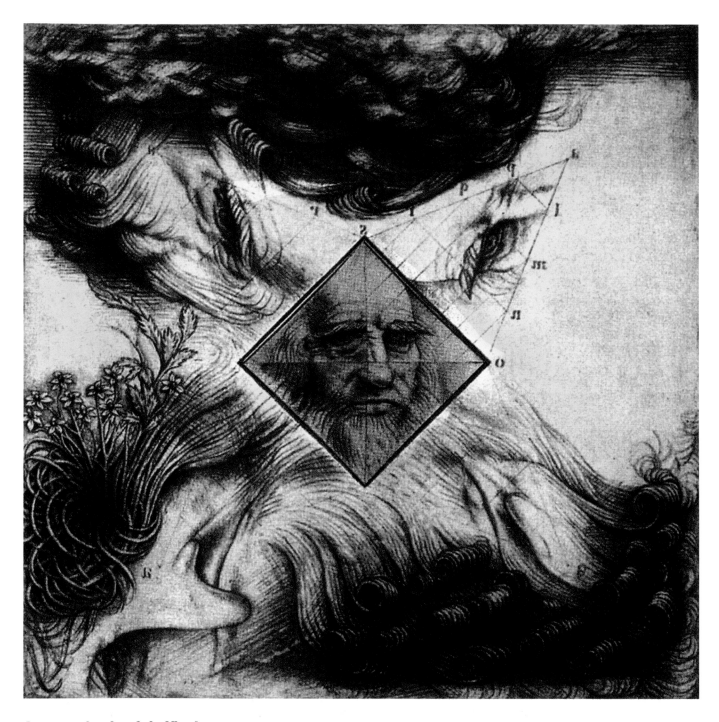

Anamorphosis of da Vinci

The portrait of Leonardo da Vinci can only be seen by looking straight down on a pyramid-shaped mirror at the center of this drawing.

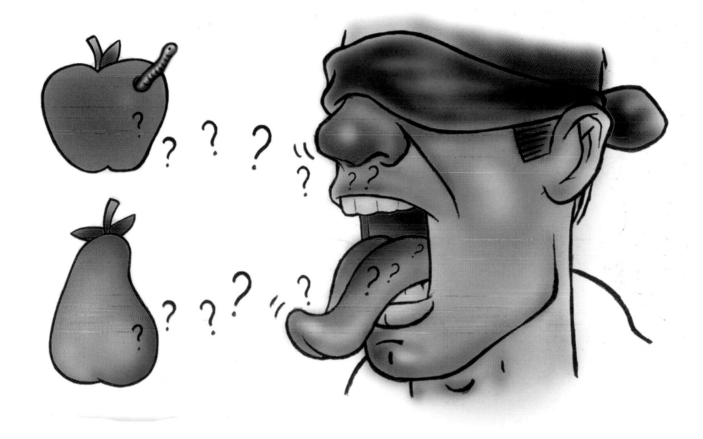

Taste Illusion

Cut slices of an apple and a pear. Blindfold your subject and ask him to hold his nose. Place a piece of apple on his tongue. Let him chew it. Can he distinguish apple from pear? Between trials have him rinse his mouth with plain water.

Repeat the experiment. This time he should be blindfolded and not hold his nose. Can he distinguish apple from pear with his nose or with his tongue and mouth? If you hold a slice of pear beneath his nose while he eats an apple, which does he think he's eating?

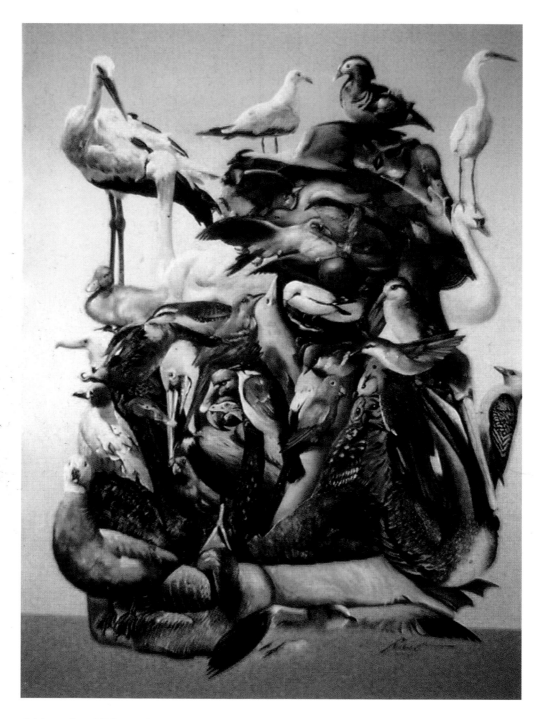

A Bunch of Birds Clowning Around

This very strange coincidence occurred after some birds visited the circus.

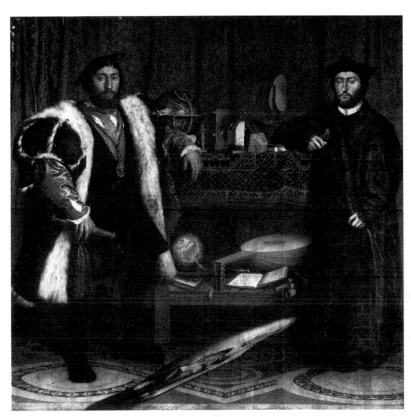
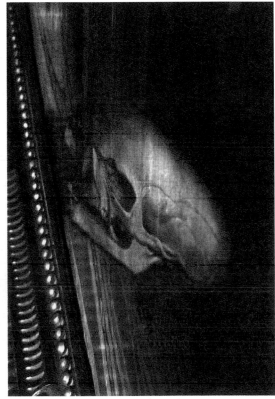

Holbein's Ambassadors

What is that strange shape that is in the middle of the bottom portion of this painting? A skull is seen when the painting is viewed from a special angle.

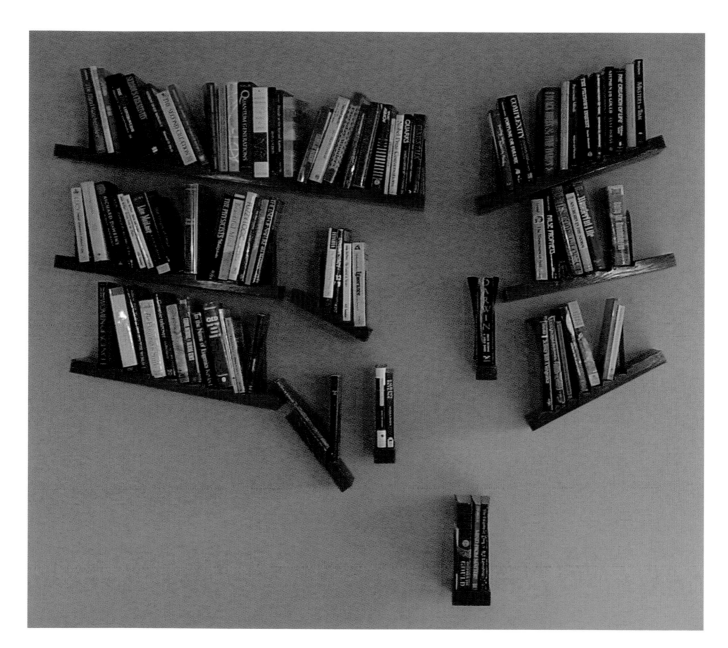

Falling Bookcase

Are all the books going to fall off the shelves?

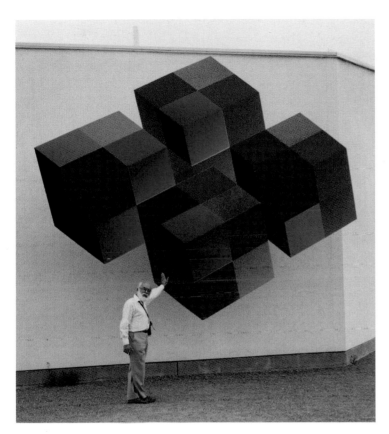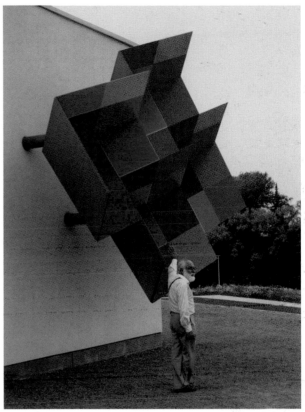

Concave or Convex Cubes?

The cubes on the outside of the building appear convex in the left photograph. If you look at the cubes in the photograph on the right, you will see that they are really concave.

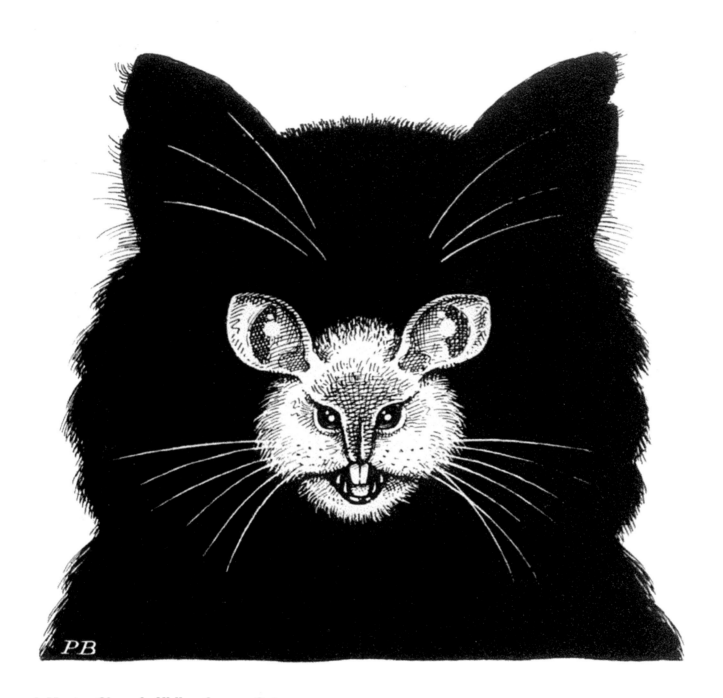

A Mouse Cleverly Hiding from a Cat

Is the cat hiding from the mouse or the mouse hiding from the cat?

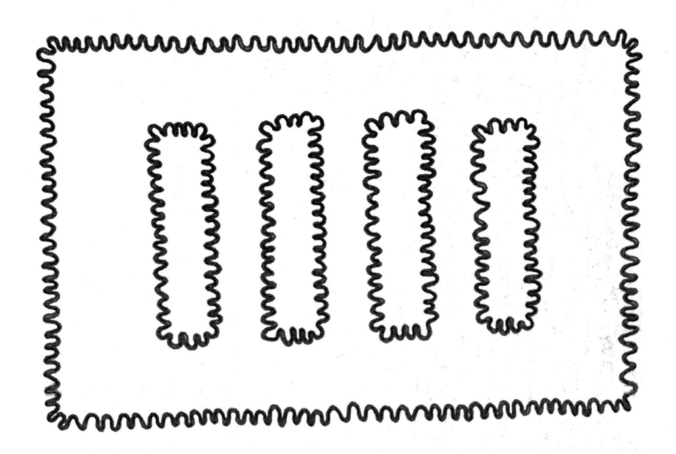

Pinna's Watercolor Illusion

Do you perceive a faint color within large regions inside the bordered areas? Look through a peephole at the inner "colored" region and you will see that there is no color.

Magical Chinese Pool

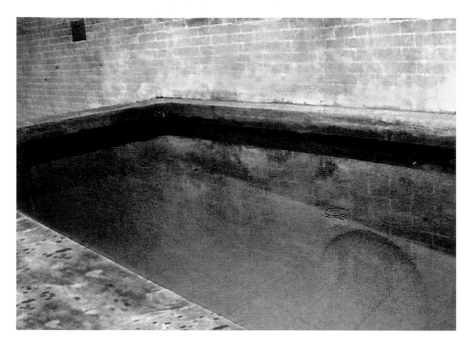

There is a "magical pool" inside the Plum Temple located in Zhaoquing, near Canton, China. It was built around A.D. 996 and has been baffling visitors for over 1,000 years! If you stand on the right side of the pool and look to the left, the pool appears to get increasingly shallower.

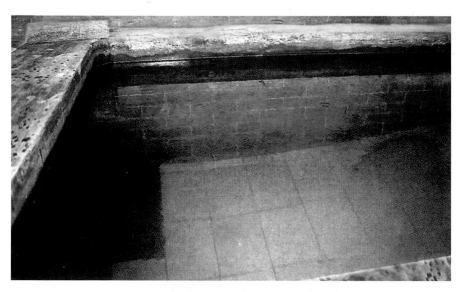

If you stand on the opposite end of the pool, it now appears as if the left end of the pool is deep and it gets shallower to the right. This is the opposite of what you saw in the previous image. How is this possible?

Pinna's Scintillating Luster Illusion

Do these circles appear to scintillate?

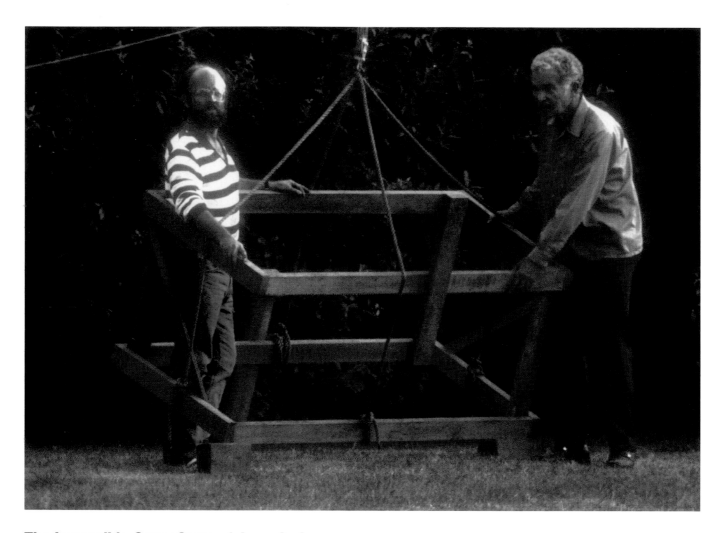

The Impossible Crazy Crate of Jerry Andrus

American magician Jerry Andrus has created a "Crazy Crate." How did he manage to connect the straight vertical support beams in such an impossible way? Try to figure it out before checking the answer on page 191.

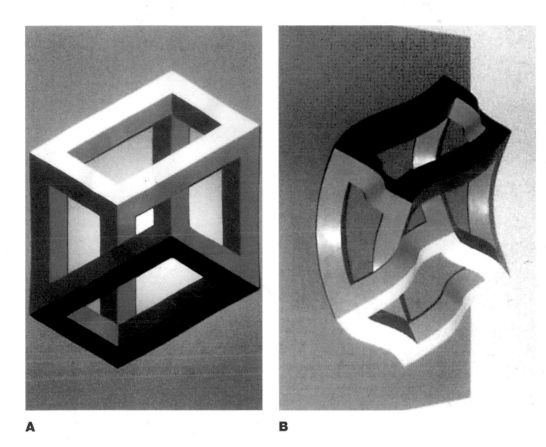

A

B

Twisted Thoughts on an Impossible Cube

The impossible cube seen in photo A is the same cube as the twisted cube seen in photo B.

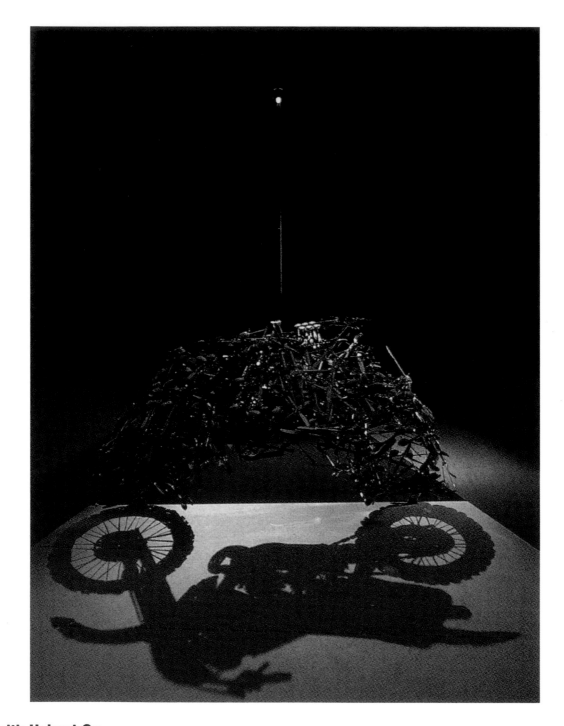

Lunch with Helmet On

A single light source illuminates a silhouette of a life-size motorcycle. The shadow sculpture is made out of 848 spoons, knives, and forks.

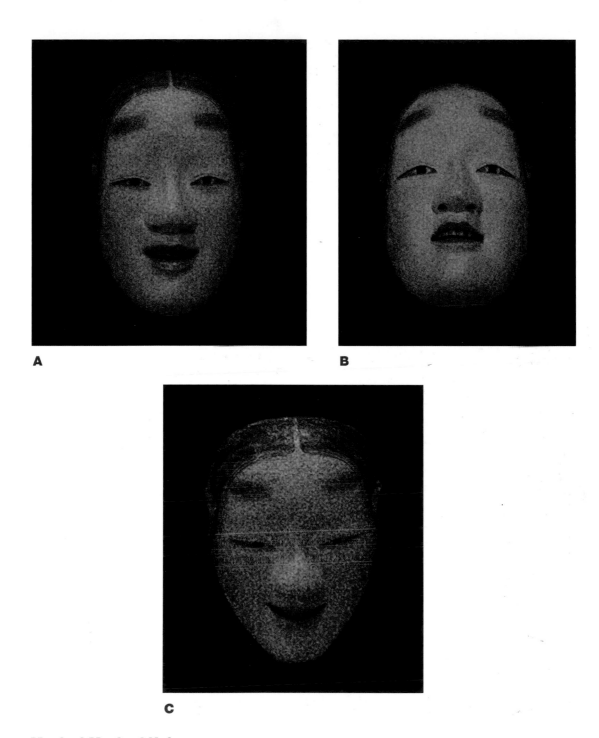

A

B

C

Magical Mask of Noh

In photos A, B and C, do you perceive three different expressions on the mask? How can a rigid mask change its expression?

The Magically Appearing Portrait of Jules Verne on the Mysterious Island

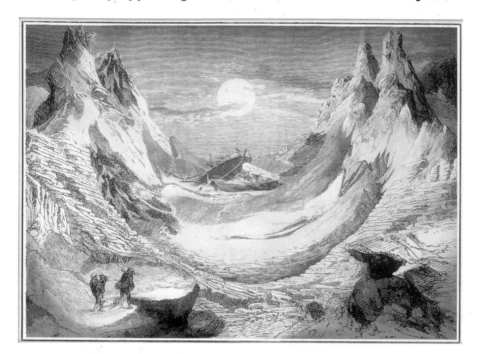

This engraving depicts a scene from Jules Verne's 19th century novel, *The Mysterious Island*. Can you find the portrait of Jules Verne hidden somewhere in this image?

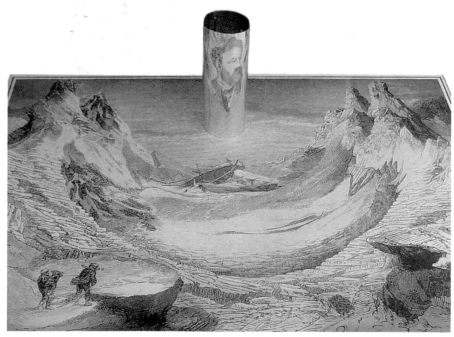

When a reflective cylinder is placed on a special location in the middle of the image, you will see the portrait of Jules Verne reflected onto the cylinder.

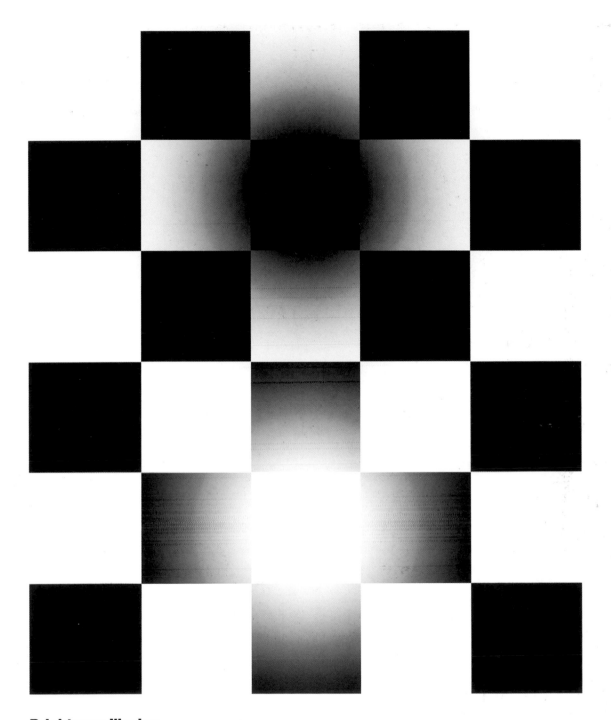

Brightness Illusion

Do the black and white checks at the centers of the "clouds" appear to be different in brightness than the other black and white checks?

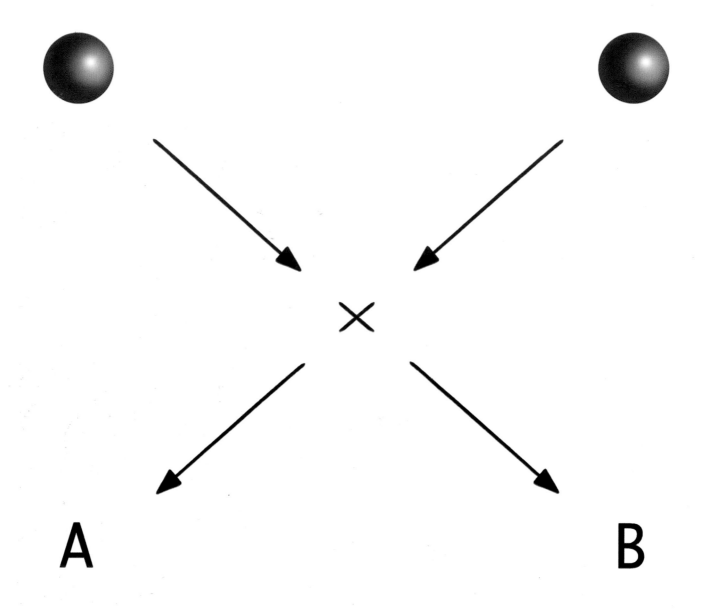

A

B

Cross-Modal Illusion

Most people would be surprised to learn that one sense can dramatically influence another sense. For example, it would be surprising to learn that sound can dramatically influence visual perception. Here is an interesting description of one such cross-modal illusion.

The ball at the top left moves at a constant rate to the bottom right (B). An identical ball, starting from the top right, moves simultaneously and at the same rate, to the bottom left (A). They pass through one another at "X." This is the motion you perceive unless you make a "colliding" sound when the balls merge at "X." Then you perceive the balls as colliding where the ball that started at the top left ends up at the bottom left (A) and the other ball that started at the top right ends at the bottom right (B). This demonstrates that even sound can influence vision!

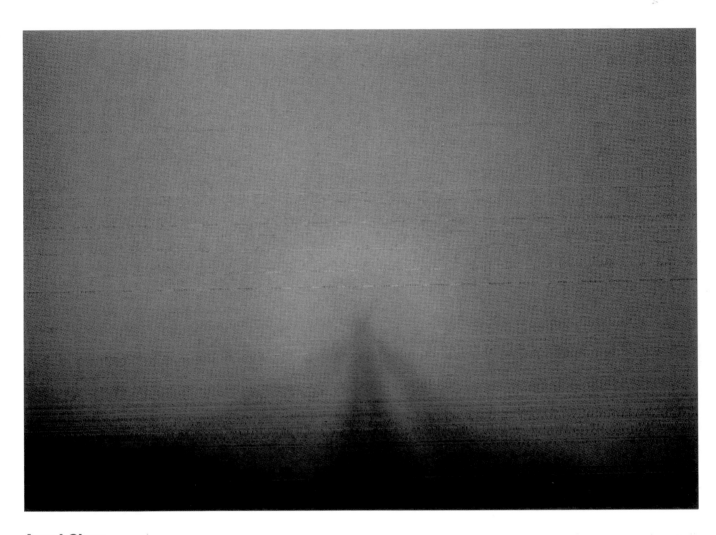

Angel Glory

This natural illusion, which is sometimes seen on foggy mountain tops, has been interpreted as an angel from heaven; hence its name: Angel Glory.

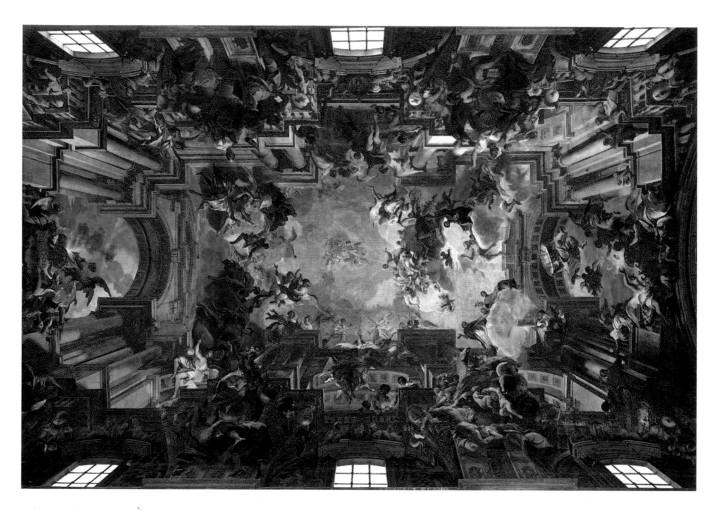

Decent Into Chaos

Some 17th century architects complained that this vaulted two-story church ceiling to the heavens was structurally unsound and would collapse. Were their fears justifiable?

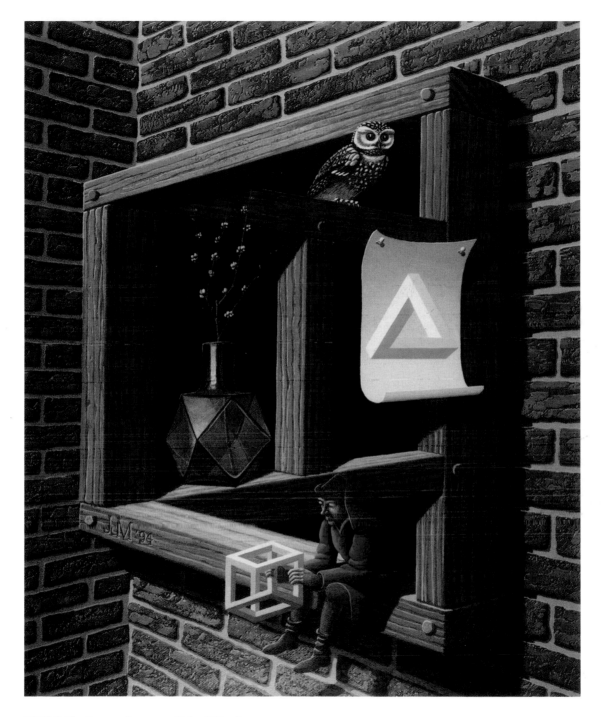

Still Life in an Impossible Window

The little man is contemplating a four-dimensional world on a strange and impossible windowsill.

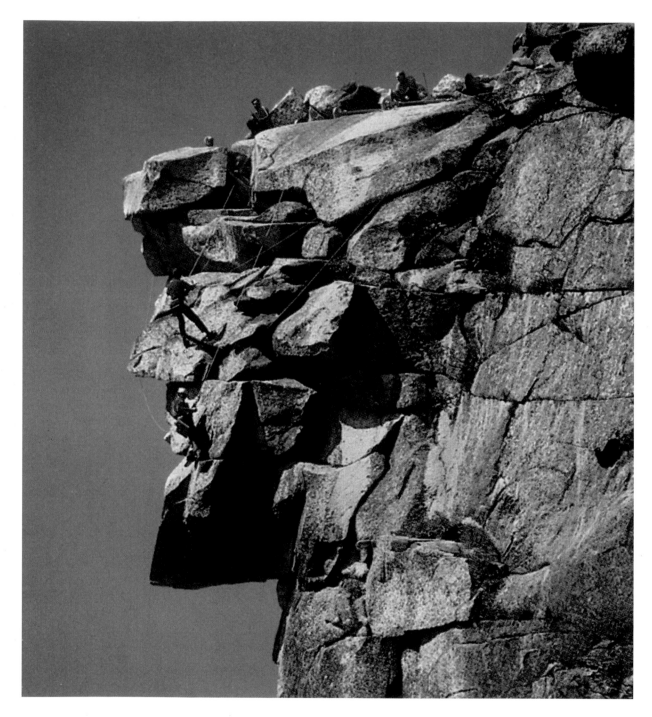

Climbing the Face of the Mountain

This photograph gives new meaning to the term "climbing the face of the mountain."

The Impossible Crazy Crate of Jerry Andrus Revealed

Here you can see the Impossible Crazy Crate of illusion #180 from another angle, revealing its true structure. The illusion only works from one very specific viewing angle.

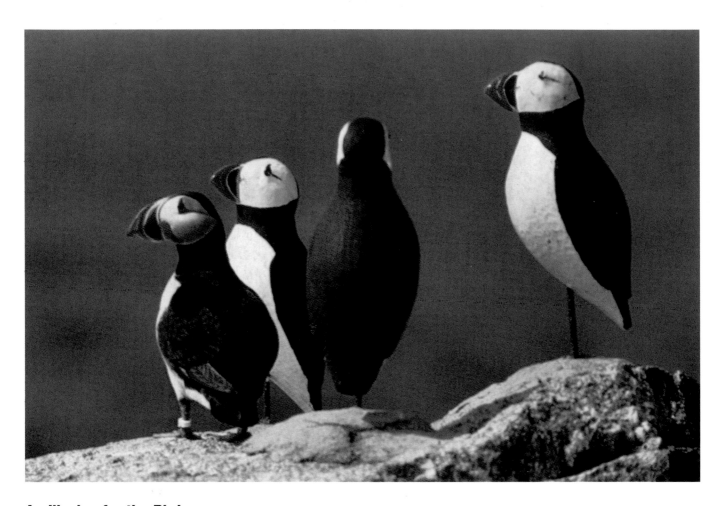

An Illusion for the Birds

Can you determine the illusion here? Can the birds?

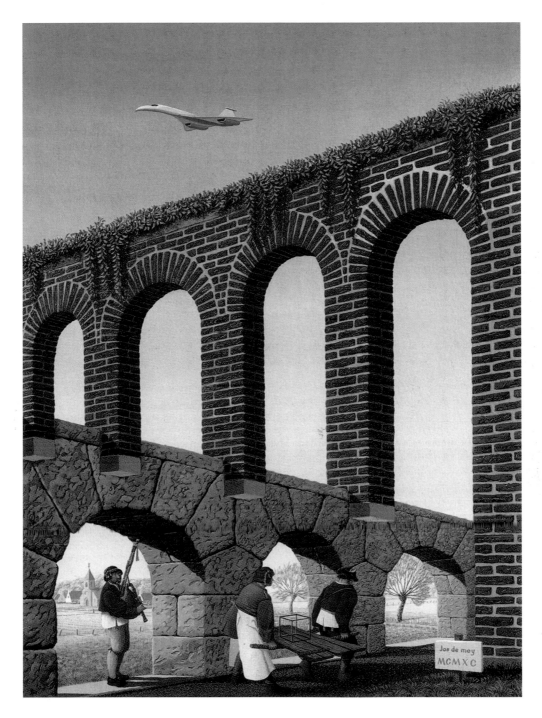

Strange Aqueduct

What is structurally impossible in this image?

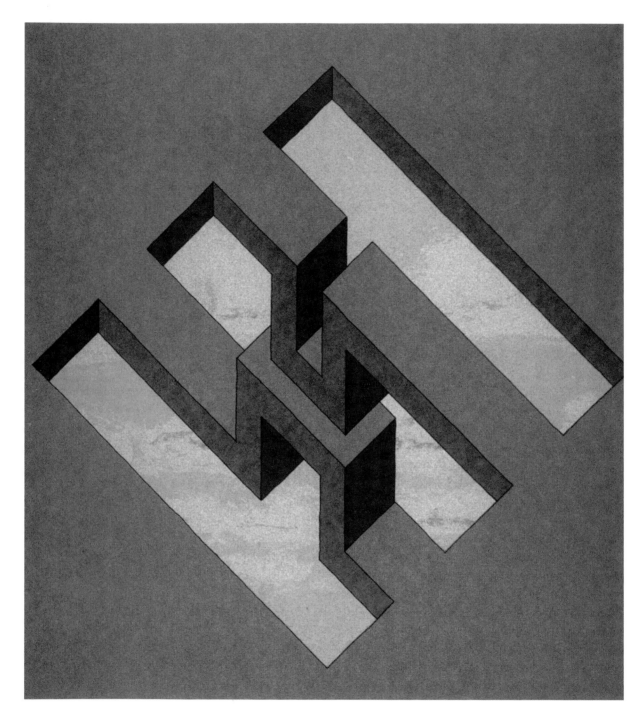

Impossible Window

Is the depth relationship between the two cross beams possible? The top of the beams are always at the same level, but somehow are both over and under each other.

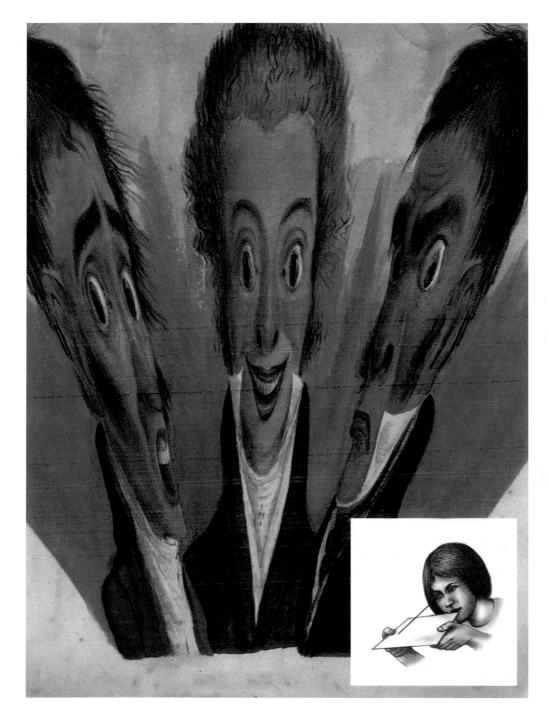

Stretched Heads

The heads on these three figures are strangely distorted. The insert shows the angle at which the heads appear normal.

12

A ⑬ C

14

What's in Red?

Read the center row both up and down as well as left to right. What does the figure in red stand for? Is it a letter or a number?

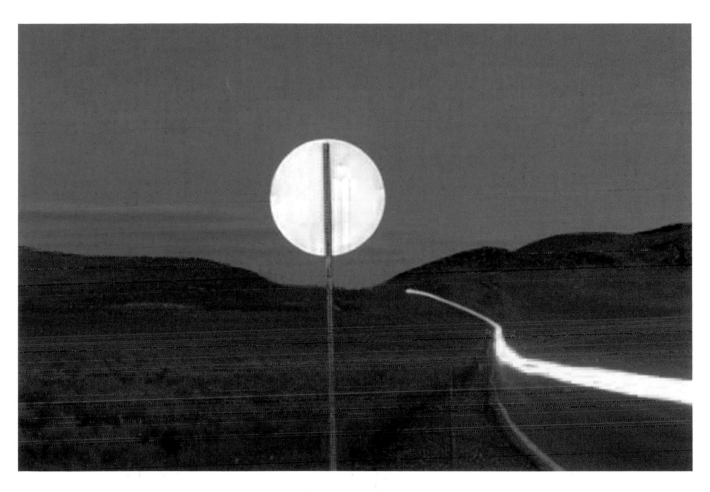

No Sign of the Moon

Examine this image. What do you see? Remember that first impressions are not always correct.

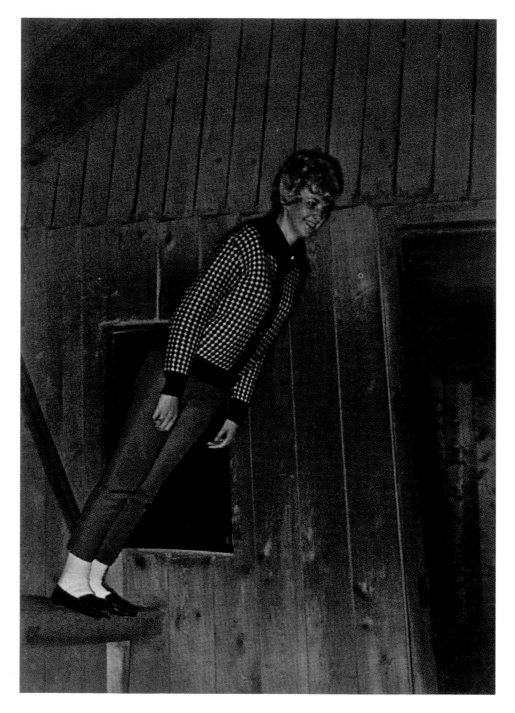

Off the Wall

At some popular tourist attractions, gravity appears to lose its grip as people are able to lean off walls without falling.

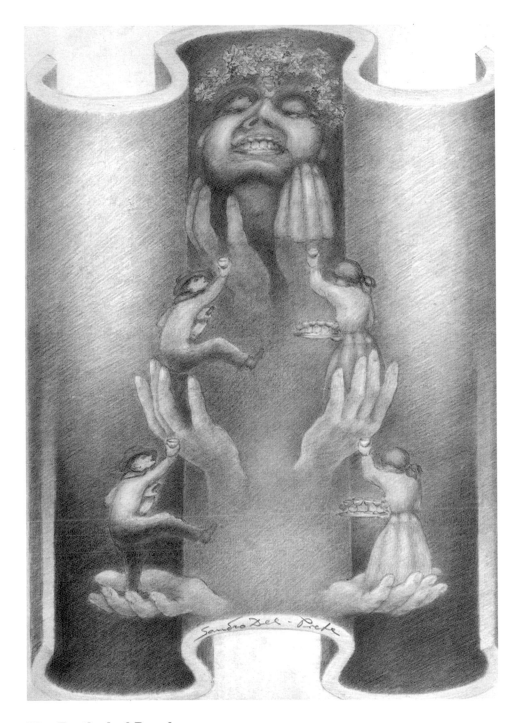

The Festival of Bacchus

Starting at the bottom and moving to the top, watch how the two people transform into the face of Bacchus.

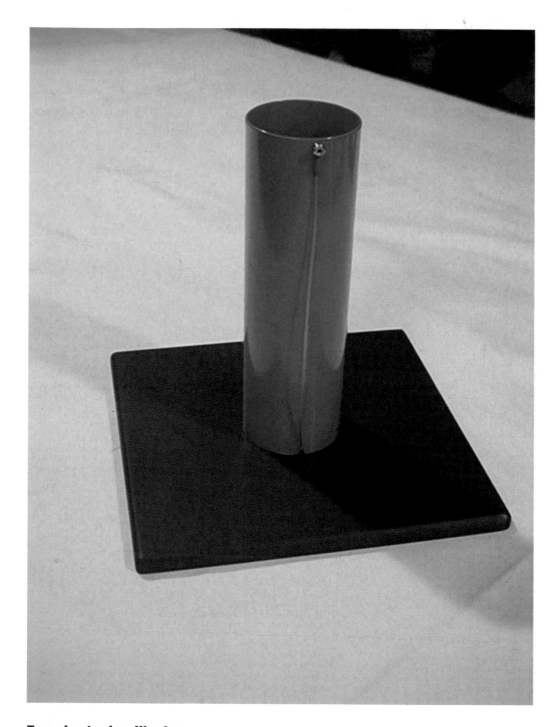

Foreshortening Illusion

Estimate the circumference of this tube without measuring it. Would you say that your estimate is less than, equal to or more than the vertical length of the tube? If you were to measure the rim with a string from the top of the tube, how far would it extend down the length of the tube?

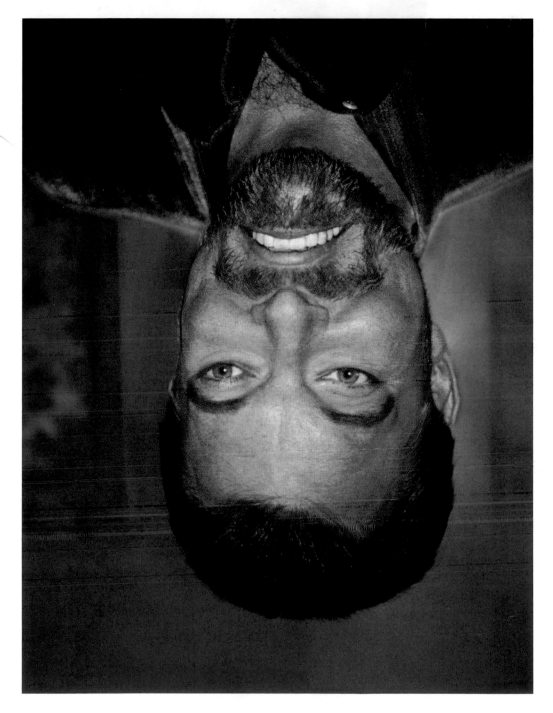

Inverted Head Illusion

This image of actor Jonathan Frakes does not look too scary until you turn the picture upside down.

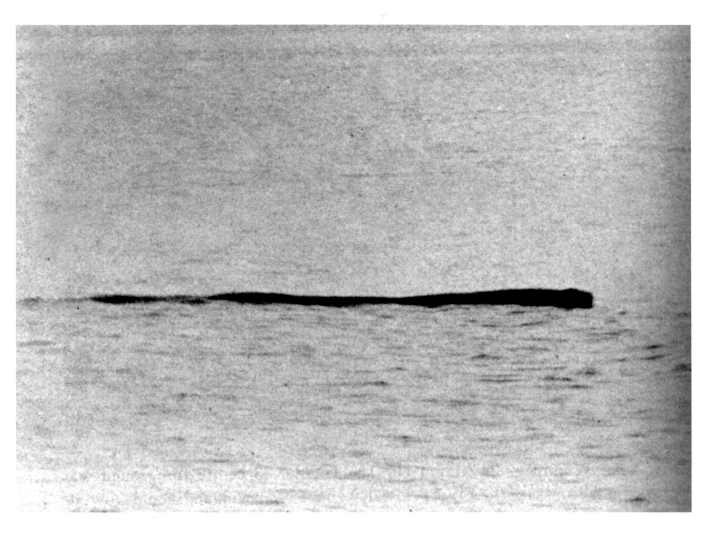

Loch Ness Monster

This is a famous picture of the Loch Ness monster. Does it look like a serpentine monster to you?

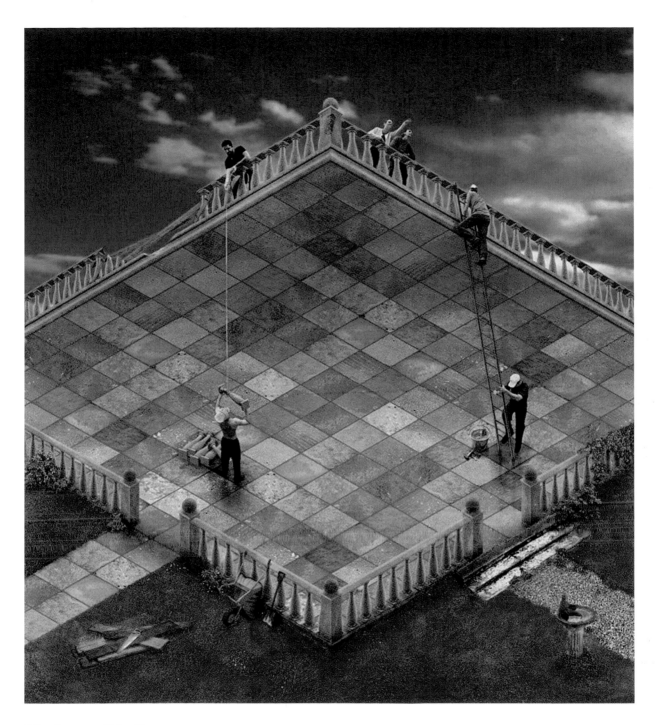

The Impossible Terrace

Are you looking at this structure from the bottom or the top? Notice how the ladder also twists in an impossible way.

A Policeman's Surprise

Can you make this policeman look surprised? You will have to invert him.

Kanai Grid

This image consists of many stationary "+" signs. They form a regular grid in the center, but the regularity is gradually disturbed in the outer regions. When you stare at the center (no strict fixation is necessary) for approximately 15 seconds, the irregularity in the outer regions is "corrected" and the entire stimulus is perceived as a regular grid pattern. You might want to adjust your viewing distance to get the best results.

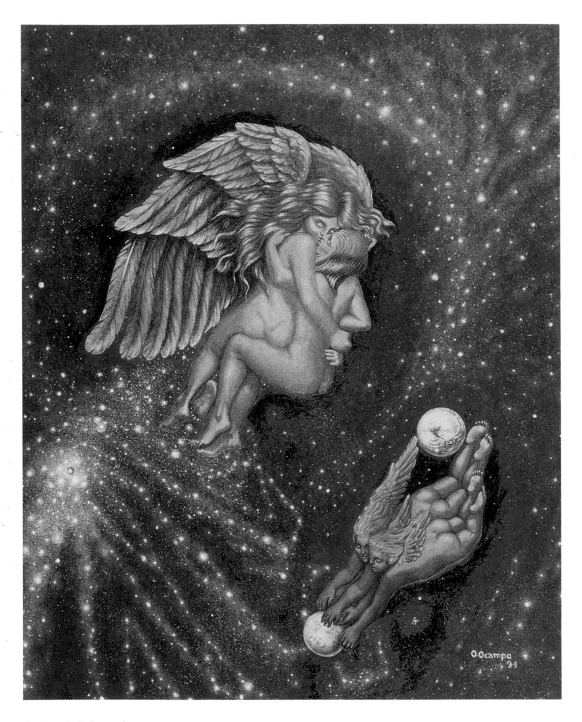

Celestial Angels

How many angles can you fit on an angel? Look closely at both the head and hand of the angel.

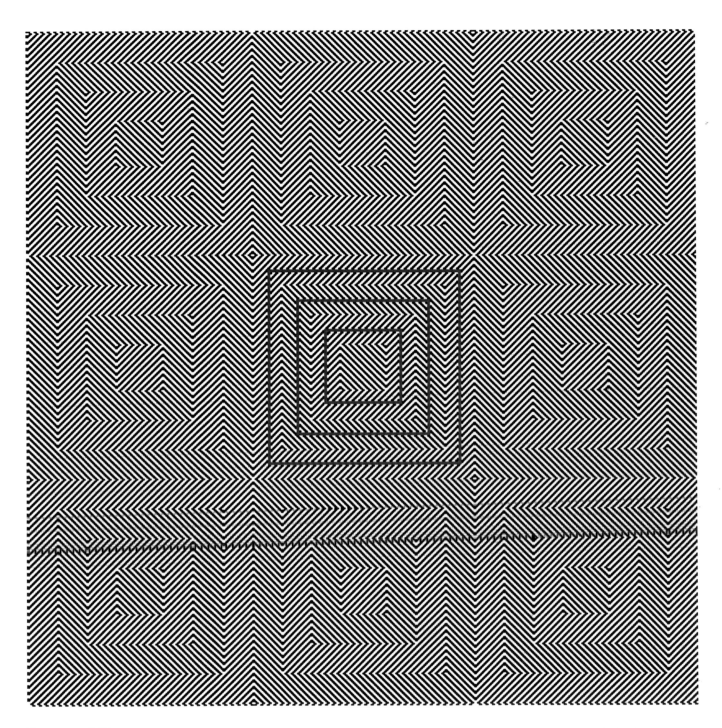

Square of Three

Do the blue concentric squares appear warped? If you shake this image, it will also vibrate.

Miracle

Stare at the midpoint between the two hands and slowly bring the image up to your face; the two hands will touch.

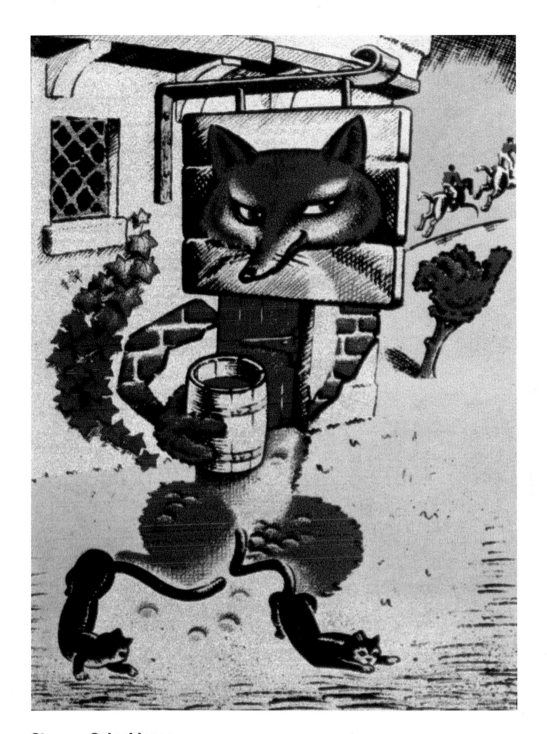

Strange Coincidence

A sly fox is cleverly hiding from the two hunters.

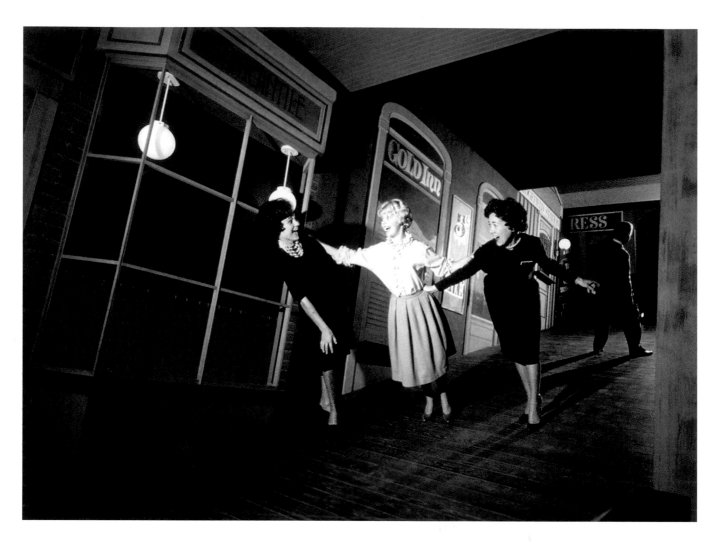

Crazy Street

Up and down are perceptually reversed when walking on this crazy street. When you are walking downhill it feels as if you are walking uphill, and vice versa.

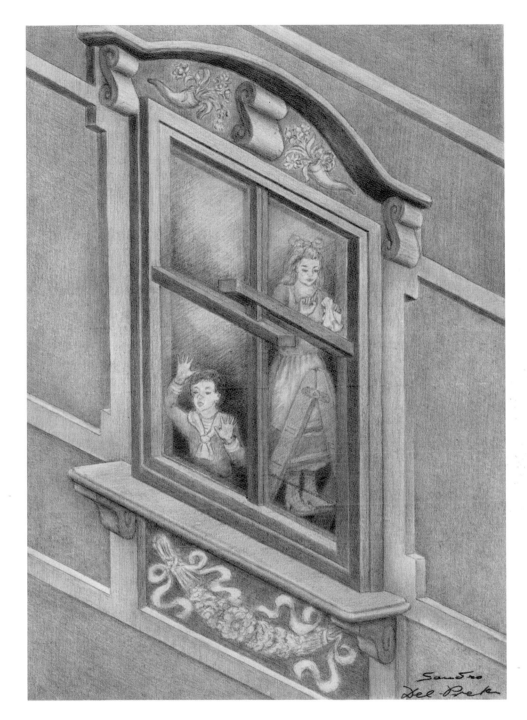

Window Gazing

In which direction is the window and surrounding wall facing? Is it possible to build this?

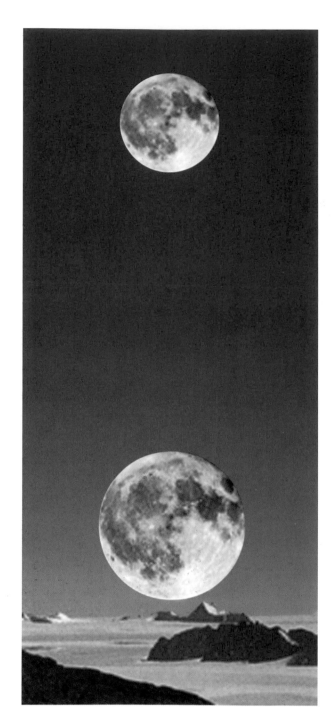

The Moon Illusion

The Moon Illusion is one of nature's most famous illusions. When the moon is just over the horizon, it appears to be roughly one-and-a-half times the size that it appears to be when it is high over the horizon. The actual size of the moon does not change between the two locations.

This doctored picture represents the relative sizes of the horizon and zenith moon, as it would appear to an observer. Interestingly, it is an effect that can't be captured on film. It has to be seen naturally to be appreciated.

Escher in Tuscany

The face of Dutch graphic artist M.C. Escher is hiding in this scene. Can you find it?

Hiding Amongst the Prey

Is there danger lurking for these animals?

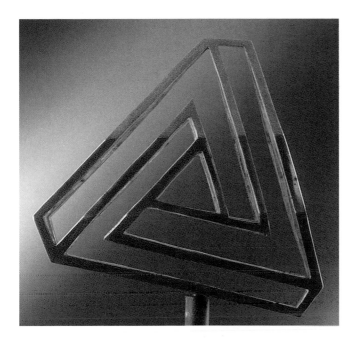
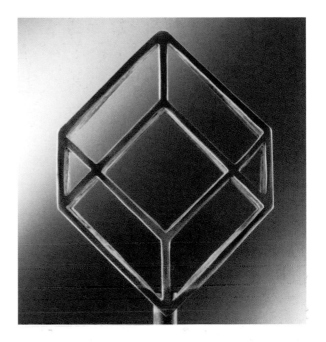
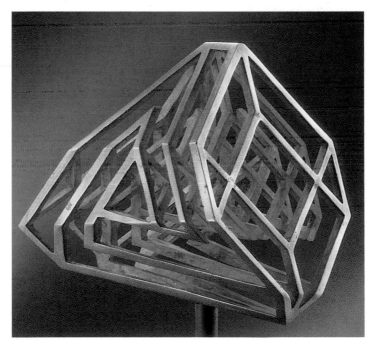

Moretti's Impossible Transformation

These three photographs depict the same bronze sculpture as seen from three distinct viewpoints. From one viewpoint it looks like a wire cube and from another angle, it looks like an impossible triangle. The bottom photograph shows an intermediate angle between the two top views.

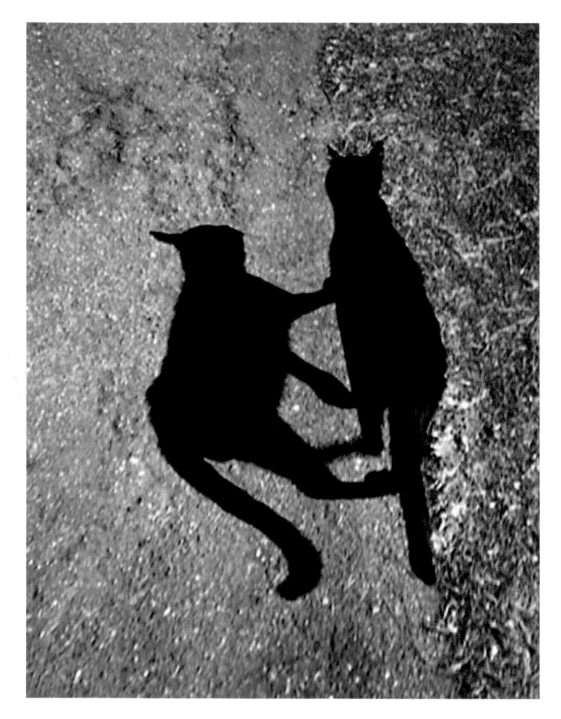

A Cat Hiding in its Own Shadow

Is the black cat walking on a gray pavement or on the grass? Which is the shadow and which is the cat? Rotate the image by 90 degrees in a clockwise direction to be sure.

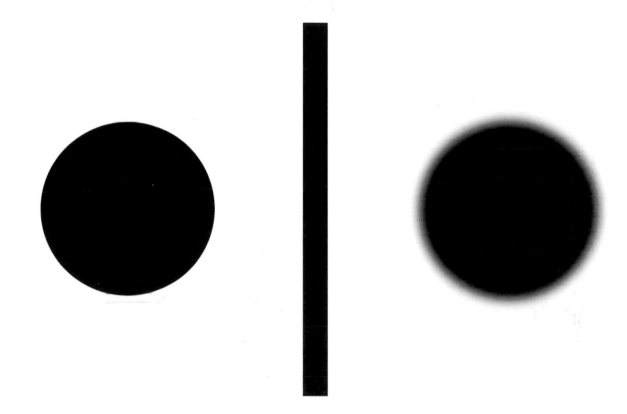

The Kaniza Blur Brightness Illusion

Does the right disk appear as dark as the left disk?

A Sudden Change of Direction

Stare at the fish in this illustration. They will face left and then suddenly change direction and face right.

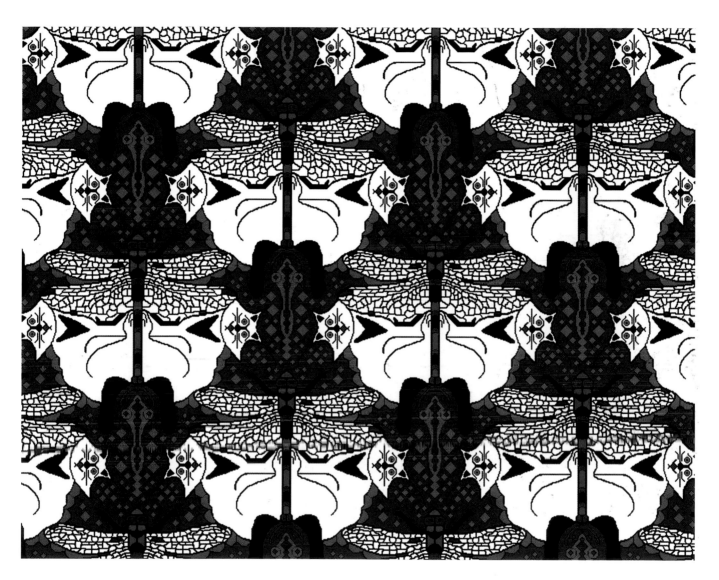

Tessellating Cats, Dragonflies and Frogs

Can you find the dragonflies, cats and frogs in this tiling image?

Two Bodies and Only One Head

Is this possible? Can two bodies have only one head?

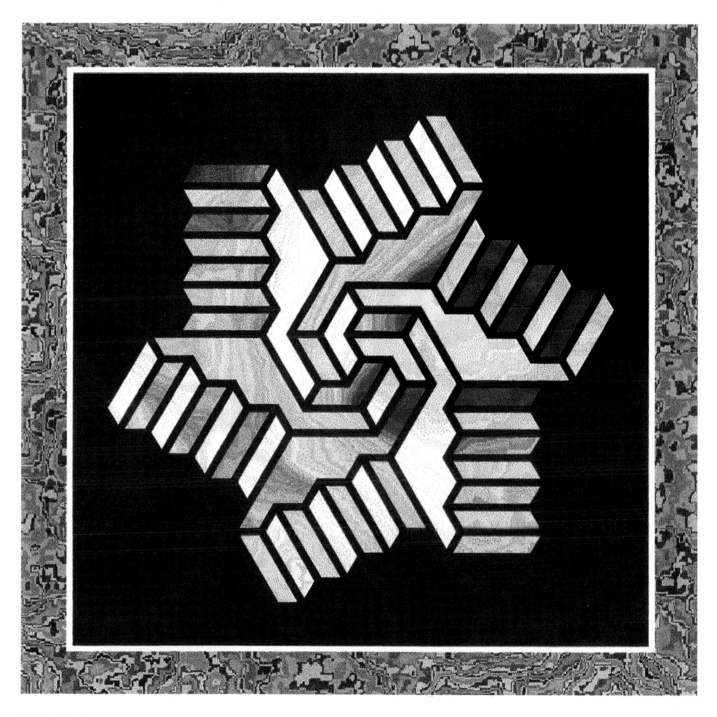

Sidewinder

What is strange about this configuration of steps?

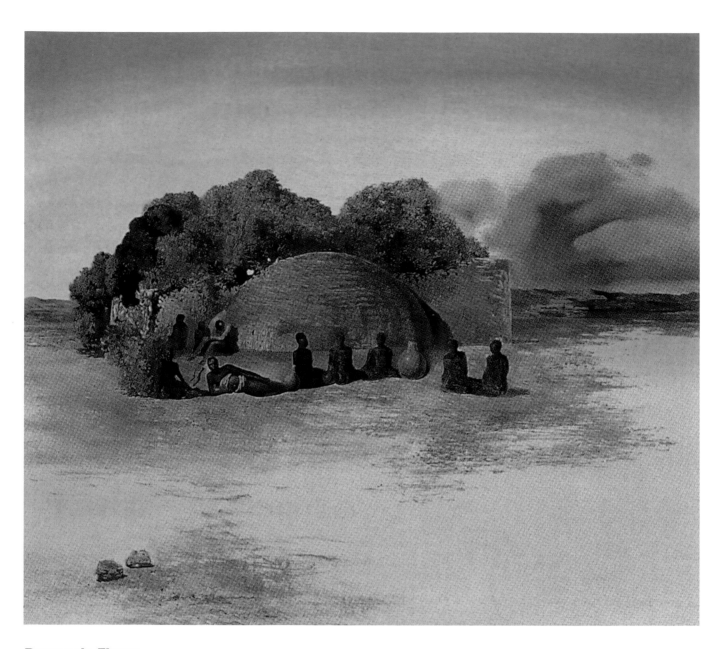

Paranoaic Figure

Can you find the face in this image?

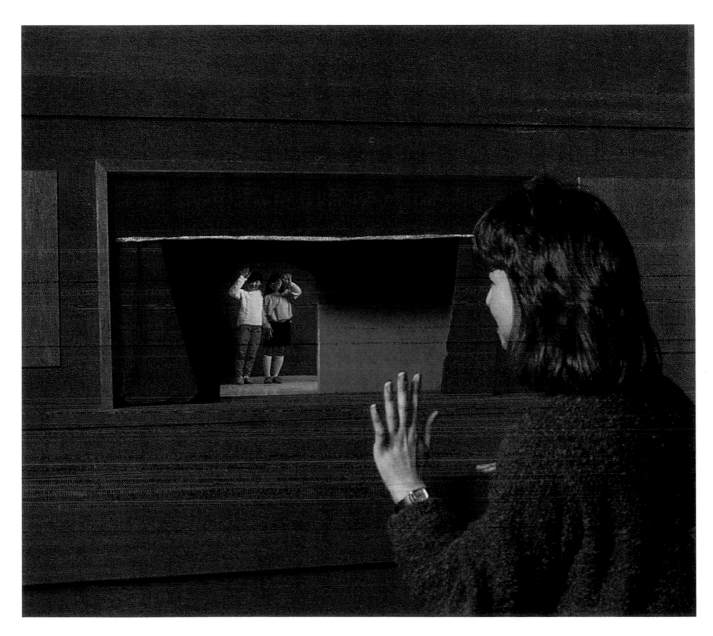

Miniature Theater

The two girls are life-sized, but they look tiny when seen through the aperture in this miniature theater.

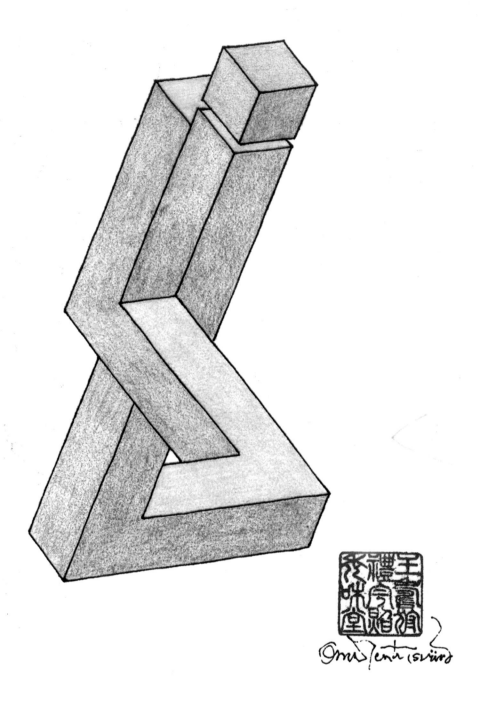

An Impossible Triangle with a Paradoxical Twist

Can you spot the impossibility in this drawing?

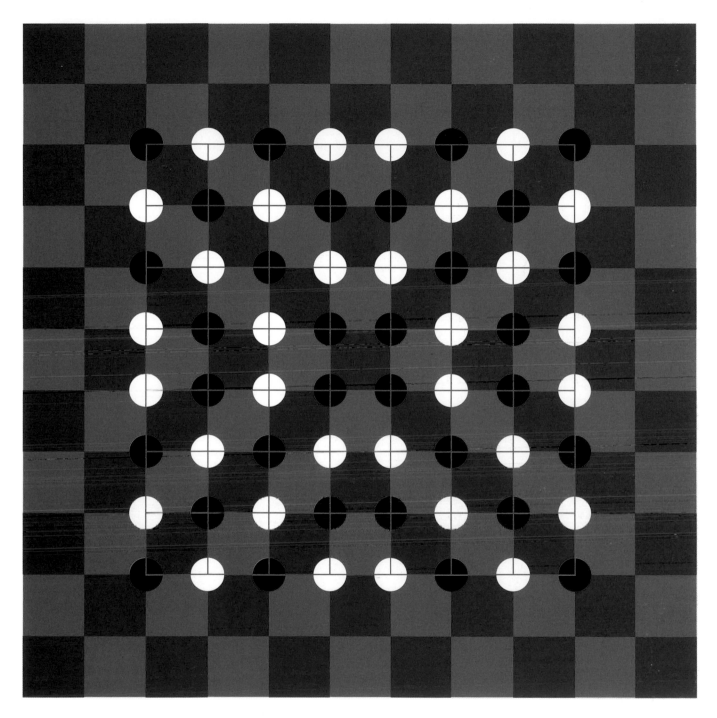

Bulging Squares

Are the lines straight or distorted? Check them with a ruler.

Cosmic Wheels

These wheels twist in a very strange way. Can such a structure really exist?

Koa Construction

In a wallpaper stereo illusion, an image is repeated across the page. All stereo pictures are designed so that they can be seen if the viewer uses what is called the divergence method. Your eyes must behave as if they are looking at something off in the distance. When you normally view a book, your eyes converge (focus) on the image in the book. When viewing a stereo image, you must relax your eyes so that you can focus "behind" the image (exactly as far as your eyes are from the book). You must look at the image long enough for your brain to decipher the stereo information.

Dino Might

This image appears completely flat. When this image is viewed properly (according to the viewing instructions in the explanation for illusion #125), the image will suddenly appear in depth. It is quite a remarkable illusion and worth the effort to see it.

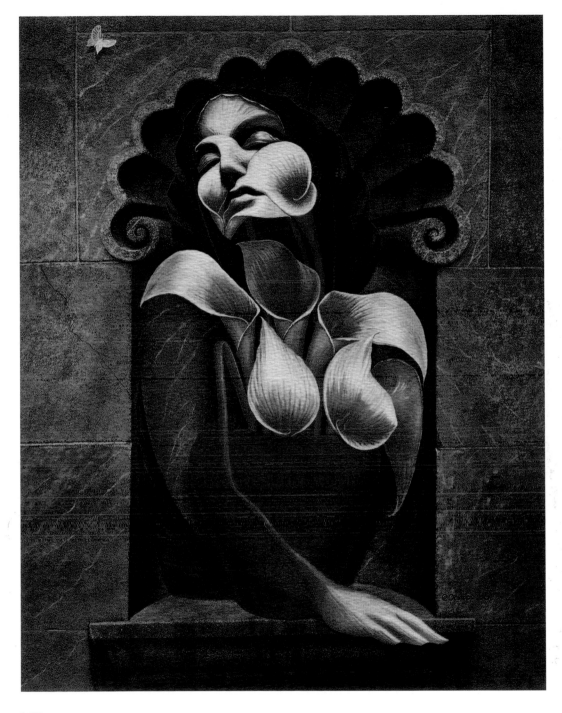

Lilies

Can you perceive images of both lilies in a vase and a beautiful woman?

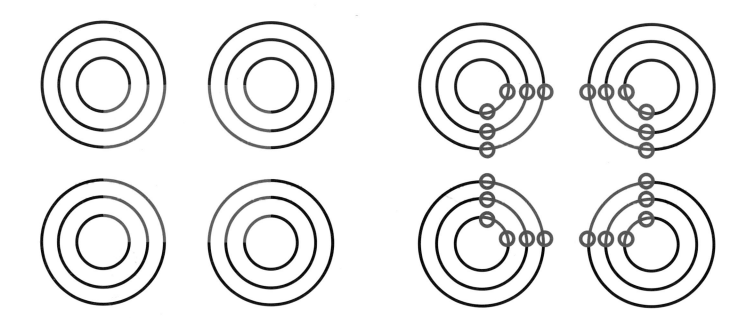

Neon Color Spreading

Do the insides of either of the two squares appear to have a slightly bluish tint?

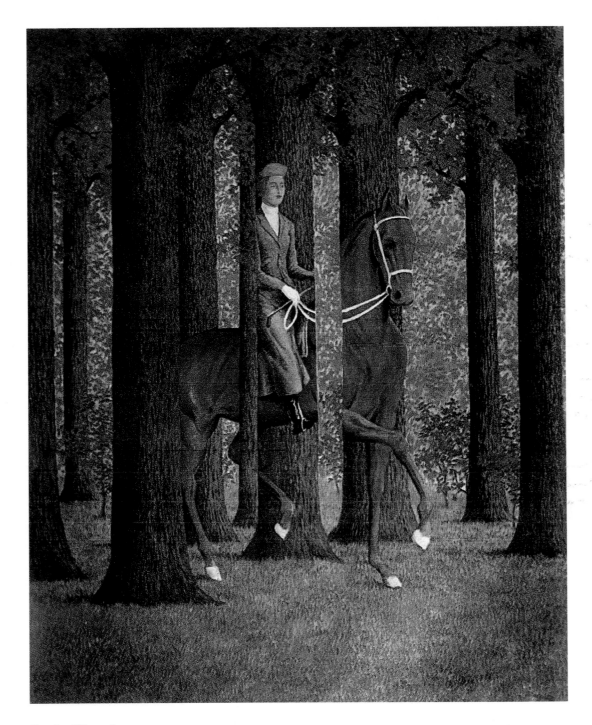

Carte Blanche

Where are the horse and rider in relation to the trees?

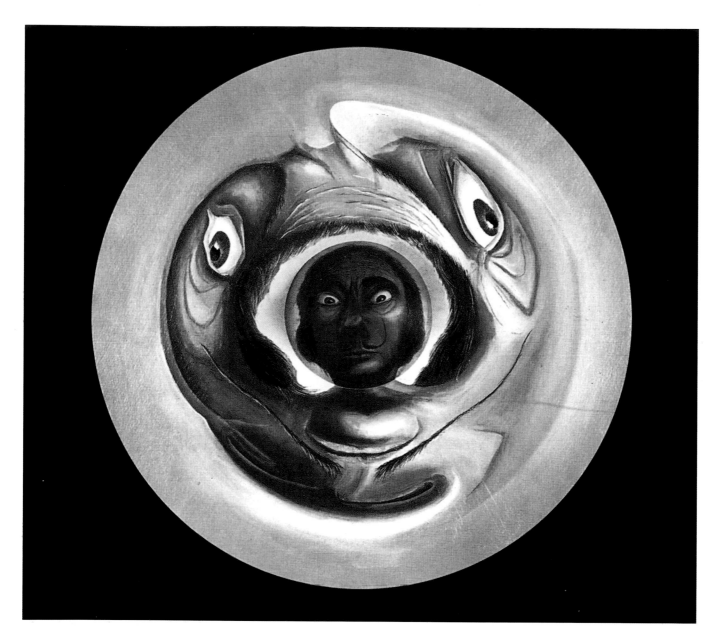

Dalí Anamorphosis

Spanish surrealist artist Salvador Dalí enjoyed hidden imagery and surprise. In this homage to him, Swedish artist Hans Hamngren has created a distorted image of Dalí, which transforms into an undistorted portrait when seen reflected on a conic mirror placed in the center of the image.

Brain Scan

Free fuse this image to find what is hidden in this 3D stereogram. For instructions on how to view this image, please consult the explanation for illusion #125.

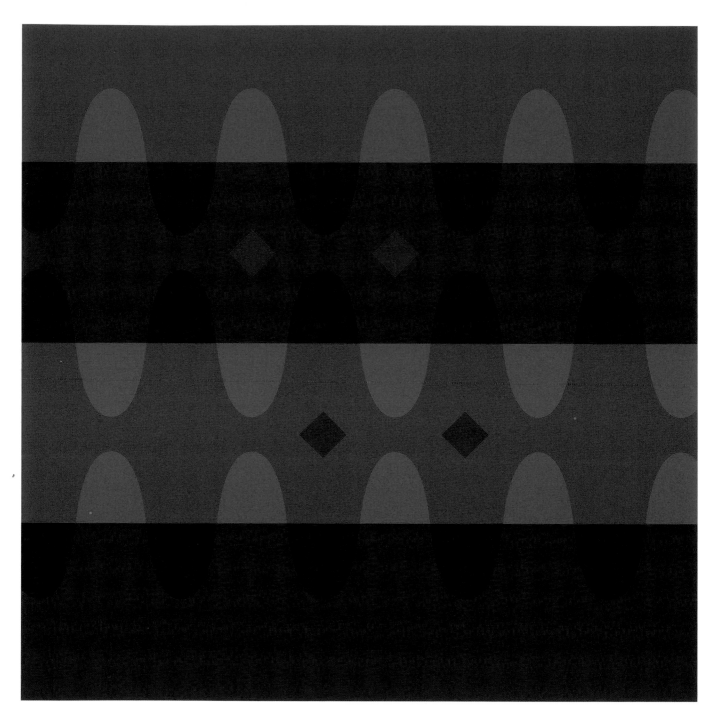

Adelson's Snake Illusion

Do the diamonds on the top appear lighter than the pair of diamonds on the bottom? All four diamonds are the identical shade of gray.

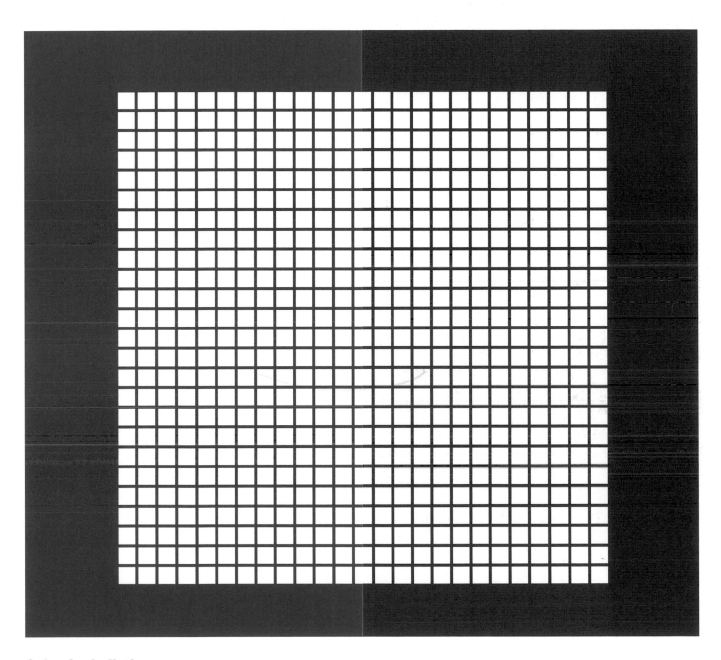

Color Assimilation

Do you perceive a reddish hue within the white squares on the right and a bluish hue within the white squares on the left?

Chevreul Illusion

Are the colors of the adjacent rectangles the same throughout? Try covering the border between any two adjacent rectangles with a pencil. What happens?

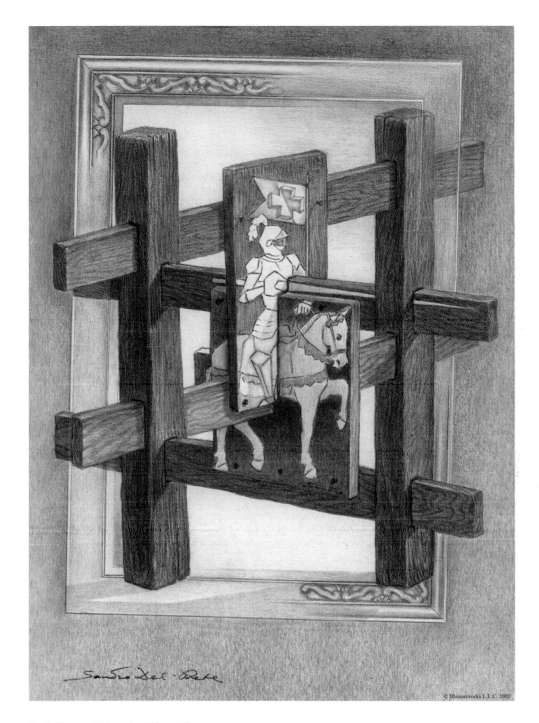

© Illusionworks L.L.C. 2002

Soldier of the Lattice Fence

Is the construction of this warrior possible?

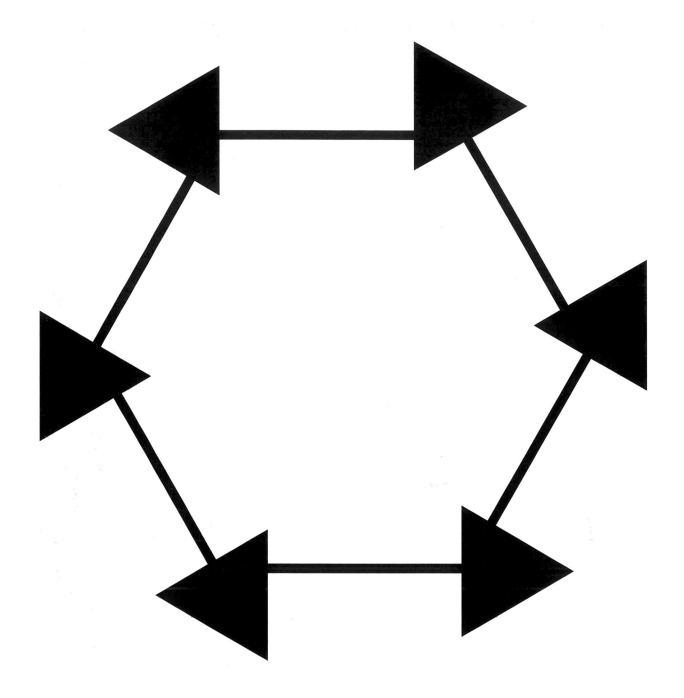

Gerbino's Illusion

Do the straight-line segments, if connected, appear to form a perfect hexagon?

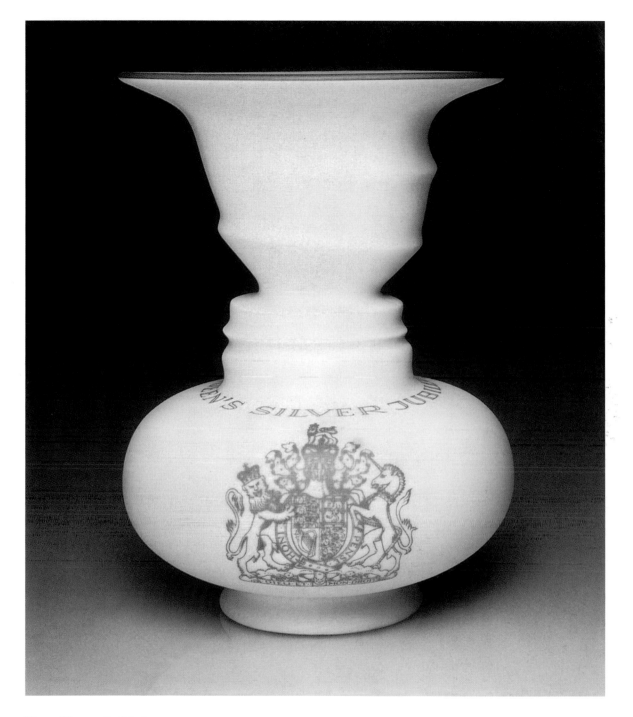

Vace/Face Goblet

Can you find the profiles of Queen Elizabeth II and her husband Prince Philip?

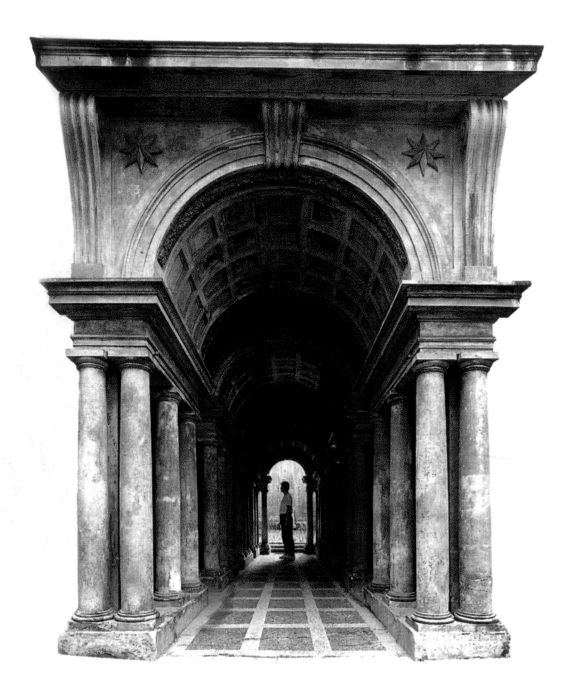

Perspective Arcade

Why does this man appear too large for the corridor?

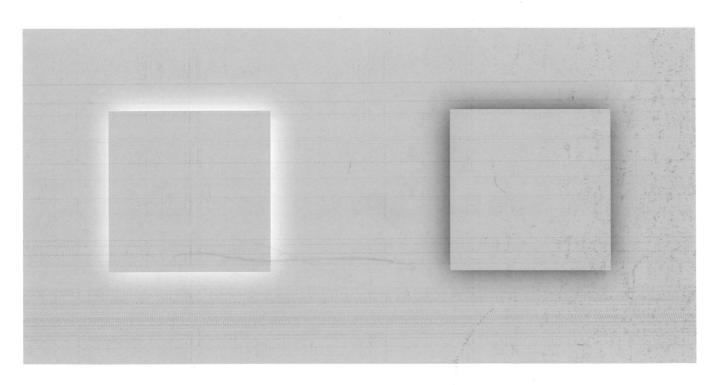

COSI Squares

Does the square on the left appear lighter than the square on the right? They are both identical shades of gray.

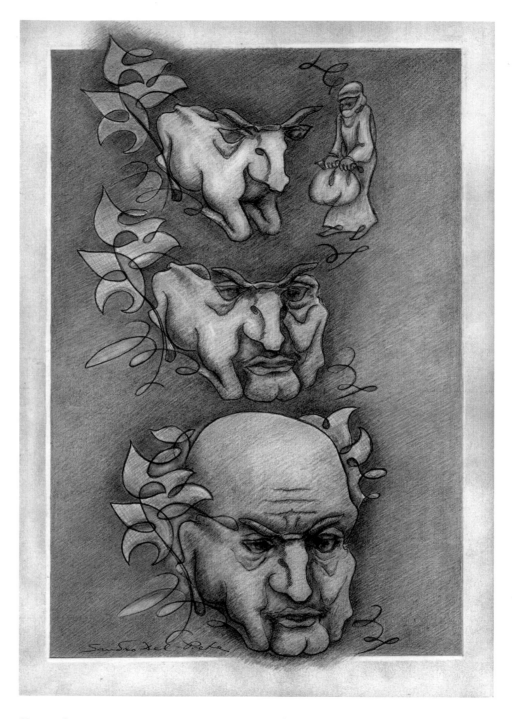

Nomad

This image transforms from top to bottom. At the top of this image, a bullock is resting underneath a shrub. In the middle, a nomad offers a water bag to the bullock. And at the bottom, one can see the expressive face of a scholar: adding the lines for the top of his head and forehead makes the difference.

A Moving Portrait of John F. Kennedy

If you look at this image, it is hard to discern any recognizable features. However, if you move the image up and down, you will be able to perceive the portrait of the late American president John F. Kennedy. Squinting your eyes will also help to discern the image.

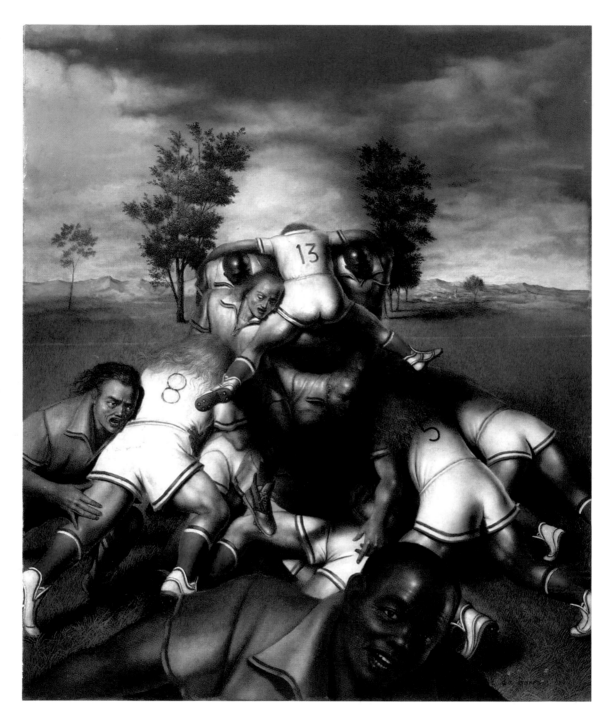

Melee on a Rugby Field

A strange configuration of rugby players produces a hidden face

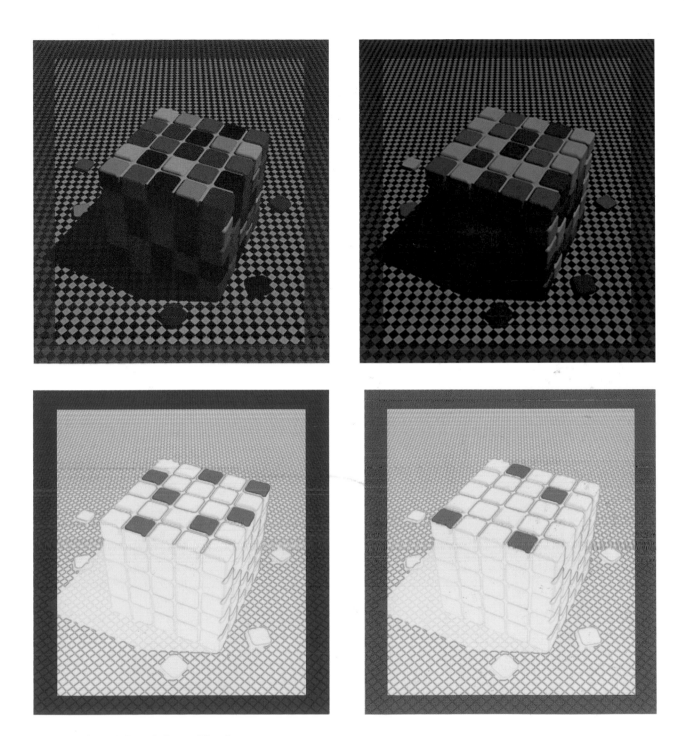

Lotto's Shade's of Gray Illusion

In the image on the top left, all the yellow squares on top of the Rubik's cube are really gray. In the top right image, all the blue squares on top of the Rubik's cube are also all gray. The bottom two images show the true colors of the squares when the yellow and blue filters respectively have been removed.

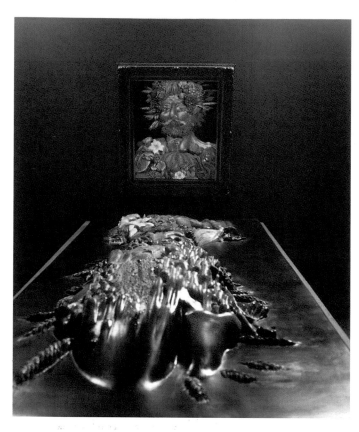

Arcimboldo's Fresh Guy

On the table is an anamorphically distorted three-dimensional sculpture, which when reflected onto the wall mirror, becomes an undistorted representation of Archimboldo's famous fruit/face portrait of Emperor Rudolph II (see illusion #62).

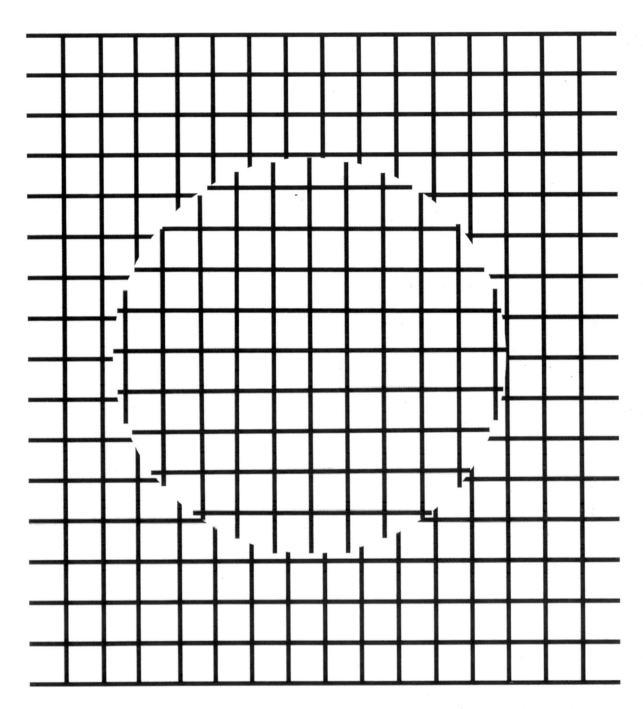

Illusory Circle

Can you perceive a circle?

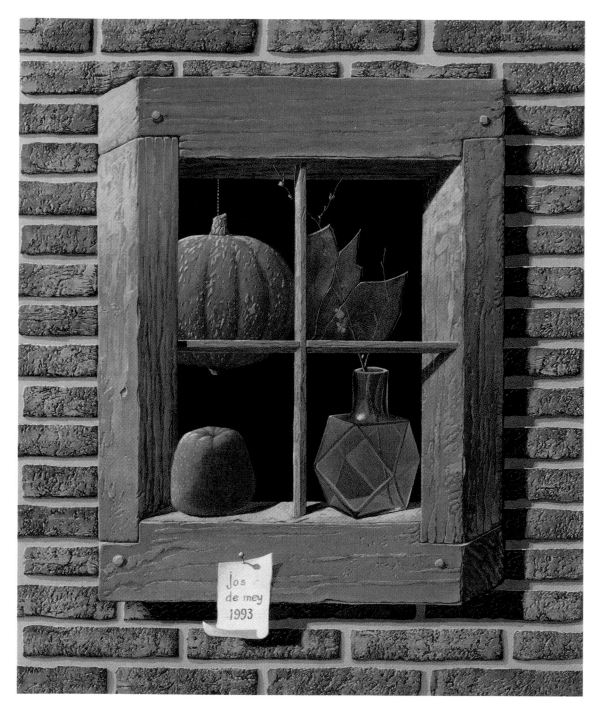

Still Life in an Impossible Window

Look closely at this window frame. Is there anything strange about it?

The Traffic Illusion

If you stare at this image you will see ghostly dots racing back and forth within the diagonal blue and white stripes.

Legs of Entirely Different Genders

Are these men's legs or women's legs?

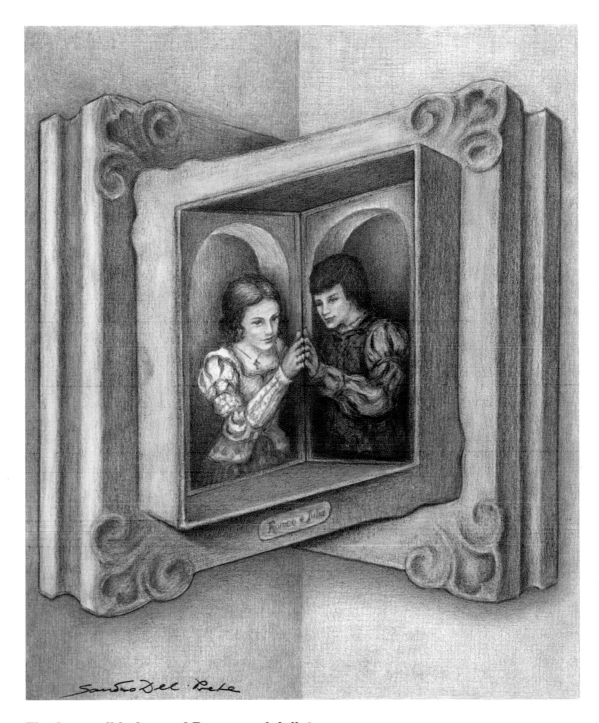

The Impossible Love of Romeo and Juliet

In this drawing, Swiss artist Sandro Del-Prete symbolically depicts the impossible barriers of love between Romeo and Juliet.

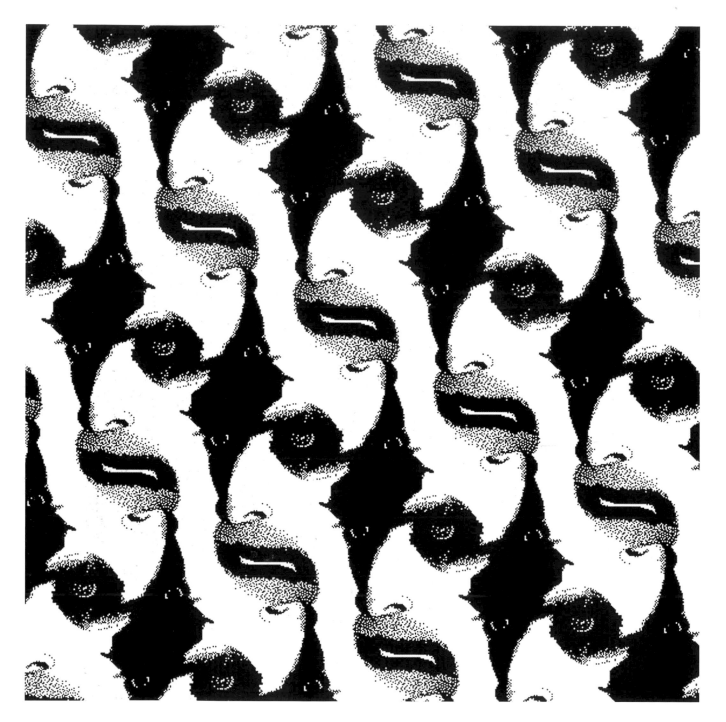

Homage to M.C. Escher

You will see multiple images of Dutch graphic artist M.C. Escher. If you invert the image, it still works.

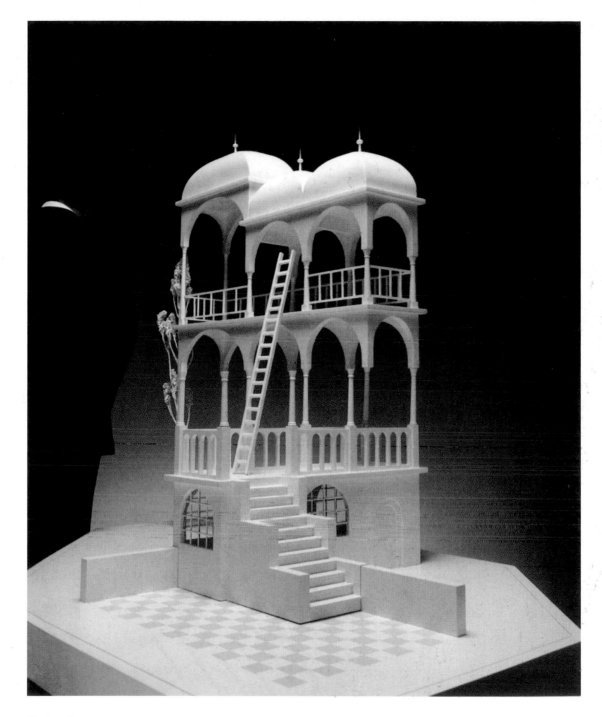

Belvedere

This is a physical model of an impossible building, based on the structure depicted in M.C. Escher's famous print, "Belvedere." The floor is perpendicular to the bottom floor, yet they are perfectly joined. The ladder also goes from being inside the building to being outside the building, and then to the inside of the building, which is quite impossible.

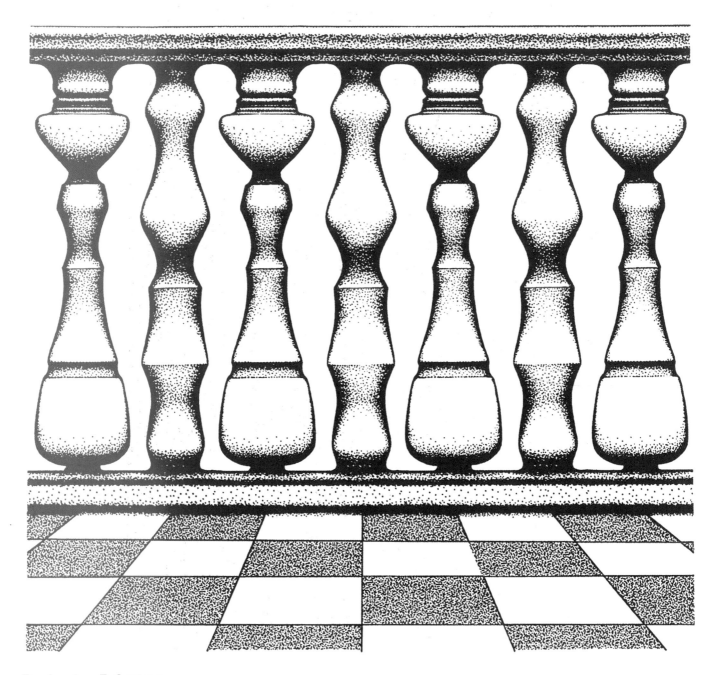

Beckoning Balusters

Can you find the figures that are hiding in this set of columns?

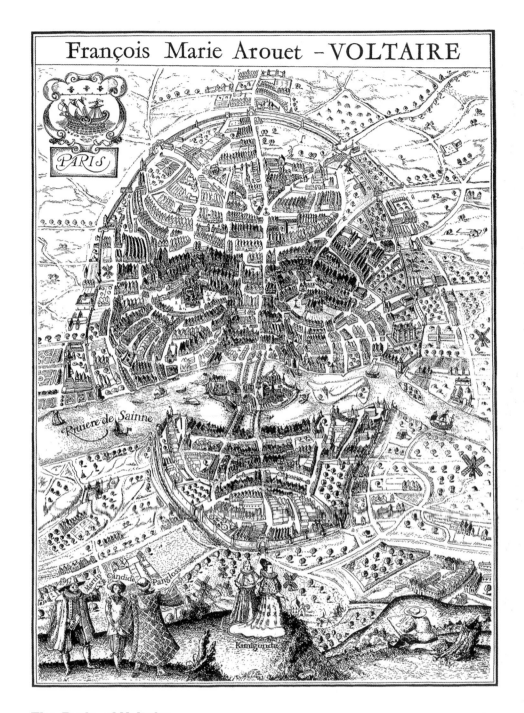

The Paris of Voltaire

Voltaire and a map of Paris.

A Crab in the Autumn

Slowly move this figure in an irregular manner and the center section will separate.

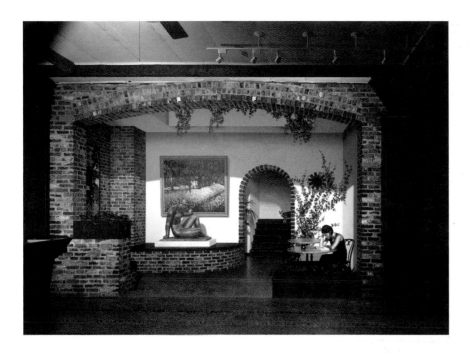

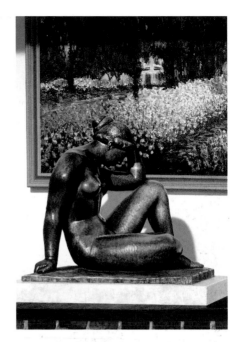

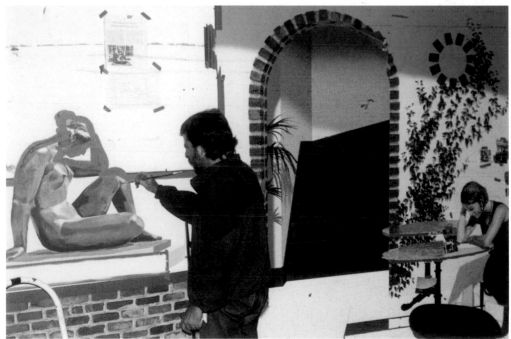

Art Imitates Life Imitating Art

At a cafe in San Jose, California, where this mural is featured, a customer complained that he received the "silent treatment" when he tried to introduce himself to the pretty woman reading a book. The woman was a painted illusion! The top right photo shows a detail from the mural and the bottom photo shows the artist at work painting it.

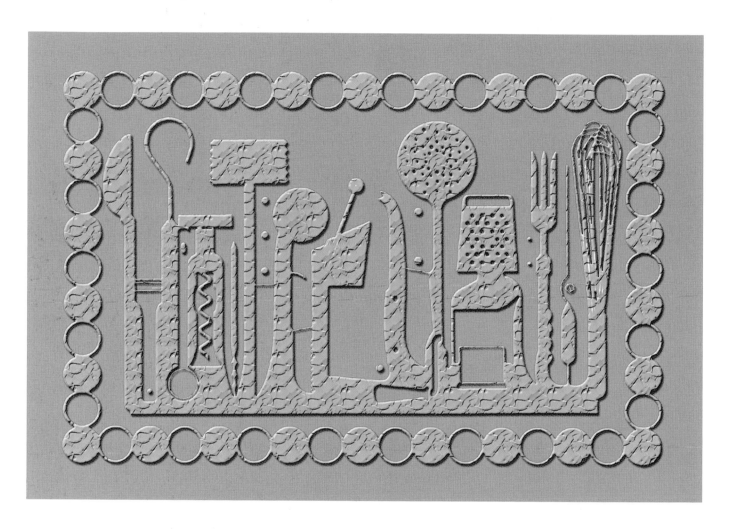

Kitchen Utensils

How many kitchen utensils can you find?

Rokuyo

When you look at this image, the wheels will appear to slowly turn in opposite directions.

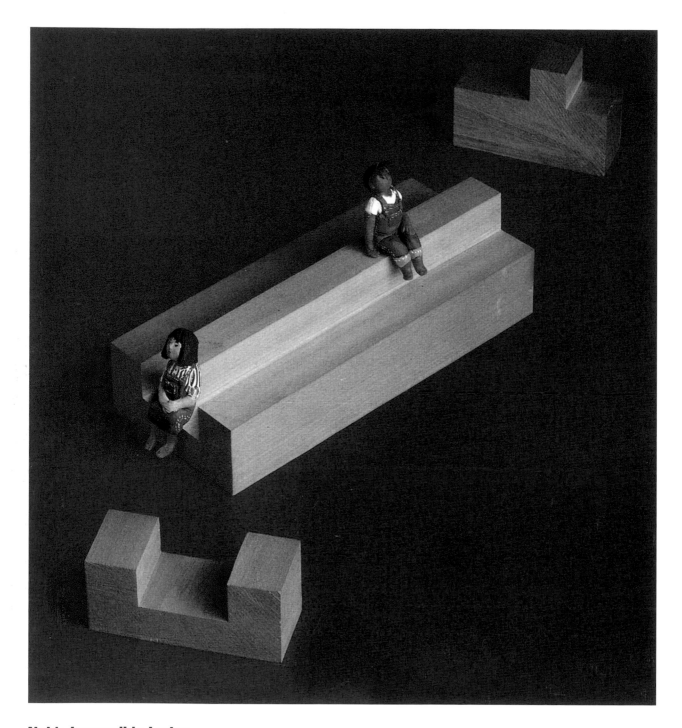

Nob's Impossible Ledge

The plastic male figure on the right is sitting on top of a wooden step, which corresponds to the piece separated on the right. If you follow the ledge to the left, you will see that the female plastic figure is sitting in a carved-out depression, which corresponds to the separated piece on the left. How could this be?

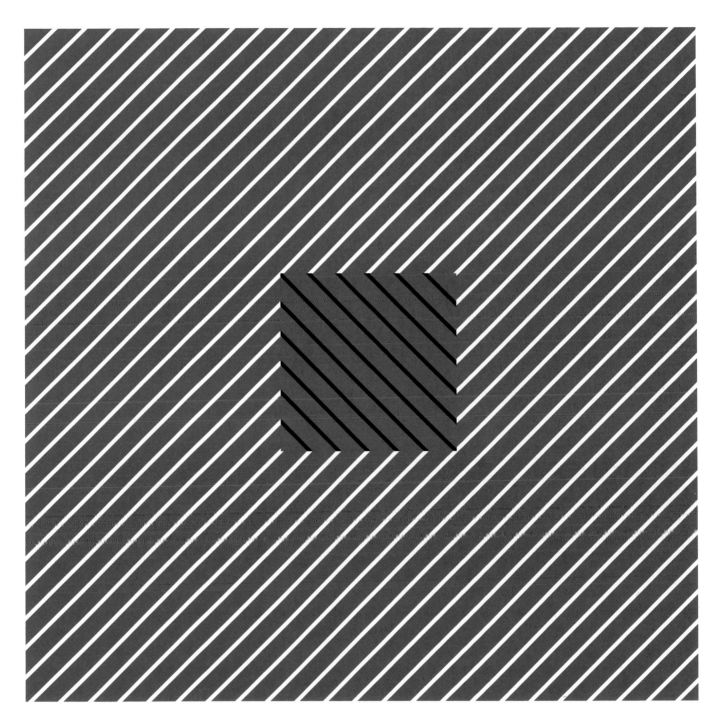

Different Shades of Green

Is the green square at the center a darker shade of green than the surrounding larger green square?

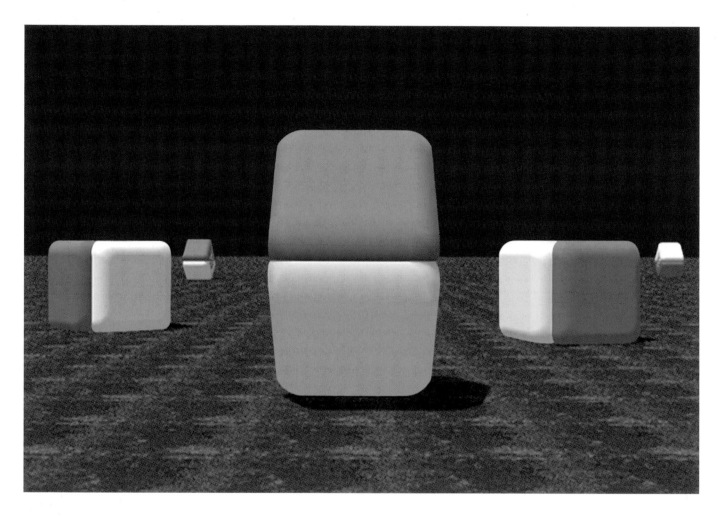

Lotto and Purves' Cornsweet Illusion

In the set of larger blocks in the foreground, do you perceive a dark gray block on top of a lighter block? Cover the middle section with your finger. What happens? Also, try covering the middle sections of the other blocks. Some you will find incorporate an illusion, while other blocks do not.

Diamond Variation of the Craik-O'Brien Cornsweet Illusion

Look at each row of diamonds. Does each row appear darker than the row above it?

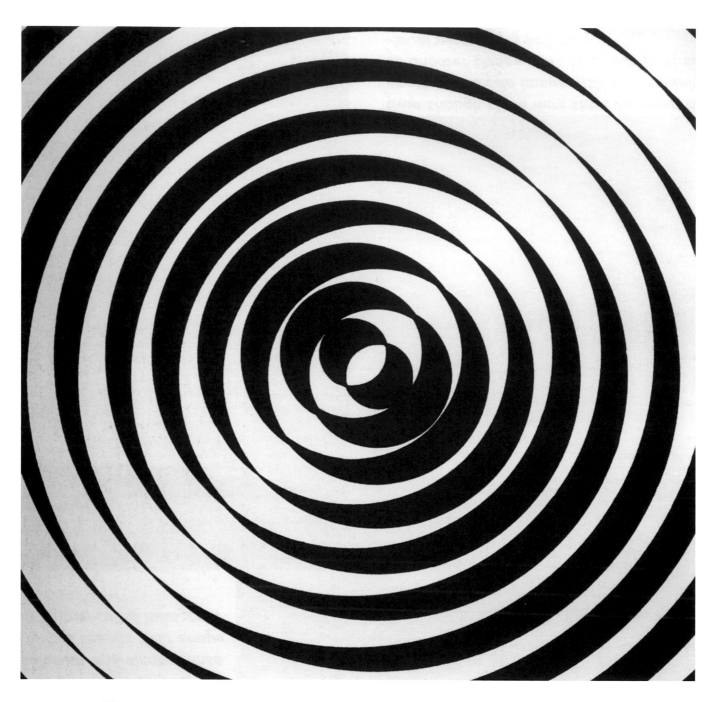

Ambiguous Rings

Stare at these rings and they will flip-flop in orientation.

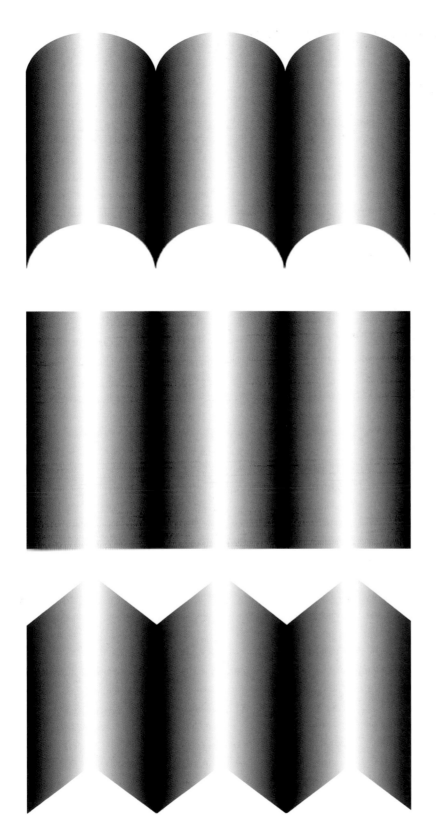

Outline Defines Shape

The gray stripes in all three images are identical, but they appear to have very different shapes.

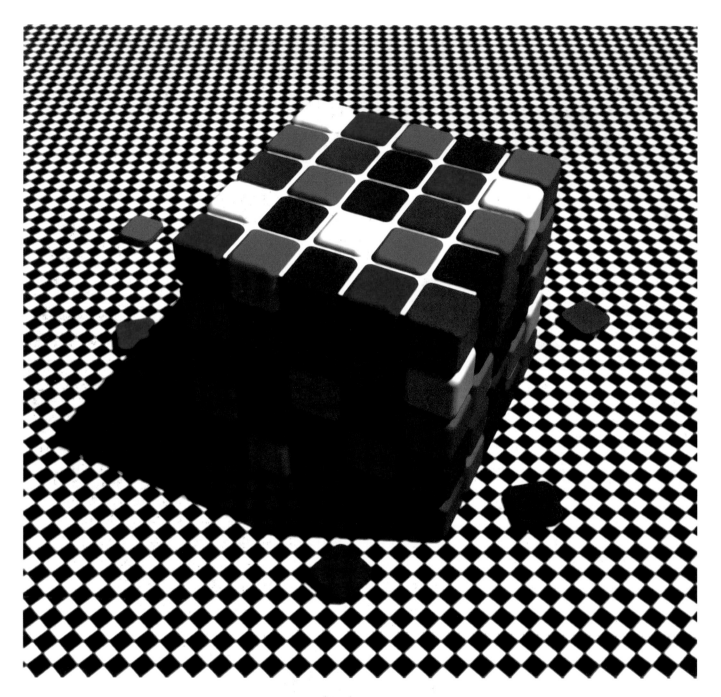

Lotto and Purves' Rubik's Cube Color Illusion

Does the brown square on the top of the Rubik's cube appear to be the identical color of the yellow square that is in the middle of the shadowed side? They don't appear to be the same color, yet haven't we fooled you so far? Cut two peepholes in a sheet of paper so they only reveal those two squares. Then remove the sheet of paper and the illusion reappears.

Wade's Hula Hoop Illusion

View this image while moving it in a circular fashion without changing its orientation. The motion should be similar to how you would rinse a cup. You should see the intermediate circle move, like a hulahoop slowly being spun around your hips.

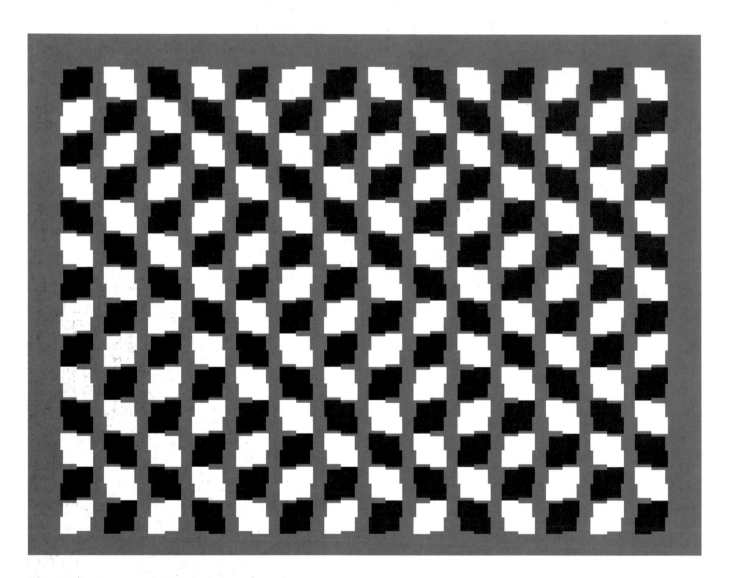

Kitaoka's Seaweed Illusion

Do the columns of "seaweed" appear wavy?

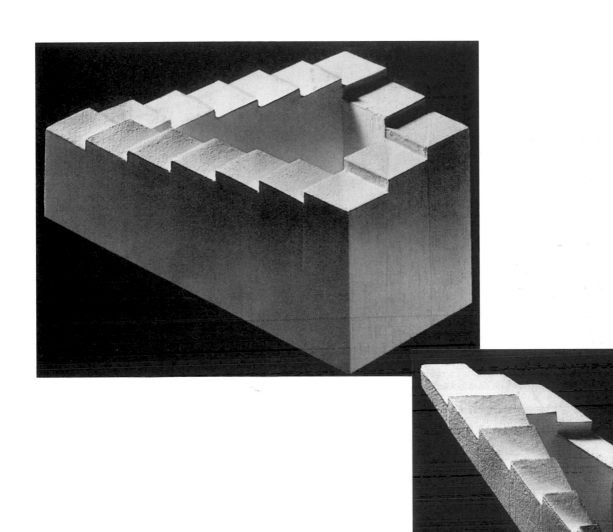

The Impossible Anamorphic Staircase

This is a physical version of an impossible staircase. The top view shows it from a vantage point that shows the illusion. The bottom photo reveals its true construction.

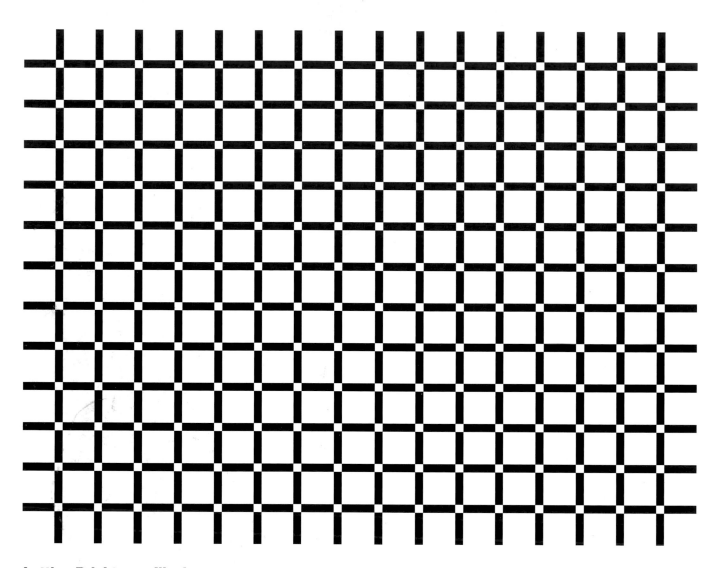

Lattice Brightness Illusion

Do the white squares inside the junctions of the black lines appear brighter than the larger white squares in between the black lines?

Hidden Jesus

In this undoctored photograph, can you find the hidden face of a bearded Jesus?

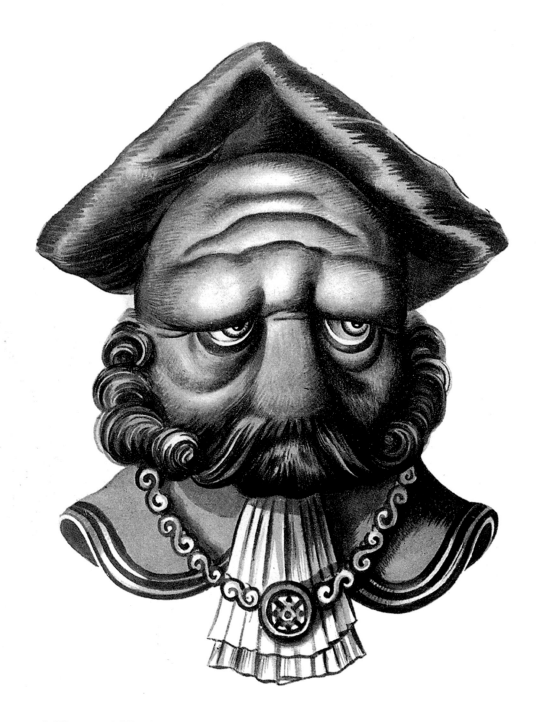

A King and His Queen

The king needs to turn his whole kingdom upside down to find his missing queen. Can you help him locate her?

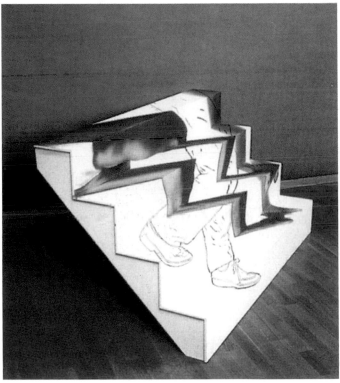

Anamorphic Stairs

From one angle, the figure on the stairs appears perfectly normal, but when you see the same figure from a different angle, it appears quite distorted.

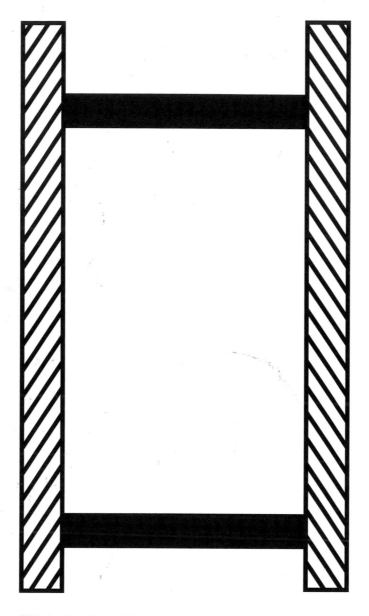

Tilt Induction Effect

Do the striped vertical bars appear to be tilted away from each other?

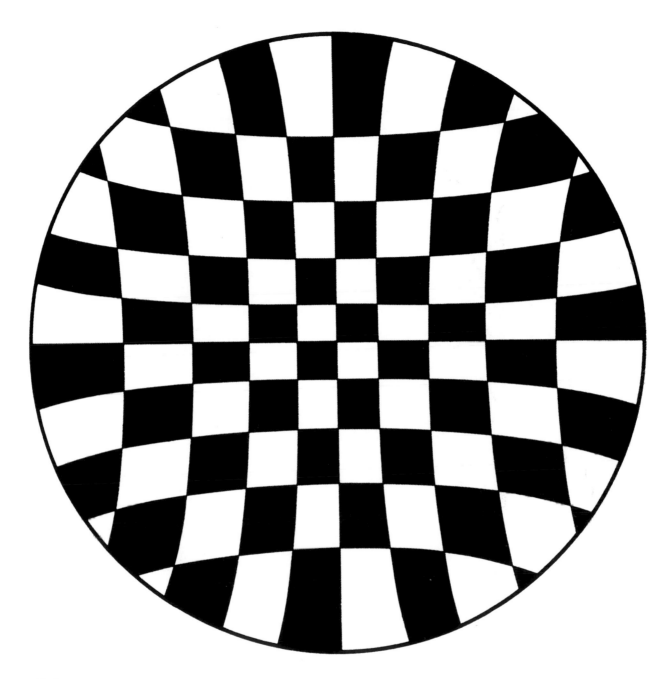

Fisheye
Using only one eye, bring the image within 1 inch (2.5 cm) of your eye. Do the curved lines now appear straight?

Puzzling End

Congratulations! You have come to the end of the illustrations. Can you puzzle out what this says?

What's Going On?

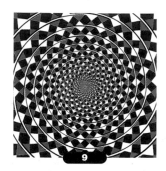

Fraser's Spiral Illusion

The "spiral" is made out of a series of several concentric circles of diminishing size. There are overlapping arc segments within each circle that terminate at the midpoint of the arc segment in any adjacent circle. These arc segments interact with the rest of the background to produce a "tilt" which is transmitted across the entire circle to produce the spiral effect. If the background is removed, and only the overlapping arc segments remain, the illusion vanishes entirely.

If you cover up half of the image the strength of the illusion is also greatly diminished. This means that the illusion is due to global image processing and perceptual grouping of the entire image. Knowledge of its true nature or successive viewing does not dramatically decrease its effect.

Fraser's Spiral Illusion is classed among a group of illusions known as twisted-cord illusions, and is among the most complex in this category of illusions. These illusions somehow mislead orientation-selective neurons, which are used by your visual system to build your mental representation of edges and their direction. The Fraser's Spiral Illusion, however, involves several different levels of perceptual processing. English psychologist James Fraser discovered this effect when he was exploring similar, but less complex, figures in 1906. Compare with # 51, 105 and 127.

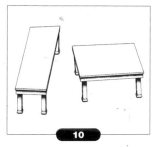

Shepard's Tabletop Illusion

Although the two tabletops are identical, the edges and the legs of the two tabletops are not the same. The configuration of the edges and legs provide perspective cues that influence your interpretation of the tabletop's three-dimensional shape. The illusion no longer works when you trace only the

outlines of the tabletops, because you have removed contextual and perspective cues.

Perspective drawings, which do not have the constraints of the physical world, can sometimes suggest three-dimensional objects that cannot possibly exist or objects that are inconsistent with what you would really perceive from the viewpoint of that object. Although the two tables appear realistic, they depict a viewpoint that you would never encounter with two physical tables.

An Illusion of Extent

AC and AB are equal. As in the previous example, perspective cues provide a context that strongly influences your perception of the scene. These perspective cues are very powerful, and even after you have measured the two lines and know they are equal, they will still appear different in length. This is because your visual/perceptual system is highly constrained by how it interprets images, and knowledge can seldom overpower the constraints of this system.

The Scintillating Grid Illusion

The standard explanation of this recently discovered illusion is the receptive field model, which relates to the special way that adjacent neurons in your retina interact and inhibit each other. The width of the lines on the Scintillating Grid Illusion produces an image on the retina that is just equal to the diameter of the center of a simple circular receptive field found in a retinal ganglion cell. In this way, the lateral inhibition network accounts for most aspects of this illusion. There are some small timing differences between center and surround responses. The center responses are quicker and more transient than the surround responses, which cause the dots at the intersections to scintillate. As you visually

scan the image, the cells that signal "white" at the intersections first give a strong center signal in response to the white dots at the intersections, but then their signal is weakened, as surround inhibition takes place. This reduction is perceived as a darkening of the spot.

Although this explanation sounds plausible, several very recent variations of this illusion suggest that the receptive field model for this effect may need some revision. It's believed that higher level cortical processes may be a contributing factor to this illusion.

Elke Lingelbach "discovered" the Scintillating Grid Illusion in 1994 (a weaker version was first demonstrated at a vision conference in 1993 by J.R. Bergen). The Scintillating Grid Illusion is closely related to the Hermann Grid Illusion (see illusion #93), which was discovered in the 19th century. Subtle differences between the two dramatically change this illusion in a number of ways, and make its effect more powerful. Compare with #93 and 144.

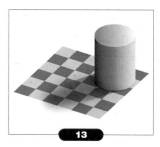

Adelson's Checkered Shadow Illusion

Your visual system works to determine the color of objects in the world. In this case, the problem is determining the gray level of the checks on the checkerboard floor. Just measuring the luminance is not enough. A cast shadow will dim a surface; so a white surface in a shadow may be reflecting less light than a black surface in full light. The visual system uses several constraints to determine where the shadows are and how to compensate for them in order to determine the shade of gray that exists on the surface.

The first constraint is based on local contrast. In a shadow or not, a check that is lighter than its neighboring checks is probably lighter than average, and vice versa. In the figure, the light check in shadow is surrounded by darker checks. So even though the check is physically dark, it is "light" when compared to its neighbors. Conversely, dark checks outside the shadow are surrounded by lighter checks, so they look dark by comparison.

A second constraint is based on the fact that shadows often have soft or fuzzy edges, while boundaries (like the checks) often have sharp edges. Your visual/perceptual system tends to ignore gradual changes in light level, so it can determine the color of the surfaces without being misled by the

shadows. In this case, the shadow has a fuzzy edge, and the cylinder appears to be casting a shadow, which is consistent with experience.

Ted Adelson created this remarkable brightness illusion to demonstrate that scene interpretation has an effect on perceived brightness. Compare with #34 and 135.

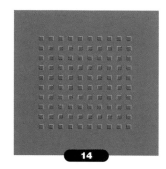

Pinna's Deforming Squares Illusion

Italian vision scientist Bangio Pinna discovered that a certain class of flat static patterns exhibits a strong illusory relative motion when moved across your visual field. The relative motion will always be perpendicular to the true motion. Transitory, looming and rotational movements of the head or the pattern can all elicit the effect. The effect is due to various orientation-selective cells found in the primary visual cortex. These cells are responsible for detecting both the orientation and the direction of movement of lines and curves. Ordinarily, this works fine, but if the line is moving in any direction other than at a right angle to its orientation, these cells become confused. When this happens, the two movements are added together, creating an illusion of motion. Compare this illustration with #58, 108, and 169.

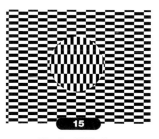

The Ouchi Illusion

This illusion, first published in 1977 by Japanese "op" artist Hajime Ouchi, has been extensively researched and discussed by vision scientists due to its surprising illusory quality. The effect relates to the "aperture problem," which is how your visual/perceptual system determines the direction of motion through an opening where the edges of the object "behind" the aperture may be obscured. Seen through an aperture, different physical motions may be indistinguishable. For

instance, a set of diagonal lines moving right to left are perceptually indistinguishable from a set of diagonal lines moving top to bottom.

The center of the Ouchi Illusion suggests an aperture, where the black and white stripes inside the circle are "behind" the rest of the figure. This suggests that this area is not attached to the rest of the surroundings; so when you move the figure, the center section may "separate." However, the depth interpretation is ambiguous, and you can also perceive the entire image as a single flat surface, in which case the entire image will move together as one solid unit. Yet, the separation is very strong, causing a "bias" in your visual system to interpret the circle as the edge of an aperture. Compare this illustration with #58 and 83.

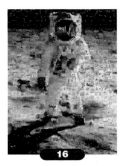

Buzz Aldrin on the Moon

A computer program created this composite portrait by analyzing the original target image (Buzz Aldrin on the Moon) in terms of several hundred values, including edges, luminance and color. The computer searched through several thousand stored NASA images, which it had already evaluated in terms of the same variables. The computer then used a matching process that selected the best smaller image in terms of relative values for each region in the target picture. If the database of pictures is sufficiently large (in this case 10,000 different images were searched) then the computer has a decent chance of finding a good match for each region. However, an artist still has to step in after the computer has done its selection process to "tweak" the final result in those areas of the image that are most meaningful, such as the reflection in the helmet. This photomozaic was created by Alice Klarke. Compare with #260.

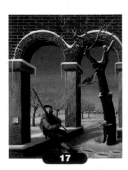

Melancholy Tunes on a Flemish Winter's Day

This scene suggests a structure that is physically impossible to construct in a straightforward

fashion. This is due to an inconsistency in the depth level of the top plane of the structure.

After the discovery of perspective, such perspective "mistakes" were considered the work of amateur artists, but recently many artists have deliberately incorporated impossible figures into their works to evoke a feeling of surprise or even humor. Belgian artist Jos De Mey did this artistic rendering, which is based on the impossible triangle. See #82, 189, 193 and 252 for other examples by artist Jos De May.

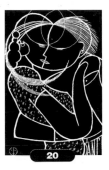

Crazy Nuts

The steel rod can pass through the two holes because the holes are not really perpendicular to each other. The shape of the two nuts is misleading. Although the two nuts appear to be convex, they are actually concave. The inside surface of the nuts is painted so it appears to be the outside surface. The lighting of this object is also important, as light normally comes from above. This object has been lit from below, which reverses your perception of convexity. It also helps that this picture was taken with a camera, which reduces stereo information to both eyes. American magician Jerry Andrus created the Crazy Nuts Illusion.

Can You Spot What Is Hiding Here?

It is a Dalmatian dog. In almost all scenes, an object (figure) will stand apart from its background (ground). Your visual system is quite adept at distinguishing figure from ground. Camouflage is a way for animals to break this distinction and hide from prey.

In this image, it is very hard for your visual/perceptual system to distinguish between figure and ground, and so it is very difficult for you to initially ascribe meaning to the image. However, once your visual/perceptual system starts "grouping" some of the dots together, and distinguishing them from the background, the image is dramatically reorganized.

After your visual/perceptual system ascribes meaning to a particular image, the meaningful interpretation dominates, demonstrating that prior

experience can help resolve an otherwise meaningless image. In this example, once you see the Dalmatian, you will never be able to view this image again without seeing the dog. In other words, this is an example of a non-reversible figure/ground illusion.

As the primary goal of your visual/perceptual system is to determine the meaning of images, sometimes it will organize meaningless images into meaningful ones, especially faces. This is why many people sometimes see the face of familiar people in otherwise meaningless patterns. Other reversible figure/ground illustrations include #66, 87, 128, 134, 176, 243 and 254.

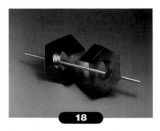

Soulmates

Either interpretation is possible. The lines that outline the face or the two profiles are ambiguous. Your visual/perceptual system will "group" together the local parts of the scene into one that is consistent with your experience. If one interpretation dominates, for example two people kissing in profile, those parts that relate to the eye (in profile) are "grouped" with the nose, mouth and other areas in profile. You do not simultaneously mix up two different interpretations. American artist Jerry Downs created this ambiguous kissing couple.

The Impossible Staircase

There is no bottom or top of the staircase, which is why it's impossible. The Impossible Staircase, first created by English geneticist Lionel Penrose in the mid-1950s, served as inspiration for M.C. Escher's classic print, *Ascending and Descending*. In the 1970s, Stanford psychologist Roger Shepard created an auditory illusion, equivalent of this staircase, where a series of tones appeared to continuously rise, but they were actually circular in pitch. Compare this illustration to #49, 145 and 273.

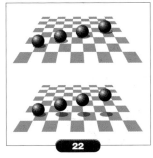

Kersten's Ball and Shadow Illusion

In the top illustration, the balls appear to be resting on the surface and receding into the distance. In the bottom illustration, the balls appear to be rising above the surface and not receding. The only difference between the two illustrations is the placement of the cast shadows, which provide a context for interpreting the three-dimensional position of the ball relative to the background. Without a shadow the position of the balls is ambiguous. Vision scientists Dan Kersten and David Knill first described this effect in 1996. Compare with #161.

Is Danger Lurking for this Couple?

The meaning of this image will flip-flop between a skull and a couple sitting at a table. This 1920s French postcard image titled L'Amour de Pierrot, featuring a skull or two lovers was a popular motif throughout the 20th century, and inspired such artists as the Spanish surrealist Salvador Dalí. The artist who created this image is unknown.

Mackay's Figure-Eight Illusion

This illusion was first described in 1958 by Donald MacKay, who noticed that light shining through horizontal Venetian blinds will induce the appearance of vertical motion on an adjacent

wall. It is not well understood why high-contrast lines produce motion effects perpendicular to the lines. There is currently an active controversy within the vision science community over the underlying mechanism that causes these effects. Compare with #271.

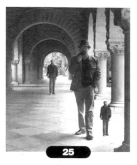

Hallway Illusion

The two little men are identical. When objects recede into the distance on a level surface, not only does their visual angle get smaller (i.e., their image size shrinks on the retina), but they also approach a visual horizon. For example, note how the bottom of the columns rise in the visual plane as they recede into the distance.

The little man in the background appears normal because not only is his visual angle smaller, he is also higher in the visual plane. This is consistent with your experience. The little man in the foreground appears tiny because, although he is the same size as the man in the background, he isn't closer to the horizon, which is what you would expect. This explanation lies at the heart of the Ames Room Illusion (see illusion #64). Compare with #52, 96 and 244.

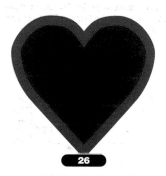

A Glowing Heart

This is known as a color aftereffect. Whenever you over stimulate the neurons in your retina, they will continue to fire for a while until they eventually settle down. Most people have experienced this effect after they have looked at a very bright light source, such as the sun or on-coming headlights, and then seen a negative glow for a brief period of time afterward. Positive afterimages also exist.

The color receptors in your eye actually work in pairs (red/green and blue/yellow). When the red receptors become fatigued through constant stimulation, the green receptors will dominate,

and vice versa. This is why you see complementary colors in a color aftereffect. When you perceive the aftereffect, it is the result of the neurons becoming less stimulated than its original source of stimulation, and this is why the image you see is fainter than the original stimulus. Compare with #91 and 130.

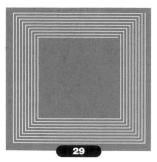

The Poggendorf Illusion

The white line intersects with the yellow line, even though you may not perceive it that way. The Poggendorf illusion is one of the most famous distortion illusions known. It was discovered over 140 years ago and there have been countless attempts to try to explain it. Recently, interactive versions have revealed new characteristics and variations of this illusion. There is, unfortunately, no theory to date that will adequately account for all the variations perceived.

The Poggendorf Illusion was actually derived from another famous illusion — the Zöllner illusion (see illusion #101). In 1860, J.C. Poggendorf, the editor of a journal of physics and chemistry, received a monograph from F. Zöllner, an astronomer, that described an illusion he accidentally noticed on a cloth pattern. Zöllner's illusion shows that parallel lines intersected by a pattern of short diagonal lines appear to diverge. Poggendorf noticed and described another effect of the apparent misalignment of the diagonal lines in Zöllner's figure. Thus, the Poggendorf Illusion was discovered. Compare with #40, 48 and 242.

The Mysterious Lips that Appeared on the Back of My Nurse

The great Spanish surrealist painter Salvador Dalí entitled this 1941 work, The Mysterious Lips that Appeared on the Back of my Nurse. According to Dalí, the nurse's back had a great symbolic meaning for him, and had its roots in his associations with his own childhood nurse.

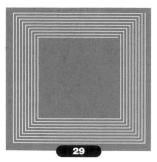

A Line of Squares

Although this illusion is not well understood, we do know that your visual system is extremely poor at curve-tracing; that is, your eye cannot determine the relative placement of fine lines without tracing them.

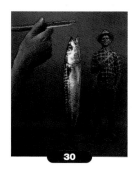

A Fish Tale in Context

When either the man or the fish are seen alone, there are no visual cues to determine their size and distance. This demonstrates that given a lack of other visual information, context may be used as a contributing factor to your perception of an object's size.

Morellet's Tirets Illusion

Your visual system tends to prefer organization and groups, so it searches for the "best" interpretation to settle in on. In most images there is a way to group and organize the image. In Tirets by French artist Francois Morellet, there is no "best" interpretation, so your visual system continues to search indefinitely.

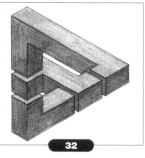

A Triangle with a Strange Paradox

A two-dimensional drawing must not be confused with a real object. There is nothing impossible about a flat drawing; it is only your three-dimensional interpretation of it that is puzzling. Nevertheless, your brain does not reject the figure because of this conceptual paradox. This is because your visual system is so highly constrained by how it interprets two-dimensional perspective drawings into three-dimensional mental representations. It is much more important for your visual/perceptual system to adhere to these constraints than to violate them because it has encountered something unusual, inconsistent or paradoxical. Swedish artist Oscar Reutersvard, (generally considered the father of impossible figures), has produced literally thousands of impossible figures since the mid-1930s. Other examples by him are #53, 75, 99, 145, 194 and 228.

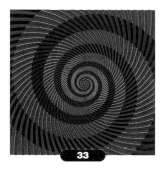

Color Assimilation

Examine the image carefully, and you will see blue stripes over the "red" spiral and yellow stripes over the "orange" spiral. This is enough to influence your perception of the spiral's color through color assimilation. Color assimilation is the opposite of color contrast. While the physiological phenomena for brightness and color contrast phenomena are well understood, the mechanism behind color assimilation is not yet known. Japanese vision scientist Akiyoshi Kitaoka created this version. Compare with #239.

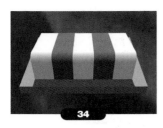

34

Brightness Illusion

There is a dramatic change in the perceived brightness when identical gray stripes are put in deep shadow or intense light. Duke University vision scientists Dale Purves and R.B. Lotto created this powerful contextual version of the standard simultaneous-contrast effect. Compare with #13 and 135.

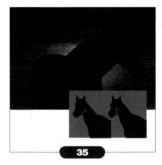

35

A Horse with a Strange Sense of Direction

Silhouettes lack certain depth cues, and depending upon the silhouette, they can suggest ambiguous depth information. In this case, there are not enough cues to resolve the depth information, and so the horse will appear to switch directions. Look at the insert. The two horse silhouettes are identical, but a single line is enough to resolve the ambiguity, and lock in a particular stable perception.

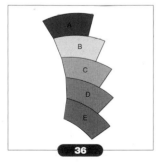

36

Wundt-Jastrow Illusion

The different arc segments appear to have widely differing curvatures and area, but they are all identical. According to assimilation theory, when two objects in a visual array are compared in size, an individual will perceive each object as the average size of the other objects involved. The assimilation theory states that since the longer arc of the second segment is placed next to the shorter arc of the first, your visual/perceptual system will "spread" or assimilate that difference over the whole length of the surface to the next

bounded area. German physicist Wilhelm Wundt discovered this illusion in the 19th century. It is sometimes referred to as the Wundt-Jastrow Area Illusion. Three-dimensional versions are also very powerful (see illusion # 102). Compare with # 57.

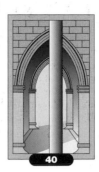

37

This Just Does Not Add Up

This addition problem will catch even bank tellers and mathematicians off guard. The adding by thousands tends to "prime" you into making a similar addition when you come to the last addition, which is 4,080 plus 20. The correct answer is 4,100, but many people incorrectly answer 5,000. Even those people who come up with the correct answer usually take a significant pause before answering.

38

Three Line Illusion

This particular viewpoint causes the image in each eye to fuse together, resulting in a third line that appears in stereo. Psychologist Christian Ladd Franklin, the first woman president of the American Psychological Association, discovered this illusion in the early part of the 20th century.

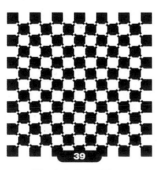

39

Kitaoka's Boli of Bugs

Examine the pattern. The white and green checks form a perfect undistorted checkerboard. At the junctions of four adjacent green and white squares, you will see a tilted set of four squares (two black and two white). The alternating position of these inner squares appears to mislead orientation-selective neurons, which code for edges. Japanese vision scientist Akiyoshi Kitaoka is responsible for this and many other novel twisted-cord illusions. Compare with #47 and 229.

40

Pillar Illusion

This is a variation of the Poggendorf Illusion (see illusion #27).

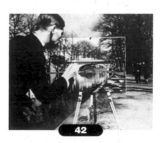

41

Hidden Star

This puzzle is difficult because there are too many possible ways to group the lines. However, once the star has been pointed out, you will never be able to see the image in its meaningless state again. The great American puzzle master Sam Lloyd created this figure/ground illusion. The star can be found in the bottom right region.

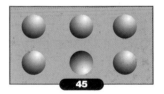

42

An Artist Paints a Fine Line Between Illusion and Reality

Drawing inspiration from René Magritte's 1936 work entitled *Human Condition I* (see illusion #100), French filmmaker Jacques Bruinis created this scene where the distinction between reality and illusion is blurred. This originally appeared in the 1939 film *Les Violons d'Ingres*.

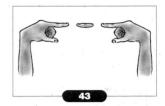

43

The Floating Finger Illusion

By focusing on the wall, the images from both eyes are automatically combined, causing the two fingers in the foreground to incorrectly overlap. The overlapping images produce a stereogram of the "floating" finger.

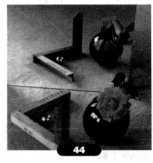

44

Reflections on an Impossible Triangle

The illusion of a physical impossible triangle works from only one special angle. Its true construction is revealed in the mirror. Even when presented with the correct construction of the triangle (as seen in the mirror), your brain will not reject its seemingly impossible construction (seen outside the mirror). This illustrates a split between your conception of something and your perception of it. Your conception is okay, but your perception continues to be fooled. Dutch author Bruno Ernst, an expert on impossible figures, created this model and demonstration.

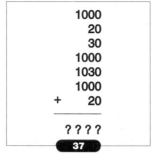

45

Shape From Shading Illusion

Shading can be an important visual cue for depth. Your visual system has a built-in "assumption" that there is only one light source illuminating the entire image and that light source comes from above. This demonstrates how shapes can be perceived as either convex or concave by shifting the direction of the assumed light source.

Flip-Flop Cube

Dutch artist Monica Buch created this ambiguous depth figure.

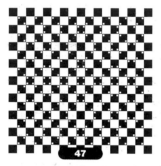

Kitaoka's Waves

All the lines are straight and parallel. The underlying checkerboard pattern is undistorted. The small white checks near the junctions of four large squares mislead the neurons that code for edges and contours. Note how the variation of the placement of the little white checks distorts your perception of a straight line in different ways. Japanese vision scientist Akiyoshi Kitaoka created this variation of the twisted-cord illusion.

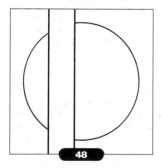

Circular Poggendorf Illusion

Although the two segments appear to be from different sized circles, they have identical curvatures. The left section also appears to be slightly smaller than the right. This is a variation of the classic Poggendorf Illusion (see illusion #29).

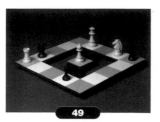

Level but Rising Chess Set

Outline and shading are powerful cues to determine depth. Here, both outline and shading are used in a way to mislead you. The impossible chess set is entirely flat. Dutch author and impossible-figure expert Bruno Ernst created this chess set based on a design by Swedish artist Oscar Reutersvärd.

God Does Not Play Dice with the Universe

This portrait of the famous physicist Albert Einstein was made entirely out of 999 unretouched dice. American artist Ken Knowlton based this portrait around an argument between Einstein and the Dutch physicist Neils Bohr about the probabilistic nature of the universe. In the course of the argument, Albert Einstein made the famous remark, "God does not play dice with the universe."

Pinna's Intertwining Circles Illusion

This is a new type of directional illusion recently discovered by Italian vision scientist Bangio Pinna. It is not yet understood what causes this effect, although the orientation polarity of the elements, the observational distance and the geometrical distance between the elements is very important. If you change the polarity between the two rings made up of squares, the intertwined effect will be perceived as a spiral.

Variation on the Hallway Illusion

The two red lines are identical in length. This image suggests the red line on the right is further away than the red line on the left. Yet, if the two red lines were really identical in size, then the right red line would be have a smaller visual angle and also be higher in the visual plane. Therefore, this illusion is a variation of the Hallway Illusion (#25).

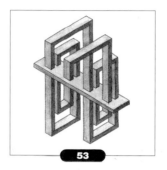

Reutersvärd's Impossible Meander

This is another example of an impossible figure. If you follow the lines, they will cross each other in a physically impossible way. Swedish artist Oscar Reutersvärd created this paradoxical meander.

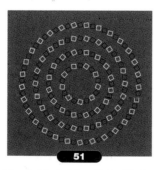

Head Count

The outlines of the bodies are ambiguous and so is the orientation of the five heads. Given the highly ambiguous state of this drawing, your visual system has a hard time locking down a stable grouping of the lines, and so the image will flip-flop between different interpretations.

This type of illusion has been popular since the 17th century, and examples (with either people or animals) can be found in Western, Asian and Indian art. This Japanese woodblock print dates from about 1850. The artist is not known. Compare with #97.

Kitaoka's Falls

This is a type of drift illusion. The effect has been known since the 1970s. English vision scientists Richard Gregory and Pricilla Heard were the first to describe that asymmetric luminance steps cause illusory movement. More recently, Japanese vision scientist Akiyoshi Kitaoka discovered that the order of the four colored regions of differing luminance, which have saw-toothed patterns, are critical to inducing the effect. The "direction" of the drift depends on the polarity of the luminance steps. The strength of the illusion also depends strongly on the background luminance. Compare with #263.

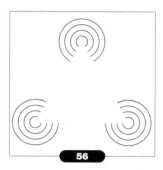

Kanizsa's Triangle

This effect is known as an illusory or subjective contour. The end points of the arcs are interpreted as though they are disappearing under a figure, but this interpretation depends critically upon the alignment of the adjacent endpoints. The illusory triangle also appears to be brighter than its background even though the luminance is identical. Your visual system tries to interpret the triangle as a separate "surface" that is distinct from its background. For the white triangle to be distinct as a "surface" from its white background, there must be a difference in perceived brightness. Since the actual luminance values are the same, your visual system adds the change in perceived brightness to the surface of the triangle to make it distinct.

Frederich Schumann first discussed illusory figures in 1900. In 1955 the Italian Gestalt psychologist Gaetano Kanizsa published a lengthy article on illusory figures, which explored powerful new examples such as the triangle shown here, otherwise known as Kanizsa's Figure. Compare with #67, 112, 234, 251.

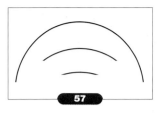

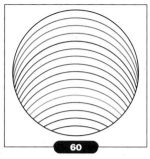

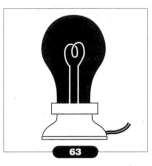

Tolansky's Curvature Illusion

Although the three arc segments appear to have widely differing curvatures, they are all identical! The bottom two segments are just shorter arc segments of the top segment. The first visual receptors only interpret the world in terms of short line segments. Curvature is perceived when the relative positions of these line segments are summed across a larger area of space. So when given a small segment of a curve, your visual system cannot easily detect its curvature. This illusion is a simplified version of the Wundt-Jastrow Area Illusion (see illusion #36).

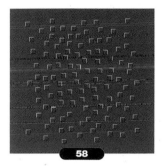

Pinna's Separating Squares Illusion

This illusion is based on the same principle as Pinna's Deforming Squares Illusion (see illusion #14). The relative motion of the elements is always perpendicular to the true motion.

Where's the Pie?

If you invert the image, your perception of how much pie there is will change.

Where's the Midpoint?

The green line is the midpoint.

Rising Line Illusion

In the absence of stereo information, perceived depth and three-dimensional layout are determined by pictorial cues. In this case, the pictorial depth cues are ambiguous and the lines can be interpreted both as lying flat and rising. The famous psychologist William James discovered this illusion in 1908.

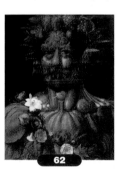

Fruit or Portrait?

Although you probably have no difficulty discerning the portrait in this collection of fruit, there are people who cannot discern the face. Usually this means that they have suffered a stroke to a specific area of the brain that determines facial recognition. This condition, known as visual agnosia, inhibits their ability to recognize faces and expressions. When shown a typical portrait by Arcimboldo, they only see the collection of fruit. No face is discernable. Other forms of visual agnosia inhibit the ability to recognize objects. In this case, the patients would only perceive the face and not the fruit. 16th century Italian artist Giuseppe Arcimboldo created this fanciful portrait of his beloved patron. See

illustration #118 for another example of a vegetable portrait by Giuseppe Arcimboldos.

Make the Lightbulb Glow!

When you focus on the lightbulb, light-sensitive photoreceptors (which convert light into electrical activity) in your retina respond to the incoming light. Other neurons that receive input from these photoreceptors also respond. As you continue to stare at the image your photoreceptors become desensitized. Your photopigment is "bleached" by this constant stimulation. The desensitization is strongest for cells viewing the brightest part of the figure, but weaker for cells viewing the darkest part of the figure. When you quickly look at a white sheet, the least depleted cells respond more strongly than their neighbors, producing the brightest part of the afterimage: the glowing bulb. This is a negative afterimage, in which bright areas of the figure turn dark and vice versa. Positive afterimages also exist. Most afterimages last only a few seconds to a minute, since in the absence of strong stimulation, most nerve cells quickly readjust. There are aftereffects, however, that can last for hours and even days.

Afterimages are constantly with us. When we view a bright flash of light, briefly look at the sun or are blinded by the headlights of an approaching car at night, we see both positive and negative afterimages. If you look at a far wall the afterimage should appear larger. Also, try tilting your head — the aftereffect tilts, but the room does not. This demonstrates that this effect is retinal in origin. There are colored afterimages too (see illusions #26, 91, 130).

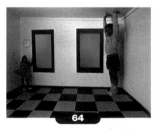

The Ames Room

When you look (through a peephole — to remove any cues from stereopsis) into an Ames Room, the room looks normal and cubic, but its true shape is cleverly distorted. The floor, ceiling, some walls and the far windows are actually trapezoids, not rectangles and squares. Although the floor appears level, it is actually inclined (the far left corner is at a much lower than the near right

corner). The walls appear perpendicular to the floor, although they are actually slanted outward.

Since the two visible corners of the room subtend the same visual angle to the eye through the peephole, the two corners appear to be the same size and distance away. The left corner, however, is actually twice as far away as the right corner. When the viewer sees the room from another angle the true shape of the room is revealed. The Ames Room consists of equal visual angles and equal lengths, rather than unequal angles and unequal lengths. In addition, the room's positioning of edges and corners relative to the horizon is crucial to seeing it as cubic. It has nothing to do with your past experience with cubic environments. All things being equal, and with no information to the contrary, your visual system will settle on a generic and simple interpretation (a cube) rather than its true shape (a trapezoid).

When you look through a peephole into an Ames Room, a person seen standing in the left corner will always appear substantially smaller than when seen standing in the right corner. The person looks too small because the image is smaller than what would be expected for the apparent distance of that part of the room. The illusion of normality is so convincing that as the person is seen walking around the room, he or she appears to be growing and shrinking rather than approaching and receding.

The generally accepted explanation is that the strange shape of the room somehow causes the size illusion. This is a rather peculiar explanation, since the average person does not normally have such effects when walking into oddly designed rooms.

Actually, the room contributes little (if only charm) to the illusion. Only an apparently horizontal path against a perspective background is necessary to produce the size illusion. The figure's relationship to the apparent horizon is what's important. The room (walls and ceiling) can be omitted.

While the additional apparent perspective lines are among several factors enhancing the illusion, their main effect is to hide correct perspective cues, not to create the illusion. In addition, the perspective cue of relative head height is not significant, compared to ground level.

In the Ames Room, when a person moves from the left corner to the right corner, that person appears to travel along an apparently horizontal and level surface. There is no observed rise in relation to the horizon as the figure recedes into the distance. This is important, because a figure receding on a level surface will approach a visual horizon. Furthermore, their visual angle will decrease. So, when the person in the physically near corner walks to the physically far corner, the visual angle of that figure will decrease, but they will not appear to be approaching a visual horizon. This means that the image on your retina is consistent with an image that is shrinking and not with one that is receding into the distance. The Ames Room illusion without the room can be observed in the Hallway Illusion (see illusion #25).

The Ames Room illusion was originally thought up by the 19th century German physicist Hermann von Helmholtz to demonstrate the ambiguity of

spatial information, but it was Adelbert Ames, Jr., who built and publicized the first physical example in 1941. Compare with #96 and 227.

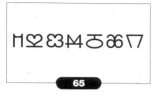

65
Camouflage

Cover the left half of every symbol to reveal the answer. You will preceive see it is the series of numbers from 1 to 7 and therefore, the next symbol would be 88. Symmetry can be a powerful and simple way to produce camouflage.

66
Time-Saving Suggestion

Figure and ground can be interchanged in this drawing. If you perceive a line of men, then the white areas constitute the ground. If you perceive a series of white arrows, the purple areas constitute the ground. Normally, figure and ground are not interchangeable in this way. Stanford psychologist Roger Shepard created this figure/ground drawing.

67
Illusory Sphere

Illusory contours can suggest a three-dimensional object. The bottom edges of the cones help define the illusory sphere. Peter Tse designed this illusory contour figure. Compare with #112.

68
The Woman with Closed Eyes

When you stare at the woman's eyes, the differences between the dark and light areas become exaggerated, and the dark areas start to resemble pupils.

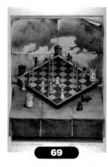

69
The Folded Chess Set

You can simultaneously see both the bottom and the top of the chessboard. Normally, you cannot see this sort of double-perspective, because it is impossible. Swiss artist Sandro Del-Prete based this drawing on the classic Thiery ambiguous figure. Compare with #139, 203, and 213.

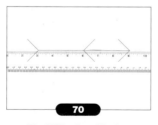

70
The Müller-Lyer Illusion

Both segments are equal in length. When the fins point inward, it causes an underestimation of size, and when they point outward, it causes an overestimation of size. This classic illusion is probably the most famous and reprinted of all illusions since its introduction in 1889. There have been many theories that try to explain it; however, there is still no satisfactory explanation to date to account for the effect.

The most popular theory, advanced by English vision scientist Richard Gregory, suggests that the illusory effect results from basic perceptual assumptions that you make when you perceive depth. He argued that the Müller-Lyer Illusion, on account of the perspective cues of the fin angles,

suggested a three-dimensional object. Gregory reasoned that the inside and outside corners of a building can serve as an example of what is happening in the Müller-Lyer illusion. For example, from the inside, when the corner is relatively far from the viewer, the edges are oriented like open arrows. From the outside, when the corner is relatively close to the viewer, the edges between the corner and the ceiling are oriented like closed arrows. He reasoned that lines that sweep out an equal retinal angle, but that are at different depths, must have a different physical size. Gregory argued that because the figure suggests a three-dimensional object, your visual system invokes inappropriate size-scaling mechanisms, which cause the equal line segments to appear different in extent.

Although Gregory's explanation is elegant and appealing, it does not fully explain the illusory effect, and has been challenged in recent years by variations of the figure, that have no perspective cues, where the illusion remained strong. It should not, however, be necessarily assumed that apparent spatial and constancy cues are not causal factors. More likely, there is no single factor or underlying mechanism that determines this illusion.

As a final note, it should be mentioned that care must be taken when assuming that an illusion is really illusory. A survey of illustrations of the Müller-Lyer figure in textbooks showed that in many cases lines of different lengths had actually been drawn, presumably to ensure that the illusion was convincing!

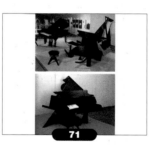

71
Fukuda's Underground Piano

Japanese artist Shigeo Fukuda has provided us with an extreme example of the ambiguity of spatial information. For example, a straight line projected on the retina can also come from a curved line in the real world that is presented at an angle where it appears straight. A continuous straight line can also come from two or more broken lines as long as they are aligned properly. In fact, any retinal image can arise from an infinite number of possibilities . Yet, your visual/perceptual system manages to arrive at the correct real world interpretation most of the time. When it does not, you get an illusion.

As long as the distorted object subtends all the same angles as the undistorted object, the two will project the same image on your retina. This trick has allowed for some clever constructions of impossible and otherwise strange objects. However, this visual trick only works from one special viewing angle. As soon as you move away from this special viewing spot, the illusion quickly breaks. Compare this with #44, 181, 257, 264, and 273.

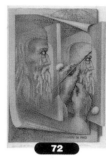

72
Homage to Leonardo Da Vinci

In this complex double-image by Swiss artist Sandro Del-Prete, you can perceive Leonardo da Vinci's ride on a mule in 1516 as well as a portrait of Leonardo da Vinci at work drawing his ride on a mule. If you look at the profile of Leonardo on the left, you will see that his face is made out of a smaller image of Leonardo riding on a mule. If you look at the portrait that he is drawing on the right, you will see that this image is repeated. It was on this journey through the Alps that da Vinci carried some valuable paintings, including the Mona Lisa, which he intended to give to the King of France.

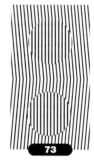

73
Blakemore's Tilt Orientation Illusion

The red lines are both vertical and parallel. It is not clear what causes this illusion, which is related to the Zöllner Illusion (see illusion #101). One theory is based on the inhibitory interactions among orientation-selective neurons. In other words, some cells respond more strongly to differences than to similarities in a visual scene. This can exaggerate the orientation of the lines. Neural inhibition is a powerful tool for building up features of scenes, but here inhibition is given a rather different role. This illusion was first described by English vision scientist Colin Blakemore in 1973 and is also related to the Tilt Aftereffect.

74
No Fault Earthquake Damage

The damage is only illusory. California muralist John Pugh painted the entire scene on a flat

surface. This form of realistic artwork is known as *trompe l'oeil*, which means "to fool the eye." See illustration #261 for another example by John Pugh.

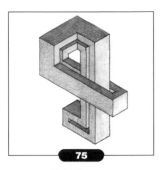

75

Tight Squeeze

There are two perspective paradoxes in this impossible figure. First, a larger piece is fitting within a smaller piece, and secondly, the block twists back on itself in an impossible way. Swedish artist Oscar Reutersvärd created this impossible figure.

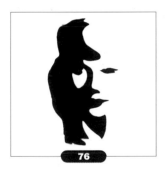

76

Sara Nader

There are two interpretations for this figure, depending upon how figure and ground are perceived. In this case, the two alternative figures are not strictly complementary. While the black area constitutes the figure in one interpretation, the white and black areas together constitute the figure in the other interpretation (with the black areas then corresponding to dark or shadowed portions of the figure). Stanford psychologist Roger Shepard created this ambiguous figure/ground illusion.

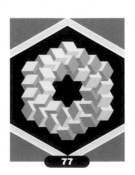

77

An Impossible Configuration of Cubes

This is another drawing that suggests an impossible physical configuration. Hungarian artist Thomas Farkas created this impossible figure.

78

Hidden Figure

It is the head of a cow looking at you straight on. The figure of the cow has been deliberately obscured with that of the background. If you have trouble perceiving the cow, try viewing the image from a distance.

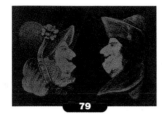

79

Courtship and Matrimony

No one knows when inverted images were first created, but they started to become popular on coins during the Reformation. These early types of topsy-turvy images typically contained hidden political and theological statements. In the 19th century, they took on a more amusing motif and were very popular in advertisements and on puzzle cards.

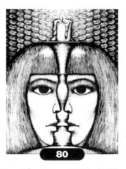

80

Egyptian-Eyezed Tête-à-tête

This is a clever adaption of the famous Dutch Gestalt psychologist Edgar Rubin's figure/ground illusion (see illusion #104) of two profiles on either side of a vase. The profiles are facing each other on either side of the candlestick, and the eyes become distorted like the faces seen in ancient Egyptian drawings. You can also perceive a single face behind the candlestick. Stanford psychologist Roger Shepard created this ambiguous figure/ground illusion.

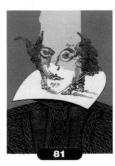

81

Portrait of Shakespeare

The use of the two theatrical musicians to create Shakespeare's face say much about Shakespeare as a creature of the theater. Hungarian artist Istvan Orosz created this wonderful ambiguous portrait.

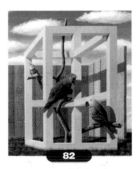

82

Strange Panopticon Construction for Parrots and Family

The straight beams go from the back to the front and back again. Belgian artist Jos De Mey created this impossible birdcage.

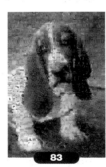

83

Basset Hound

American digital artist Alice Klarke corrected the computer-generated image by emphasizing the facial features of the dog, especially the eyes.

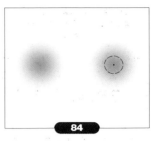

84

Filling-in Illusion

Your visual/perceptual system only responds to the presence of change in a visual scene. The filling-in illusion occurs because the eye constantly makes tiny eye movements. These movements help to keep the visual scene changing and thus visible. In the left figure, your eye movements change the position of the center dot, but that dot by itself is too small to affect most of the smudge. In the right figure, the eye movements cause the dotted line to move and its size allows most of the smudge to be refreshed. Compare with #167.

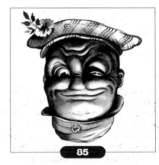

85

Aging Illusion

In 1948, the English muralist Rex Whistler brought topsy-turvy portraits to new heights in a book appropriately titled *OHO*. The book had no front or back, or rather two of each. This is one of the portraits from that book. See #276 and 296 for more fun topsy turvy illustrations by Rex Whistler.

86

My Wife and Mother-in-Law

Both interpretations are possible. This classic illusion of perceptual ambiguity demonstrates how your visual/perceptual system tends to group features into a single meaningful interpretation. If one part of the image is identified as an eye, then other areas corresponding to the nose and the rest of the face will be grouped accordingly. If the area that corresponds to an eye in one

interpretation is identified in another interpretation as an ear, then the different segments that make up a face in that configuration will also be grouped accordingly. Your visual/perceptual system does not simultaneously mix up the two different interpretations. The American psychologist Edwin Boring made this illusion popular, and it is sometimes know as the Boring Figure. He adapted the figure from a popular 19th century puzzle trading card. No one knows who made the original version but it first appeared in Germany around 1880.

Shade of Napoleon

Napoleon is hiding in between the trees. The outline of the tree's inner trunks form the standing figure of Napoleon. Normally, a figure stands apart from its background. In this case, the contours that determine the figure and ground are ambiguous. What is formerly the background (sky), becomes the object (Napoleon). Variations of this illusion were popular on postcards shortly after Napoleon's death in 1821.

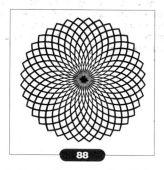

An Illusion Causing Another Illusion

At the intersection you will see faint ghostly dots (Hermann Grid Illusion, see illusion #93). These dots give rise to an impression of a series of concentric circles. English vision scientist Nicholas Wade created this double illusion.

Hole in Your Hand

Your visual system fuses the images from both eyes, resulting in the "hole" in your hand.

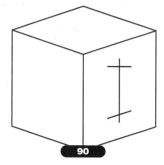

Perspective Box Illusion

The perspective cues of the box provide a context for the orientation of the line segments of the central figure. Remove the box and your visual system must use another context.

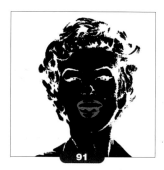

Marilyn's Red Lips

This illusion is known as a color aftereffect. When you stare at any color, you will briefly get its complementary color as an aftereffect. Another example can be seen in illusion #17.

Triangle Extent Illusion

The green line appears to be longer than the red line, but they are both identical in length.

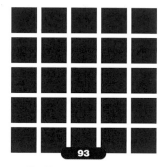

The Hermann Grid Illusion

The standard explanation of the Hermann Grid Illusion relates to the way adjacent neurons in the retina interact by exciting and inhibiting each other. Until very recently, the underlying neuronal mechanisms that gave rise to this illusion were thought to have been well understood. However, new versions of this illusion have shown that this explanation may not be valid, and that higher level cortical processes may also be a contributing factor.

It is known that eye movements are not required to elicit the illusion, but with fixation and subsequent adaptation, the illusion quickly diminishes.

Ponzo Illusion

Both bars are identical in size, although the inner bar appears to be larger. This perspective illusion is greatly enhanced by the two center radiating lines. Mario Ponzo discovered this illusion in 1913.

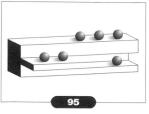

Impossible Shelf

Try covering the left half of the figure. The right side appears perfectly possible with two protruding ledges which hold four balls. If you cover the right side of the figure, it will also appear perfectly possible, but now, instead of two protruding shelves, there is only one. If you uncover the entire image, and follow the protruding shelf on the left side of the figure, you will see that it "twists" in an impossible way. The upper surface of the ledge becomes the front surface of an indentation, and the front surface of the ledge transforms into the upper surface of the bottom ledge. Although locally the image is fine, when the image is viewed globally, it becomes paradoxical. You are so constrained on how you interpret two-dimensional perspective drawings into three-dimensional mental constructs, that you can't stop doing it, even when faced with something that is inconsistent, paradoxical or impossible.Compare with #264.

Terra Subterranea

The two figures are identical in size. This drawing suggests a scene in perspective. In the real world, when objects recede into the distance, not only does their visual angle get smaller, but they also approach a visual horizon (see also illusion #25). In this drawing, the background figure is higher in the visual plane, but its visual angle has not correspondingly decreased, which is what you would expect from two equally sized figures where one is in the distance. Therefore, your visual/perceptual system assumes that the background figure is larger than it really is. If you could somehow move the background figure to the same level as the foreground figure, the illusion would no longer work. Stanford psychologist Roger Shepard created this version of the Hallway Illusion.

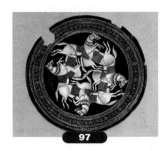

Persian Horses with too Many Bodies

There are four heads and ten bodies. This Persian design was made sometime in the 17th century.

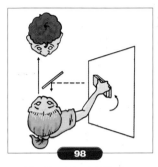

The Cheshire Cat Illusion

The image that you see is actually the combination of different images (one from each eye), which are fused in your brain; you notice your friend's face because it is more interesting than the white wall. When you move your hand, your visual system replaces portions of your friend's face with white, because the motion of your hand suddenly draws more attention to the white wall; however, since facial expression and gaze is also important, these areas remain while the rest of the face disappears. Sally Duensing of the Exploratorium, an excellent hands-on museum in San Francisco, discovered the Cheshire Cat Illusion.

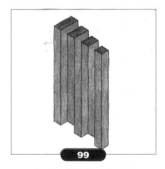

Impossible Paradoxes

There appear to be four separate bars at the top, but they do not appear to transform properly to the structure at the bottom. Swedish artist Oscar Reutersvärd created this impossible figure.

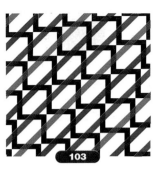

Human Condition I

In Human Condition I Flemish artist René Magritte was determined to depict the ambiguity that exists between a real object, one's mental image of it, and its painted representation. Compare this with illusion #42.

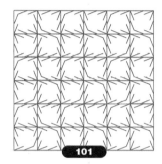

Zöllner Illusion

The horizontal lines appear to tilt alternatively, i.e., the acute angles formed by the horizontal lines and the short inducing lines appear to expand. The illusion is at maximum strength when the intersecting angle is 10°–30°. Japanese vision scientists Kitaoka and Ishirara showed evidence that the Zöllner Illusion is formed by three elemental illusions: two are acute-angle-expansion illusions and the other is an acute-angle-contraction illusion. One of the expansion illusions is of a local type while the rest are of global types. Compare this with the Poggendorf Illusion (see illusion #27). Japanese vision scientist Akiyoshi Kitaoka created this version of the Zöllner Illusion.

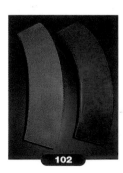

Wundt-Jastrow Blocks

This is a three-dimensional version of the Wundt-Jastrow Area Illusion (see illusion #36).

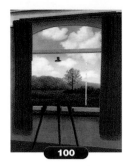

Kitaoka's Tapes

Closely examine the figure. The colored stripes pass "over" the staircase pattern of black stripes. Somehow the entering and exiting of these stripes confuses your visual/perceptual system's method for determining edges. When two colored stripes pass through such a pattern, you will notice that their apparent bend is mirror-symmetric, as the black staircase pattern is also mirror-symmetric. Since this is a repeating pattern, it gives rise to the impression of a series of continuous waves. Japanese vision scientist Akiyoshi Kitaoka created this new illusion.

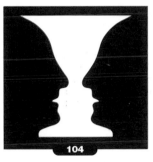

Rubin's Face/Vase Illusion

One can see both interpretations. The Gestalt psychologist Edgar Rubin made this classic figure/ground illusion famous. Rubin drew his inspiration for this illusion from a 19th century puzzle card.

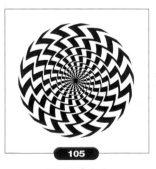

Wade's Spiral

English vision scientist and "op" artist Nicholas Wade gives us his version of Fraser's Spiral Illusion (see illustration #9). Although it looks like a spiral, it is really a series of concentric circles. Compare with #127.

Toy Soldier

This image of an American Civil War soldier is made entirely out of unretouched plastic war toys. American artist Victor Muniz created this portrait.

L'Egs-istential Quandary

The legs certainly have problems as they change from figure to ground. This is a variation on the Impossible Fork (see illusion #147) but to avoid the counting paradox, Roger Shepard introduced the more conspicuous line discontinuity at the far right. Both of these figures have discontinuous boundaries but the impossible elephant exhibits no unclosed lines.

Spa

This is another variation on the relative motion illusion #14. The perceived motion is perpendicular to its true motion. Japanese vision scientist Akiyoshi Kitaoka created this image based on an effect discovered by Italian vision scientist Baingio Pinna.

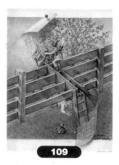

109

The Garden Fence

The construction of the fence is impossible. If you cover up the left side of the fence, you will see that the slats of the fence on the right side are aligned vertically. If you cover the right side of the fence, you will see that the slats on the left part of the fence are aligned horizontally. As in all impossible figures, locally the scene is quite consistent. It is when the image is seen as a whole that it becomes impossible. Swiss artist Sandro Del-Prete created this impossible scene, which has its basis in the impossible triangle.

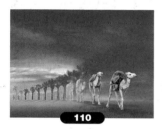

110

Desert Mirage

The areas, which consist of sky or background, transform into camels as you move from left to right. American artist Alice Klarke created this digital image inspired by a work of Canadian artist Robert Gonsalves.

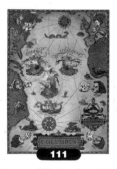

111

The Voyage of Christopher Columbus

Hungarian artist Istvan Orosz created this ambiguous portrait of Christopher Columbus.

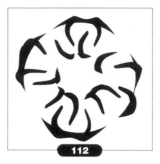

112

Illusory Torus

This is an example of an illusory contour that suggests a three-dimensional shape. Peter Tse created this figure.

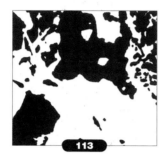

113

Hidden Figure

It is the face of a bearded man. He is looking right at you! Figure and ground have been deliberately obscured in this image. It helps to view this image from a distance.

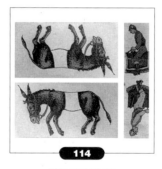

114

Ride that Mule!

Don't read this unless you have really tried hard to solve this puzzle. The great American puzzle inventor Sam Lloyd created this wonderful puzzle. The solution involves an illusion! The bodies of the mules are ambiguous. For a further hint, look at illusion #97.

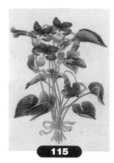

115

Corporal Violet

There is a profile in each group of flowers. This image appeared in 1815. Supporters of the exiled Emperor wore bouquets of violets as a secret sign of their allegiance, and would toast "Corporal Violet."

116

Gesture of a Dancer

On the left is the gesture of the hand of the dancer, who holds the image of the dancer on the right. In the palm of the left hand you can just perceive the dancer's face and chest. The left hand is transformed into the dancer on the right by slightly altering the middle fingers. Swiss artist Sandro Del-Prete created this double image.

117

Estimation Illusion

The red dot is located exactly halfway up the triangle, although it appears to be much higher. Given an absence of information, your visual/perceptual system is not very good at estimation. This is a variation of the upside-down T illusion.

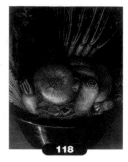

118

The Vegetable Gardner

This is the second of 16th century Italian artist Giuseppe Arcimboldo's portraits to incorporate topsy-turvy features. Twenty years earlier, Arcimbodo mada a similar topsy-turvy portrait of a cook. Topsy-turvy portraits were popular on coins of that period, which satirized religious and political leaders.

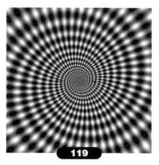

119

Warp

When you move toward or away from this image it appears to loom. Additionally, the little stars at the intersection do not really twinkle, but are fixed. The twinkling appears to increase as the image comes close or moves away, if you keep your eyes fixed on the center. It is not known what causes this scintillating effect. Japanese vision scientist Akiyoshi Kitaoka created this image.

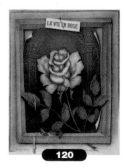

120

The Flowering of Love

The petals of the rose form the outline of a couple kissing or that of a single rose. The contours that define each interpretation are ambiguous, which results in the two separate meaningful interpretations. Swiss artist Sandro Del-Prete created this charming love scene.

121

Arcturus Brightness Illusion

The "brighter" diagonal areas have the same level of luminance as the diamonds they rest on. For example, if you were to measure any of the concentric strips with a photometer, you would find that the same amount of light is reflected from all points along any one strip, which of course, includes the part of the strip along the diagonal that appears brighter.

This illusion was created by Hungarian/French "op" artist Victor Vasarely, who was quite fond of putting simultaneous contrast effects into his artwork.

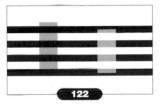

122

White's Illusion

The gray vertical bars have identical gray values. The gray segments that replace the black parts of the black bars appear much brighter than the gray segments that replace parts of the white bars. This is surprising, because of local simultaneous contrast, the gray patches that are surrounded by white should appear darker than the ones surrounded by black.

White's Illusion only occurs when the luminance of the gray patches lies between the range of minimum and maximum values of the inducing stripes (the long white and black stripes).

123

Thiery's Figure

Although the image on your retina is constant, your interpretation of the depth of this figure will change because of contradictory depth cues. It was discovered by experimental psychologist Armand Thiery.

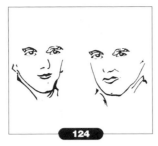

124

Perceived Gaze Illusion

There are at least two components to how we determine the direction of gaze. The first is the location of the eye in the eye socket and the second is the direction in which the head is positioned. We normally combine these two sources to determine the direction of gaze. In this case, we have an illusion, because mirroring the image on the right – except for the eyes, which remain unchanged (not reversed) – created the image on the left. This causes a dramatic change in the perceived direction of gaze. W.H. Wollaston first noticed this effect in 1824.

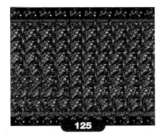

125

3D Grand Prix

All stereo pictures are designed so that they can be seen if the viewer uses what is called the divergence method. Your eyes must behave as if they are looking at something in the distance. When you normally view a book your eyes converge (focus) on the image on the book. In viewing a stereo image, you must relax your eyes so that you can focus "behind" the image (exactly as far as your eyes are from the book). You must look at the image long enough for your brain to resolve the stereo information.

In hidden image stereograms, you will see a pattern of "random image noise," which very cleverly masks the stereo differences of a hidden image. When the image is resolved, the image will clearly appear to have depth and the hidden object will be resolved. You will definitely know when you are successful, because there is quite a delightful "Aha!" experience, especially when seen for the first time. The effect is definitely worth the effort, so please keep trying. Gene Levine created this wonderful stereogram. Another hidden image random dot stereogram can be found at illustration #237.

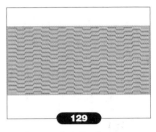

126

Ernst's Chess Set

The chessboard is entirely flat, but it uses deceptive outline, shading and coloring to give the illusion that it is not flat. Bruno Ernst constructed this chess set. See another example by Bruno Ernst (illusion #39).

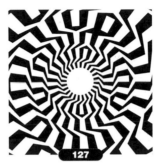

127

Wilcox's Twisted Circle Illusion

They are all perfect circles. James Wilcox created this variation of the twisted cord illusion when he was 12 years old. Compare with # 9 and 105.

128

St. George and the Dragon

To preceive both interpretations you must be able to perceptually switch figure and ground. The hair of the large profile defines the battle. Swiss artist Sandro Del-Prete created this ambiguous figure/ground illusion.

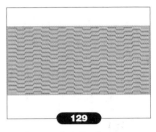

129

Heat Devil

It is not yet fully understood what gives rise to this effect, but eye movements certainly contribute to it. Japanese vision scientist Akiyoshi Kitaoka created this version of the perceptual drift illusion.

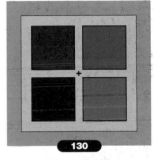

130

Color Aftereffect

This is a color aftereffect. For an explanation, see illusion #26.

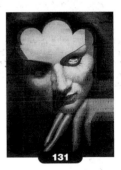

131

Marlena

The details of Hollywood film star Marlena Dietrich's fur coat, trademark hat and purse blend beautifully into her face. Mexican artist Octovio Ocampo created this ambiguous portrait. Other ambiguous portraits by this artist are #208 and 233.

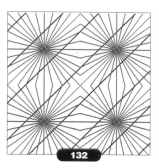

132

The Hering Illusion

Although the red lines appear to bend around the midpoint of the radiating lines, they are perfectly parallel. It is not fully understood why radiating lines appear to confuse your visual/perceptual system in this way. Edward Hering first described this illusion in 1861. In 1879, German psychologist Wilhelm Wundt was able to reverse the effect when he demonstrated that the angular lines do not need to cross the parallel lines in order to create the illusion.

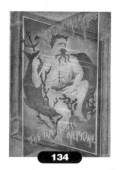

133

Glee Turns Glum

The heads change their orientation from bottom to top. The heads at the bottom differ in mood from the ones at the top. Stanford psychologist Roger Shepard created this topsy-turvy image.

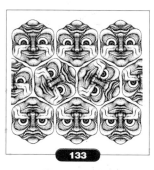

134

King of the Sea

To perceive both interpretations you must be able to perceptually switch figure and ground. The fish, dolphins and plants form the outline of Neptune. Swiss artist Sandro Del-Prete created this ambiguous figure/ground illusion.

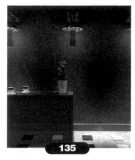

135

Lotto and Purves' Brightness Illusion

Duke University neuroscientists Dale Purves and R.B. Lotto created this version of Adelson's Checkered Shadow Illusion (see illusion #13).

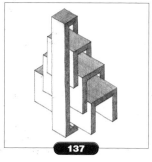

136

A Most Peculiar Transformation

It will transform into a horse if you rotate the image. This originally appeared on an American puzzle card in 1880.

137

One Size Fits All

Larger pieces seem to be fitting within progressively smaller ones. Swedish artist Oscar Reutersvärd created this perspective paradox.

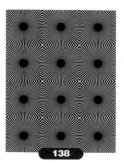

138

Visual Vibrations

It is not well understood why high contrast thin lines will produce motion effects perpendicular to the lines. This is similar to the Mackay effect (see illusion #24).

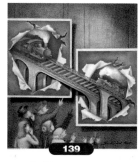

139

A Strange Incident on a Railway Bridge

The two trains won't collide in this double-perspective drawing by Swiss artist Sandro Del-Prete.

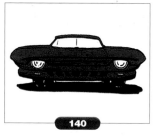

140

Two Cars for the Price of One

The headlights in the front-on view serve as the wheels in the side-on view.

141

Wallpaper Stereo Illusion

In a wallpaper stereo illusion, an image is repeated across the page. All stereo pictures are designed so that they can be seen if the view uses what is called the divergence method. Your eyes must behave as if they are looking at something in the distance. When you normally view a book your eyes converge (focus) on the image on the book. In viewing a stereo image, you must relax your eyes so that you can focus "behind" the image (exactly as far as the eyes are from the book). You must look at the image long enough for your brain to resolve the stereo information. American artist Gene Levine created this image.

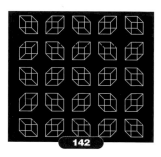

142

All Together Now

The necker cubes provide ambiguous depth cues, and so your brain cannot settle on a stable configuration. However, your visual system tends to "group" similar objects and motions together, and so when they flip-flop, they all flip-flop simultaneously.

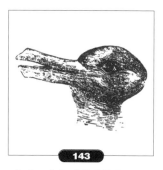

143

Jastrow's Duck/Rabbit Illusion

Both interpretations are possible, but you need to rotate the figure to see the other animal. Although the meaning of this image is ambiguous, it does not involve a figure/ground reversal. Different parts get grouped differently. What is an ear on the rabbit, becomes part of the duck's bill. Psychologist Joseph Jastrow created this classic illusion around 1900. Compare with #220.

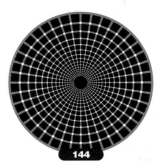

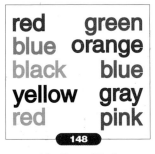

A Quirky Variation of the Scintillating Grid Illusion

This is a quirky variation of the Scintillating Grid Illusion (see illusion #12). This complex perceptual effect occurs only under specific circumstances. It may be related to other forms of "visual disappearance," and is termed "blanking." It is not fully understood what causes the disappearance, which is no doubt due to a different underlying mechanism than the scintillation effect. American vision scientists Michael Levine and Jason McAnany discovered this blanking effect in 2002 after experimenting with the classic Scintillating Grid Illusion.

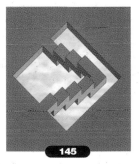

Level, but Rising

In this impossible scene by Swedish artist Oscar Reutersvärd, you will always remain at the same level when you climb this set of stairs.

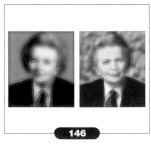

Spatial Frequency Facial Effect

Quite different perceptual processes mediate the perception of expression, age and sex as well as the recognition of a particular person's identity. Some researchers have suggested that feature and surface details as represented by high spatial frequencies may be useful for some tasks, such as identifying a face. Low spatial frequencies may relate to configuration information and may be useful for other tasks such as identifying gender.

When you squint, blink or look at this image from a distance you change spatial frequencies. The image of Margaret Thatcher is perceived when you use low spatial frequencies and that of Tony Blair when you use high spatial frequencies. The Thatcher-Blair Spatial Frequency Illusion was discovered and reported by English vision scientists Vicky Bruce and Andrew Young in 1998.

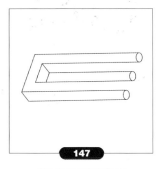

The Impossible Fork

It is easy to describe the multiple sources of confusion in the Impossible Fork. First of all, the fork lacks the intact borders characteristic of solid objects. The figure does not have a silhouette and cannot be colored in. The outline of the middle prong merges into the outline of the two outer prongs. In addition, the middle prong appears to drop to a level lower than the two outer prongs. The figure is particularly unusual because it gives the initial impression of being an intact solid, when in fact it does not have a complete contour. Finally, you will notice that three prongs miraculously turn into two prongs. The paradox is quite powerful, because within it are various sources of impossibility.

Cover the right half of the figure. The left half is perfectly possible. The foreground figure is perceived as built of flat faces constituting two rectangular prongs.

Now cover the left half and look only at the right half of the figure. You interpret this figure as curved surfaces constituting three separate cylindrical lines.

Locally this figure is fine, but globally it presents a paradox.

In this case, when the whole figure is observed, your visual system is confused because several contours are ambiguous. The same outline can be seen as belonging to either one of the two objects or interpretations.

For example, the impossible fork makes use of the fact that a pair of lines can represent a cylinder, while a rectangular bar requires three lines. The illusion is constructed by completing each pair of lines to make a cylinder at one end, and each triplet to make a square bar at the other end. Furthermore, when you join the two parts, surfaces that have one interpretation (part of the foreground figure), get a different interpretation (part of the background). This impossible fork, therefore, violates the basic distinction between the background and an element of the object.

There is also an edge ambiguity that makes the figure violate another basic distinction, that between flat and curved surfaces, where a flat

strip twists into a cylindrical surface. The two outer edges can be interpreted as either the straight edge of a rectangular surface, or as the "slide off" edge of a cylindrical surface. Furthermore, the figure gives contradictory cues for the depth estimation for the position of the middle prong.

A related observation is that the separation of the locally consistent ends affects the perception of the entire figure. When the impossible figure is redrawn so the ends are further apart, its impossibility is not perceived immediately. This is because the contradictory cues are too far apart. When the figure is medium in length, the figure is easily interpreted as a three-dimensional object, and its impossibility is quickly perceived. If the prongs are very short, the two different interpretations are both within the same local area. There is no consistent interpretation and the illusion breaks.

This analysis explains why your visual system could be fooled by the figure's ambiguities, but not how it is actually confused.

An extremely important feature, not mentioned in previous analyses of this illusion, is that the prongs are counted. Although this observation sounds trivial, in fact, the number of prongs is one of the few variables that is immediately apparent in comparisons between local regions. The counting paradox is more conspicuous than a transition from a cylindrical to rectangular shape or from figure to ground. The latter inconsistencies are only apparent after a closer inspection of the figure, but the different number of prongs in local areas is grasped almost instantly.

This is consistent with the observation that impossible forks that are composed of more than seven prongs are much more difficult to assess. A figure that contains a large number of prongs will still have all the various ambiguities and paradoxical figure/ground relationships, but the paradox is not readily apparent. It may be that working memory is an important factor in the successful resolution of these figures.

This may account for why this figure is easily recognizable as "wrong" among the general public. There is a qualitative difference in the speed of recognition of the figure's flaws as opposed to other illusions, as well as other types of impossible figures. Very young children see this paradox but are unable to see anything wrong with other types of figural paradoxes.

This suggests that "counting and comparing" is fundamental at the early stages of visual processing.

It is not known who created this figure. Its first publication was in 1964, and it has been reprinted many times since.

The Stroop Effect

There are six words and six colors to match. When the name and the ink color are different, most people slow down. When you try to say the color, you are also reading the word. The two different sources of information conflict, and it will slow down your response time. This effect can also be applied to misnamed objects as well. It is not so much an illusion as a perceptual confusion. The Dutch psychologist John Ridley Stroop discovered it in 1935.

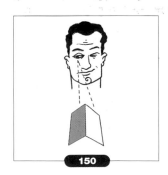

Natural Camouflage

It is an American bittern and its nest. The bittern even mimics the movements of the reeds in the background to avoid being spotted.

Mach Illusion

The folded card will be ambiguous in terms of depth, especially if you remove any additional stereo cues from both eyes (stereopsis). You can also try this by taking convex objects, making them inside out, but painting the outside to look like the inside. When you move from side to side, the object will appear to follow you. This is due to a reversal in motion parallax. Motion parallax is what you perceive when you are driving down a road and look out the side window. The objects that you see are all moving in a direction opposite

to your motion, but those that are close to you are moving at a much faster rate than those physically far in the distance. In these types of reversed perspective images, those parts that are physically far away are perceived as closer and those parts that are closer are perceived as far away. When you move past them, there is a reversal in the motion parallax, so instead of going in a direction that is opposite to your motion, they go in the same direction and appear to follow you. Compare with #175.

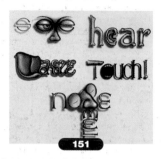

The Five Senses

About this play on the five senses, creator Roger Shepard wrote, "Here, I set myself the challenge of integrating into one picture, for each of the five senses (a) the verb appropriate to that sense (for example, see, for the sense of vision), (b) the noun for the organ of that sense (for example, eye), and (c) a graphic portrayal of that organ itself (for example, a picture of an eye) I gave myself license to depart from this constraint only for the fifth sense. For that, I incorporated the verb touch, but instead of a noun for the organ of touch, I included the expletive that may follow too sharp a touch: 'Ouch!' Also, in rendering the 'o' of 'Ouch!', I portrayed the organ for emitting that expletive. The organ of the sense of touch is represented by the sharply 'touched' finger – both in side view (as the top of the T) and in end view (as the dot of the exclamation point)."

Did you also find the hidden word "tongue" in the word "taste"?

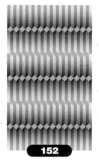

Kitaoka's Brightness Illusion

All the blocks have the same gray value. Japanese vision scientist Akiyoshi Kitaoka created this version of Logvinenko's brightness illusion.

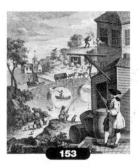

Mistakes of Perspective

One can find examples of optical illusions in art since Roman times, but these were mainly dismissed as mistakes of perspective errors that crept into works by careless artists. In this engraving by William Hogarth, published in 1754, he challenged the viewer to find all the perspective mistakes.

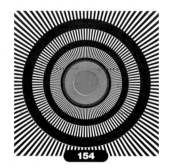

Leviant's Enigma

Fixation on the center induces in most, though not all people, a strong perception of motion occurring within the rings. The motion is in opposite directions in different rings and can change direction in any ring during one continuous viewing, which is not surprising, as the rings are symmetric and there would be no preferred direction. The streaming always moves perpendicular to the high contrast lines, which induce it. The effect takes place very early on in visual processing where the image is detected, but it is still unclear what underlying neuronal mechanisms are giving rise to this effect. French artist Isia Leviant created this image in 1984, after being influenced by the Mackay Effect (see illusion #24). Leviant titled it "Enigma," because scientists were mystified about it. Another example by Isia Leviant can be found at #253.

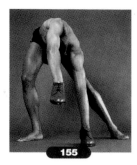

What is This?

It is a dancer whose hands are in the shoes and whose head is tucked behind one of his arms. Although all the parts of this image are easily identifiable, they are intentionally posed to present an overall scene that does not conform to your normal prior experience. Therefore, when your perceptual system is first presented with this scene, it has a hard time grouping the familiar parts into a coherent and meaningful interpretation. It thus appears very strange indeed. In this particular case, your perceptual system regroups the various parts so that the overall scene takes on a more meaningful interpretation. Once your perceptual system does this, it no longer looks so strange.

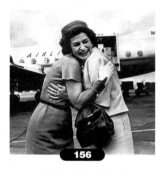

Being of One Head

The head is connected to the body on the right. Some people (primarily women) try to fix the correct placement of the head through fashion cues (matching the hat with the dress). However, the depth of the hat is a bit misleading, because it is really behind the head, and not on top of the foreground head.

The Café Escher Illusion

It is not completely understood what causes this illusion, but it is known that it takes place very early on in visual processing, when the brain is encoding edges and contours. The Café Escher Illusion is categorized among a class of illusions known as "twisted-cord" illusions, and is one of many wonderful variations created by Japanese artist and vision scientist Akiyoshi Kitaoka.

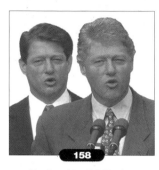

The Presidential Illusion

Look closely at this image and you will see that it is not former President Bill Clinton and Vice President Al Gore. Although Clinton is depicted properly in the foreground, the background figure has Clinton's face, but has Al Gore's hair and trademark black suit. This shows how important context can be in forming your perception of a scene, and how seemingly important details can be inadvertently missed. In this case, you were misled by context, not actual facial features. In addition, hairline and the width of the head are also important to facial recognition. If you cover just their respective hairlines, the match between the two faces becomes very obvious. This illusion works best with people who are quite familiar with the Clinton/Gore team. MIT vision scientist Pawha Sinha created the Presidential Illusion.

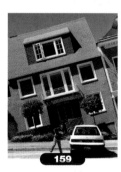

Tilted Houses

No, these houses have not collapsed! They are located on a very steep street in San Francisco. The photographer tilted the camera so that it is level with the street, but not with the true horizon, which is obscured. A horizon line is a very powerful cue for your perceptual system. We tend to align the horizontal and vertical with a reference frame. In this case, the frame is furnished by the rectangular shape of the picture, whose horizontal does not correspond to the true horizon line. Therefore, a misleading horizon line, which is not perpendicular to gravity, can produce all sorts of illusions. The woman augments the illusion by leaning in a way that appears to be perpendicular to the street. Ordinarily, she would be perpendicular to the true horizon. Compare with #198.

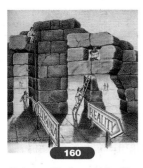

160

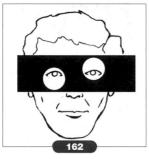

162

"non-generic" points of view. Moretti's blocks, because of this occlusion, transform in a very radical way — a straightforward vertical alignment transforming to a straightforward horizontal alignment. Another example of a transforming impossible sculpture by Guido Moretti is #217.

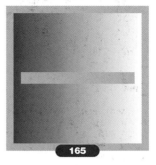

165

167

Between Illusion and Reality

The physical construction of this scene is impossible. Carefully examine the two passages by first covering the bottom half. You will notice that the top half of the passage extends outward. This is perfectly possible. If you then cover the top half of the passage, you will see that the bottom passage extends inward, which is physically incompatible with the protruding top section. The critical transition occurs at about the upper quarter of the panel with the faint people on the left. That quarter is opaque, but the lower portion appears open. This would almost never occur in natural scenes without a definite boundary between the two. When the image is seen as a whole, it violates the most basic distinction of figure/ground separation. Normal scenes depict figures (objects) as distinctly separate from their grounds (backgrounds). In this illustration, the figure merges into the ground. This demonstrates that the constraints of your visual/perceptual system are applied to local portions of the image without global error checking.

Swiss artist Sandro Del-Prete created this impossible scene, which takes place somewhere between illusion and reality.

Misaligned Eyes

The eyes are perfectly aligned. The circles are a frame of reference for each eye, and your tendency is to judge the alignment in terms of the frames of reference. This illusion only works with a simple two-dimensional representation of a face. A similar cutout will not work with a real face. There are far too many cues that will interfere with the effect. It is not understood why your brain perceives a misalignment with only a two-dimensional representation.

163

Hidden Car

Look closely at this image and you will see an antique car. American artist Rusty Rust created this image and #172 and 216.

Simultaneous Contrast Illusion

The horizontal gray bar is uniform throughout. The color or brightness of the right side of the bar is contrasted with the light background, making it look darker, while the reverse happens on the left side. The neural mechanisms of this effect are currently being studied and revised by vision scientists. Compare with White's illusion #122.

166

Filling-In Illusion

Your visual system only responds to the presence of change in a visual scene. This is because a changing stimulus is more important than a static one. Your eyes are constantly making tiny eye movements, which help to keep the visual scene changing and thus visible. The blue dot gradually fades into the green because there is no reference for the visual system to gauge the eye's movement, and the steady-state stimulus is gradually ignored.

Almost any stimulus that does not change will eventually be ignored, whether it is a tight shoe, an undersized ring or the beating of your own heart. Pain receptors, however, seem to be relatively free of adaptation, which may account for lingering aches and pains.

In addition, a critical factor in this illusion is the fact that human vision tends to spread color to the nearest luminance-defined borders. Since there is no strong luminance between the green and the blue, the green spreads out over the blue.

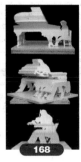

168

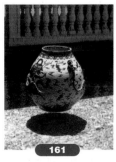

161

The Floating Vase Illusion

Shadows can be a very important cue for your visual system in determining relative height and depth. Normally, shadows are "attached" to objects that are resting on the ground and not "attached" to objects that are floating above the ground. In this scene, the shadow is not attached to the vase, and therefore the image suggests a floating vase. Specially controlled lighting produced this effect. The image was not digitally altered. Compare this with illusion #22.

164

Moretti's Impossibly Transforming Blocks

Moretti's impossible blocks, aside from their seemingly paradoxical structure, provide another sense of surprise to the viewer. They violate one's expectations about shape constancy, which is the tendency of your perceptual system to keep consistent the true shape of objects, even when they are seen at different orientations. Experience dictates your expectation on how an object should transform as you move around it. If you look at photo A, you will see a set of vertically aligned transparent blocks. The lines carefully occlude the structure seen in photo B. We normally don't encounter such "devious" structures in nature, which is why photos A and B are considered

There's an Angle to This!

In the top photo, although it is hard to believe, all the colored angles are 90° right angles. An image of an angle on the retina is quite ambiguous. We need to know its precise angle in depth. According to Dale Purves and R. Beau Lotto of Duke University, the orientation of the angle exerts a strong bias in the judgment of its extent, depending on the frequency of occurrence of particular angles at that orientation in our experience. Angles at the orientation of the red angle tend to be large and that of the green angle tend to be small, so we overestimate the red and underestimate the green.

In the bottom photo, although the angles all appear to be identical, they are in fact, quite dissimilar. So, it is quite possible to make physically different angles appear the same by presenting mutually inconsistent information. Although each of these objects appears to form a right angle, none of them projects in this way.

This illusion is greatly weakened for people who have extensive experience with perspective or in building carpentered works.

Encore

This sculpture consists of two silhouettes (the pianist and the violinist) at 90° angles to each other. In fact, you can create an endless variety of these types of silhouette sculptures by just carefully cutting a block from two different silhouettes at 90° angles to each other. There have also been examples made that incorporate three silhouettes, where the third silhouette is on the top surface. The noted Japanese artist Shigeo Fukuda created this wonderful example in 1976, which he called *Encore*.

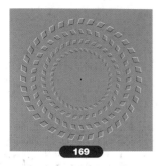

169

Pinna's Revolving Circles Illusion.

This pattern of lozenges triggers an illusory motion that is perpendicular to its true motion (as seen in illusions # 14, 58 and 108). In this particular configuration, your visual/perceptual system tends to "group" all the different components together, which causes the entire ring to rotate. The rings alternate in polarity which gives rise to the counter-rotation. Italian vision scientist Baingio Pinna created this effect in 1999.

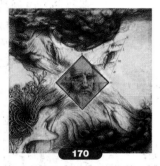

170

Anamorphosis of da Vinci

The picture is divided up into four equal quadrants. There is a pyramid-shaped mirror (as seen from above) at the junction of the four quadrants. Each quadrant has a portion (one-fourth) of the total image. The different portions appear meaningless, because not only is each portion of the image distorted, but they also have different axes of rotation. A mirror placed at the center will resolve the image, because each quadrant reflects its own portion onto one of the sides of the mirrored pyramid, which now becomes undistorted. When viewed from above, you can see the entire image properly. Dutch artist Hans Hamngren created this anamorphic portrait as an homage to Leonardo da Vinci, who created the first anamorphic image, circa. 1500. Anamorphic images using reflective cylinders can also be used (see illusion #184).

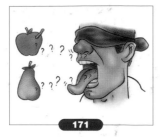

171

Taste Illusion

Your sense of smell is very important in discerning the full flavor of foods. This is because there are receptors in your nose that respond to all sorts of molecules that your taste buds do not. This is why serving gourmet food to someone who has a bad cold is a waste of time.

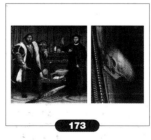

172

A Flock of Birds Clowning Around

In an homage to the 16th century Italian portrait painter Giuseppe Arcimboldo (see illusion #62), American artist Rusty Rust created this portrait of a clown out of various birds.

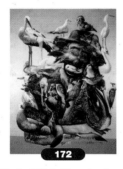

173

Holbein's Ambassadors

Leonardo da Vinci created the first known example of an anamorphic drawing (of an eye), in 1485. During the Renaissance, artists who experimented with the geometry of perspective perfected techniques of distorting images so they could be seen without the illusion from certain angles.

In the sixteenth through nineteenth centuries, the art of anamorphosis became extremely popular and supplied an ideal means of camouflaging dangerous political statements, heretical ideas, and even erotic pictures. It reached a high point in Henry VIII's court painter Hans Holbein's "The Ambassadors," a portrait of the two French ambassadors Jean de Dintevill and George de Selve. A strange shape is seen in the bottom portion of the painting, which would transform itself into a skull when viewed from an oblique

angle relative to the right side of the picture plane. The painting was originally hung on a staircase in Jean de Dinteville's chateau, so that the skull appeared when viewed from below left or from going down stairs. Although numerous explanations have been offered about the symbolic presence of the skull, including that it is a play on the artist's name – Holbein, which means "hollow bone" in German, the reason for its inclusion in the picture is still unclear. Compare with #195, 250, 273 and 277.

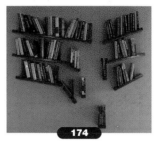

174

Falling Bookcase

Even a static construction can imply movement, as seen in this bookcase, built by the author.

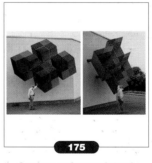

175

Concave or Convex Cubes?

This is a shape-from-shading illusion. Depending upon the lighting, when viewed monocularly or from a distance (to remove any cues from stereopsis), the cubes can be perceived as convex, when its true shape is actually concave. The insides of the cube have been painted to appear like the outside of the cubes. When the cubes are perceived as convex, and one moves past them, the cubes will appear to follow the viewer. This is due to a reversal of motion parallax. Compare this with illusion #150.

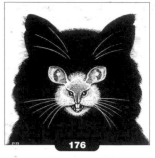

176

A Mouse Cleverly Hiding from a Cat

English artist Peter Brookes created this charming ambiguous figure/ground illusion.

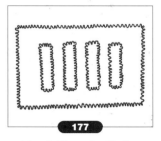

177

Pinna's Watercolor Illusion

The large regions within the bordered areas have no color. The watercolor effect, recently discovered by Italian vision scientist Baingio Pinna, is elicited when a purple contour is accompanied by an orange inner edge. Human vision tends to spread color to the nearest luminance-defined borders. Under these conditions the entire enclosed area will appear to be uniformly colored in the hue of the edge. The colored flanking line accompanying the darker border assimilates its color onto the enclosed white area over distances of up to 45°. The color spreading is stronger on a white background than on gray or black backgrounds. The illusion is broken when a narrow white zone or gap is inserted in between the two inducing lines. It is not necessary, however, for the colored lines to be continuous. Chains of colored dots will also create the color spreading effect. See also the neon-color-spreading illusion #234.

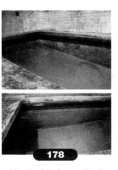

178

Magical Chinese Pool

The paradox of the perceived depth of the Magical Chinese Pool is a consequence of the refraction of light as it leaves the water in the pool, which makes the pool's flat bottom appear

curved. The base of the pool is light-colored, so it reflects more light than the upper wall surface reflection, and hence we see the brighter image — the principle of the one-way mirror.

The reason that the cement lines in the pool's wall are straight is because these tiles are not under the water, but are actually the reflection of the wall above the pool, above the water's surface. These cues also make the pool appear deeper on either end. The pool walls are dark; probably the same color as the wall above, but they are obscured by the reflection of the upper wall. Hence you see the reflected upper wall with straight cement lines, as these lines are not influenced by refraction.

Pinna's Scintillating Luster Illusion

This illusion is a modification of the Ehrenstein Brightness Illusion and the Scintillating Grid Illusion (see illusion #12). Vision scientists Baingio Pinna and Lothar Spillman discovered this effect in 2003.

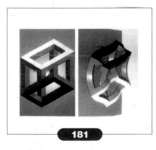

Twisted Thoughts on an Impossible Cube

What appear to be straight lines are really curved lines. Like many impossible objects, they work from only one specific viewing angle. Belgian artist Matheau Haemaker's constructed this cube so that the curved lines would appear straight when seen from a specific viewing angle. Compare with #224.

Lunch With Helmet On

This shadow sculpture by Japanese artist Shigeo Fukuda is far more challenging to construct than it seems because it is very difficult to get light to pass evenly through such a structure.

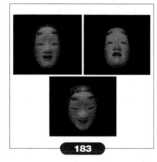

Magical Mask of Noh

It is not three separate masks, but only one mask that has been tilted. The Japanese Noh mask trick dates back to the Kamakura era (1192-1333). The rigid mask was thought to be possessed, because of its "magical" ability to change facial expression. The shape of the mask emphasizes certain features, particularly the depth of the contours of the mouth. Slight changes in viewpoint will change the relative position of the corners of the mouth to the lips. Our visual system is particularly sensitive to tiny changes in facial features, and thus interprets the mask as having different emotional expressions. The illusion is similar to a bar trick in England, known as the "bank note illusion," which is done on folded English currency. The note is folded along either side of the person's expression, and when tilted, the face changes expression.

The Magically Appearing Portrait of Jules Verne on the Mysterious Island

Artists have used anamorphic images since the time of Leonardo da Vinci. However, it was Hungarian artist Istvan Orosz who took this art form to a whole new level. Formerly, artists would make a straightforward distortion of an image, which would be revealed on an appropriately placed reflective cylinder. The image by itself would just look distorted. Orosz managed to obscure the image in an overall scene, which could stand on its own without the cylinder.

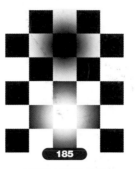

Brightness Illusion

The black and white checks at the center of the "clouds" are identical in brightness to the other unaltered black or white checks. The blur of the edges appears brighter than the same area with a sharp edge, and that causes your visual system to interpret the whole surface. This is a variation on the Kaniza's Blur Brightness Illusion (see illusion #219).

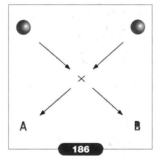

Cross-Modal Illusion

Your perceptual system has evolved a wonderful "bag of tricks" to resolve the various ambiguities inherent in retinal images. Given an ambiguous stimulus, your visual system will lock onto any reasonable cue that will resolve that ambiguity. In this example, given an ambiguous visual stimulus, a sound can be utilized by your visual system to resolve the ambiguity. However, the sound needs to be made at the point of "impact." If the sound comes too early or late, it will not dramatically change your perception. Caltech vision scientist Elizabeth Ho discovered this interesting cross-modal illusion.

Angel Glory

The Angel Glory, also known as the Specter of the Brocken, is sometimes seen on mountaintops when you are breaking through the mist with clouds below. The apparition moves as you move and is clearly a magnified projection of yourself. A halo also appears around its head.

Decent into Chaos

In the latter part of the 16th century, a church was planned in Rome, which was to have an enormous dome and tower, but the neighboring Dominican monks complained that the resulting structure would cut their library off from light. Commissioning the Italian artist Andrea Pozzo to create a painted dome and an adjacent second story on a flat surface solved the problem. Nevertheless, this clever solution was not without its problems. If you stand away from the correct viewpoint (and there were only two "correct" spots in the very large church), the illusion crumbles. Although many people at the time were amazed by the illusion, Pozzo was severely reprimanded by other architects who criticized the painted architecture's "physical construction." In his defense, Pozzo replied that a friend of his would bear "all damages and costs" should the structure ever fall down!

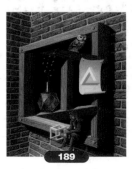

Still Life in an Impossible Window

The man holding the cube is in homage to the man holding an impossible cube in M.C. Escher's famous print *Belvedere*. An impossible triangle is posted on the windowsill. Belgian artist Jos De Mey created this lovely setting.

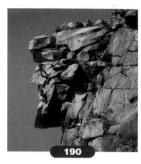

Climbing the Face of the Mountain

This rock face is known as "The Old Man on the Mountain," and was a famous tourist attraction located in New Hampshire before it collapsed in 2003.

The Impossible Crazy Crate of Jerry Andrus Revealed

Here you can see the Impossible Crazy Crate of illusion #180 from another angle, revealing its true structure. The illusion only works from one very specific viewing angle

An Illusion for the Birds

On an island off the coast of Maine, a puffin, left, stands among three decoy puffins placed there by the National Audubon Society, a conservation group. Because of over hunting, puffins vanished in the 1800s from their island homes. Now people are trying to lure them back, and it appears that the decoys are working. So, birds can be fooled too!

Strange Aqueduct

The top of the aqueduct is perpendicular to the bottom of the aqueduct, creating a structure that is physically impossible. Belgian artist Jos De Mey created this scene of two people carrying a necker cube the long way around. Compare with #257.

Impossible Window

The depth relationships are not possible. Compare this drawing with illusion #145.

Stretched Heads

An "anamorphosis" (from the Greek for "to transform") refers to a deliberately distorted image, which when viewed head on, appears either unrecognizable or strangely distorted. It is only when the image is viewed from a certain viewing angle that it suddenly assumes a normal appearance. This bizarre use of perspective was first described in the notebooks of Leonardo da Vinci, although the term "anamorphosis" was not coined until the 17th century, and was a popular trick form of art used to hide political statements or eroticism. English artist E. Purcell created this anamorphic print of stretched heads in 1822.

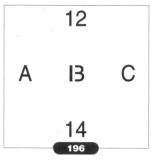

What's in Red?

What you perceive depends upon the context. A scene's context can "prime" you into a specific perception if the image is ambiguous. If you are reading the image from left to right, you perceive it as a "B," because the surrounding letters A and C provide a context. On the other hand, if you read this from top to bottom, the surrounding numbers 12 and 14 provide a different context, and so you view it as the number 13. Roger Shepard created this ambiguous context illusion.

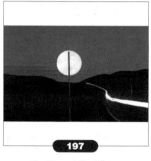

No Sign of the Moon

The round disk is not the moon, but the back of a railway sign. Context, not actual features, will mislead most people. Jerry Downs created this contextual illusion.

Off the Wall

According to the tour guides at these attractions, all the effects seen are due to forces "outside the scope of modern science." Instead, they explain, the anti-gravitational forces are due to (depending upon the tourist attraction you visit) UFOs, paranormal activity, magnetic anomalies emanating from the Bermuda Triangle, and so forth.

During my tour of the "Mystery Spot" in Santa Cruz, California, the guide there offered no real scientific explanations, proclaiming that "scientists were completely baffled by what they saw." Perhaps they felt that if the mystery were explained, they would have to call it "Spot," and that wouldn't attract as many people.

Nevertheless, these tourist attractions contain some of the strongest visual illusions known. Familiarity with how they are constructed will not break the illusion. A visit to an anti-gravity house is well worth the effort. When you enter the house, you will notice that it has a strange tilt. All references to the true horizontal are removed from your sight. This is always true whether you are just outside the house or inside it. For example, there is always a wooden fence around the house to remove any significant comparisons to the true horizontal.

The anti-gravity house is actually built at an angle of 25° off the true horizontal. This will explain every effect seen. Once in the area of an anti-gravity house you are always comparing the effects to what you are used to – normally level floors and walls that are perpendicular to the ground.

People in such rooms are perpendicular to the true horizontal, but they have no visual access to it. They just have access to a "new" horizontal, which is parallel with the tilted floor. Since people inside the room have no access to the true horizontal, and are judging their surroundings by a misleading horizontal that is created by the room, this causes an internal change of reference about orientation.

So, how do balls and water roll and flow "uphill"? The board or trough is at a very slight downhill incline from the true horizontal (about 5° to 7°). The house is tilted at an angle of 25°. Someone inside the house perceives the upward incline of the ramp to be 20° (in comparison to the floor), which is a pretty dramatic incline!

Many of these tourist attractions claim to be the original site where this effect was first discovered. A little research on their chronology has revealed the following timeline. The House of Mystery in the Oregon Vortex, Gold Hill, Oregon, was the first one built. It was constructed during the 1930s, as an attraction during the Great Depression. The attraction proved popular enough to produce imitators, and other anti-gravity houses started appearing, each identical in construction, appearance and presentation of effects. This, of course, started lawsuits between the various owners. Compare with #159 and 212.

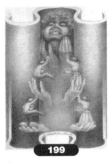

199

Festival of Bacchus

This image contains a remarkable transformation that moves from the bottom of the illustration to the top. At the bottom you can see two small figures. On the left is a man holding a wine glass, and on the right a woman is carrying a tray with wine glasses. There is a festive atmosphere as Bacchus makes his appearance. In his hands he holds the two elated figures. He slowly brings them together so they can toast each other's health. The transformation of the festival is complete. If you examine the inebriated face of Bacchus, you will see that it contains the two celebrants. Swiss artist Sandro Del-Prete created this scene.

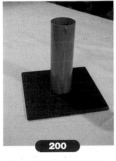

200

Foreshortening Illusion

Most people estimate that the circumference around the tube's rim is less than the vertical length of the tube. If you measured the rim with a string, it would extend from the top of the tube all the way down to the tabletop, which is consistent with elementary geometry. Try this experiment at home. It works best with the cardboard core of a paper towel or toilet paper roll. Which is greater: the circumference of this cylinder or its height when stood on its end? Cut the toilet paper roll perpendicularly and you'll find the circumference is the longer edge of the resulting rectangle. In both cases, the illusion is due in part because the lip of the rim is foreshortened while the length of the tube is not.

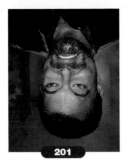

201

Inverted Head Illusion

A face that has its eyes and mouth inverted appears grotesque when it is upright, but not when it is inverted.

We have special areas of our brain devoted to processing faces, including their identity, emotion, gender and direction of eye gaze. "Configural" processing is important for face recognition, rather than recognition being based solely on the details of a face's constituent features. Because our experience is almost exclusively with upright faces, these brain areas have become specialized for processing only upright faces. In particular, we are inefficient at interpreting the emotions of inverted faces. Because the face is initially upside down (only the mouth and the eyes are inverted), this facial area is inactive. When you turn the face right-side up, you see the extreme nature of the expression.

It has been demonstrated that some species of monkeys, which hang from trees and routinely see upside down faces, do not have this facial inversion effect.

This illusion was discovered by English vision scientist Peter Thompson, and was first used on an image of former English Prime Minister Margaret Thatcher, which is why it was formerly known as the Margaret Thatcher illusion.

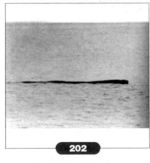

202

Loch Ness Monster

Illusions can often be formed by context. This floating log would never be mistaken for anything but a floating log, except to waiting and eager tourists on Loch Ness. A tourist photographed this log thinking he had captured the elusive and famous monster on film.

203

The Impossible Terrace

Graphic artist David MacDonald adapted Del-Prete's Folded Chess Set (see illusion #69) into an impossible balcony. Compare the two images. Note that MacDonald had difficulty resolving the two different perspectives created by adding the balcony balusters. He had to literally chop off the right and left ends of the image to make it work. Del-Prete's image was more successful in this regard.

204

Bottom's Up

The hole appears to have a double-perspective, which makes it impossible. The figures add to the illusion. Japanese artist Shigeo Fukuda created this image.

205

"Eye" am a Mouth

The eyes become the mouths in this charming ambiguous drawing by American artist Dick Termes.

206

A Policeman's Surprise

English muralist Rex Whistler created this topsy-turvy portrait as part of a series of such images in his appropriately titled book *OHO*.

207

Kanai Grid

The effect cannot be solely attributed to the lack of visual acuity in the periphery, because for the first several seconds, the irregularity can be clearly sensed, although we cannot see the details of the individual crosses. Rather, this illusion seems to imply an involvement of rapid neural plasticity in early visual systems, adjusting themselves to conform to global regularity. Dutch vision scientist Ryota Kanai discovered this illusion in 2005.

208

Celestial Angels

The large head and hand of the angel is comprised of smaller angels in this ambiguous painting by Mexican artist Octovio Ocampo.

Square of Three

The three blue squares in the center appear to be tilted with respect to one another when placed against the background of Reginald Neal's painting *Square of Three*. This is an example of the Zöllner Illusion (see illusion #101). If you move your head or slowly shake the image, you will also see a strong illusory movement.

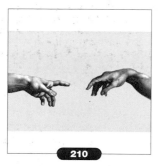

Miracle

When you bring this image close to your face, each eye sees only one part of the scene (the left eye sees the hand of God and the right eye sees the hand of Adam). These two images then start to become fused and they appear to touch.

Strange Coincidence

British illustrator Bush Hollyhead captured this strange coincidence.

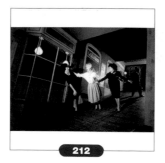

Crazy Street

This is another illusion that is caused by a misleading horizon line. The explanation is the same as in illusion #198.

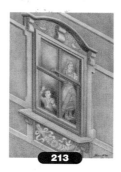

Window Gazing

This window has an impossible double perspective! Swiss artist Sandro Del-Prete wanted to depict how the world would look if you could look in two different directions at once.

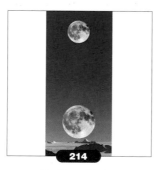

The Moon Illusion

The Moon Illusion has created quite a controversy about what gives rise to the effect, and there are many explanations for why the illusion occurs. The only agreement seems to be that it is not an atmospheric effect.

Part of the complication stems from the fact that there are many visual cues that the brain relies on in assessing size and distance relationships. These cues work fairly well for objects that are in relatively nearby locations; however, these cues tend to break down for objects that are extremely distant, such as the Moon, planets, stars and so forth.

Normally, when objects recede into the distance against a perspective background, not only does their visual angle get smaller, but they also approach a visual horizon. The Moon, because of its enormous distance from us, does not change its visual angle much (only about 2 percent) as it traverses across the heavens. However, your perception of its size does change. This is because your brain is interpreting the image on your retina based on visual cues that it uses for assessing the size and distance of objects in a nearby proximity, i.e, between the visual horizon and you.

Also, your visual system tends to be quite good at assessing the size and distance of objects that are resting on the ground, but your visual system has a much harder time assessing the distance of objects that are "floating" or not "attached" to the ground. It is even more difficult for your visual system to assess the proper size and distance of objects if a perspective background has been removed, as in the case with the Moon in its zenith position. In fact, there are many other visual cues that are used by the visual system in assessing size and distance relationships, such as ground texture or terrain, angular distance, relative alignment of the object to the true horizon (the moon has no such alignment, being a disk), lens accommodation, surrounding objects and so on. These visual cues more or less act in unison, but if they conflict with each other, you can get a size/distance illusion.

The Moon Illusion is difficult to recreate in an unnatural setting. It does not work at all in a planetarium. Double exposures of the Moon taken at both its horizon and zenith positions also destroy the illusion. Separate pictures of both positions also fail to capture the illusion. Therefore, it appears only to work in a natural environment. This is in contrast to many size/distance illusions, which can be reproduced photographically or by illustration.

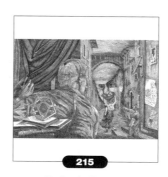

Escher in Tuscany

Hungarian artist Istvan Orosz drew his inspiration from the fact that Escher spent a lot of time in Tuscany.

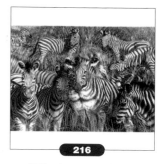

Hiding Amongst the Prey

There is a lion's head hidden in this image by American camouflage artist Rusty Rust.

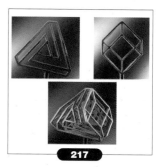

Moretti's Impossible Transformation

See illusion #164 for a similar illusion and explanation.

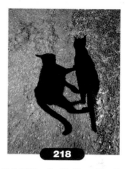

A Cat Hiding in its Own Shadow

The intersection between the gray wall or pavement and the grass is ambiguous, so it is difficult to tell whether the gray area is a vertical wall or pavement. Hence, it is confusing to determine whether the cat's shadow is on the grass or on the wall. However, there are a variety of small cues, such as two ears on the cat and one ear on the shadow, that give away the fact that the cat is walking on the gray pavement. Joe Burull captured this interesting ambiguous scene.

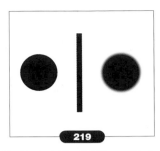

The Kaniza's Blur Brightness Illusion

The right disk does not appear as dark as the left disk, even though they are the same color. The blur of the edges looks brighter (grayer) than the sharp edge, and that edge information is carried across the surface of the disk. Italian vision scientist Gaetano Kanizsa discovered this illusion.

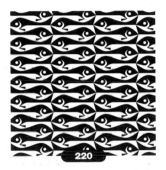

A Sudden Change of Direction

The tessellating pattern of the figure/ground fishes have no preferred direction. There are as many fish that point left as there are fish that point right. When you reverse the figure/ground relationship, you also reverse the direction of the fish. Your visual/perceptual system will group all the figure/ground fish together, and so there is not an odd mixture of fish swimming in different directions. They will all switch simultaneously.

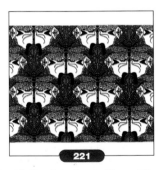

Tessellating Cats, Dragonflies and Frogs

The Dutch artist M.C. Escher was famous for creating tessellating patterns, or tiling figures. This image, clearly in Escher's tradition, was created by American artist Ken Landry.

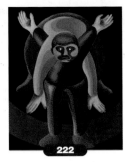

Two Bodies and Only One Head

American artist Dick Termes created this fun ambiguous drawing. Compare this with a real life interpretation in illusion #155.

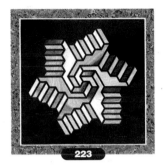

SideWinder

This is an impossible staircase with a strange twist. If you start on any step in a vertical position and walk around, you will suddenly change your orientation to that of a horizontal position. This impossible staircase by Hungarian artist Thomas Farkas, is based on a design originally conceived by British physicist Roger Penrose.

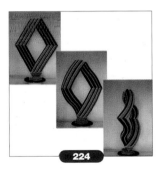

Haemaker's Square

This sculpture illustrates the ambiguity of spatial information. A curved line can appear to be straight when there is no information to the contrary. Belgian artist Matheau Haemaker's made this impossible twisted sculpture by utilizing this principle. From one very special viewing angle, the sculpture appears to be a three-dimensional impossible object.

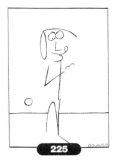

Numbers Setting Three Free

The 0 is the sun; 1 is the shadow; 2 is his legs; 3 is a bird; 4 is his body; 5 is his neck; 6 makes up his mouth and tongue; 7 (inverted) is his nose; 8 makes his eyes; and 9 is his hairline and left ear. American photographer and artist Jerry Downs created this image.

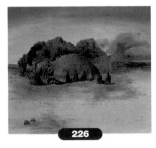

Paranoaic Figure

Try turning the image 90° clockwise to see the face. Spanish surrealist Salvador Dalí created this ambiguous painting after being inspired by a scene on a postcard that Pablo Picasso sent to him.

Miniature Theater

In assessing size and distance relationships, your brain interprets the images that are projected onto the back of your retinas. When objects recede into the distance against a normal perspective background, not only does their visual angle get smaller, but they also approach a visual horizon (see illusion #25). In the case of the Miniature Theater, the two waving girls are physically faraway in the distance, so their visual angle is small. The relationship of the two girls to the true horizon is obscured, so they look tiny when viewed through the aperture. This is similar to the Ames Room illusion (see illusion #64). This miniature theater is in the famed Deutsches Museum in Germany.

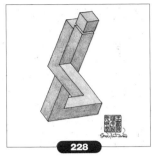

An Impossible Triangle with a Twist

Look at the top portion of the two bars. One bar passes behind and merges with the other bar in an impossible way. A line normally cannot change from convex (as when two surfaces meet away from the viewer) to concave (when two surfaces meet pointing toward the viewer), or vice versa, without passing through a vertex. The upper portion of the lighter colored surface ends in a Y vertex on its right side, with the middle segment being concave. As that segment extends upward toward the red cube it becomes convex without passing through a vertex, which is an impossibility. This impossible figure is by Swedish artist Oscar Reutersvärd.

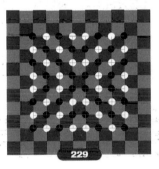

Bulging Squares

The lines are all straight. The pattern consists of a regular red and yellow checkerboard. At the junctions of each of the four squares, you will see a mirror-symmetric (up/down and right/left) series of white and black disks. On top of this array of disks, there is a cross pattern of thin yellow (same yellow as the yellow checks) lines. When you closely examine the pattern, you will notice that outside the disk, the distinct lines disappear into the yellow check. Yet, when you view the image globally, the lines appear to be quite continuous and distinct. Somehow the exiting and entering of these lines through these disks appears to confuse orientation-selective neurons that are responsible for the building up of edges and contours. This is a variation of an illusion created by Japanese artist and vision scientist Akiyoshi Kitaoka.

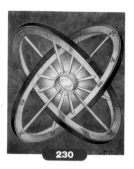

230

Cosmic Wheels

If you examine this image closely, you will see that the sides of the wheels (the two outer wheels as well as the inner wheel) twist in an impossible way. Additionally, the spokes can not be aligned in this way. Swiss artist Sandro Del-Prete created this impossible set of wheels.

231

Koa Construction.

The explanation for this wallpaper stereo illusion is the same as for illusion #141. American digital artist Gene Levine created this stereogram.

232

Dino Might

The explanation for this is the same as for illusion #141. American digital artist Gene Levine created this stereogram.

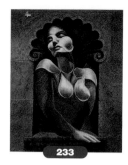

233

Ecstasy of the Lilies

Mexican artist Octovio Ocampo's *Ecstasy of the Lilies*, depicts a girl dressed up for her "coming out party". This is symbolic of her official transition from girlhood to womanhood, where she experiences the power, passion and energy that is the threshold of awakening. The lilies are indoors, alluding to her eventual role as the heart and soul of the "home." The artist keeps her innocence intact through this transition by keeping her eyes closed to the world.

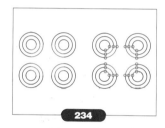

234

Neon-Color-Spreading

The illusory square on the left has a faint bluish color from a phenomenon known as neon-color spreading. In fact, the inside of the square is perfectly white. Only the blue semi-circles, which induce the illusory square, are blue. Your visual/perceptual system tends to spread color over a bounded surface. On the right, when circles are placed at the edges of the illusory square, the neon color disappears. Vision scientist Marc Albert created this illusion. Compare with #56 and 177.

235

Carte Blanche

Is the horse and rider on the tree or behind the tree in this painting by René Magritte?

236

Dali Anamorphosis

This anamorphosis uses a conic mirror. You need to view it from directly above the cone. Compare this with other types of anamorphoses, as seen in illusions #170, 184, 195, 250. Swedish artist Hans Hamngren created this anamorphosis.

237

Brain Scan

The word "3D" is hidden. See illusion #125 for the explanation. American digital artist Gene Levine created this stereogram.

238

Adelson's Snake Illusion

The four diamonds are identical in color and brightness in this brightness illusion by MIT vision scientist Ted Adelson.

239

Color Assimilation

The white squares surrounded by red lines appear reddish, and those that are surrounded by blue

lines appear bluish. Thus, the white squares take on their surrounding colors. Such a phenomenon is called color assimilation, which is the opposite of color contrast. The contrast and assimilation phenomena are also found for brightness and darkness. These particular effects are not yet well understood.

240

Chevreul Illusion

Each stripe from light to dark has a uniform brightness within the stripe, but increases in luminance at the border from one stripe to another in staircase fashion. At a border going from light to dark, the light edge makes the dark edge next to it appear even darker, and the stripes appear scalloped.

Originally the explanation for the Chevreul Illusion was similar to that for the Mach Band Illusion, namely that lateral inhibition on the contours makes them look inhomogeneous. However, the lateral extent of the inhibitory interactions required to account for this illusion is more complex than that required to explain the Mach Band Illusion. Furthermore, there are important differences between the two illusions. In particular, the Chevreul Illusion is unaffected by dark adaptation and is perceived under a variety of lighting conditions where Mach bands are not perceived. So there may be a different underlying physiological mechanism to explain the Chevreul Illusion, which is not yet known.

The illusion is named after Michel Chevreul (1786-1889), a well-known French chemist who was later to become extremely influential in the world of art, specifically Pointillism and Divisionism. He was hired as director of the dye plant of the Gobelin Tapestry Works in Paris, where he had to respond to many complaints about the substandard quality of dyes. Many complaints were legitimate, but others were due to an illusion of color contrast. He discovered that the appearance of a yarn was determined not only by the color used to dye it, but by the colors of the surrounding yarns. Chevreul investigated the specifics of this phenomenon and established the rules that describe the influence of the surrounding context on the perceived color of a target. He first described this illusion in 1839.

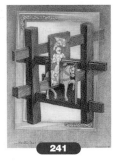

241

Soldier of the Lattice Fence

No, it is not possible. Swiss artist Sandro Del-Prete incorporated three impossible triangles in this illustration of a warrior off to battle.

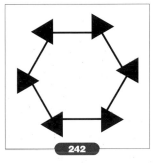

242

Gerbino's Illusion

The lines, if connected, would form a perfect hexagon. The points where they would connect are "masked" by the triangles. One line enters the midpoint of the base of the triangle, and the "connecting" line enters significantly off-center, which causes the "twist." In some ways it may be related to the Poggendorf Illusion (see illusion #27).

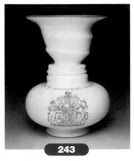

243

Vase/Face Goblet

This vase is based on the famous two-dimensional figure/ground illusion of Danish psychologist Edgar Rubin (see illusion #104).This goblet was made as a gift for the silver jubilee anniversary of Queen Elizabeth II of England, and her husband, Prince Philip. If you view the dark area as the figure instead of the ground, you will see the outlines of the two profiles (facing each other) on either side of the goblet. The Queen and her husband were delighted with the gift of this illusionary goblet.

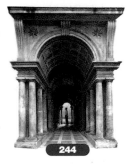

244

Perspective Arcade

This illusionary arcade, which can be found in the inner courtyard of Palazzo Spada, Rome, gives a false impression of depth. The columns actually get smaller the farther back they go, as do the ceiling coffers; the floor slopes upward and the cornices downward; the columns are thicker at the front than at the back; and the "squares" on the pavement are actually trapezoids. Francesco Borromini, one of the most important architects of the 1600s, created it.

245

COSI Squares

This variation on the simultaneous-contrast illusion shows that a small border is enough to make the two identical gray squares appear different. This is known as the Craik O'Brien Cornsweet Illusion. The explanation for this effect is currently undergoing revision.

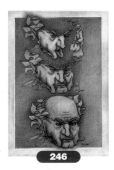

246

Nomad

This is one of Sandro Del-Prete's first attempts at transforming an ambiguous image. Although in this picture the same fragment is visible no less than three times, it undergoes a complete change owing to several major additions. At the top, a bull is resting under a shrub. In the middle, a nomad offers a water bag to the bull. And, at the bottom, you can see the expressive face of a scholar: the difference is made by adding the lines for the top of his head and forehead.

247

A Moving Portrait of John F. Kennedy

The portrait of President Kennedy is near the threshold of visibility, and is hidden within a clearly visible geometrical pattern. English vision scientist and "op" artist Nicholas Wade created this portrait.

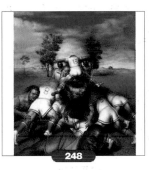

248

Melee on a Rugby Field

French artist Andre Barros created this Arcimboldo inspired theme. Compare this with illusion #62.

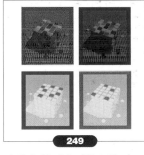

249

Lotto's Shade's of Gray Illusion

As incredible as it seems, the yellow and blue squares on top of the Rubik's cube are identical shades of gray. In the image on the left, the gray squares are seen through a yellow filter, which makes them appear blue. On the right image, the gray squares are seen through a yellow filter, which makes them appear blue. The unfiltered mask in the bottom photo shows their true colors. Yet, it is not just the yellow and blue filters that cause this apparent change in your perception of color, but also the scene's context, and how you interpret the colors as being in shadow as well as in context. English vision scientist R.B. Lotto created this brand new illusion. Compare this with illusion #270.

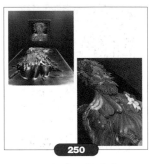

250

Arcimboldo's Fresh Guy

This is an example of an anamorphosis, where the image is stretched and distorted. Only when seen from a special viewing angle does the image appear normal. Japanese artist Shigeo Fukuda created this anomorphosis.

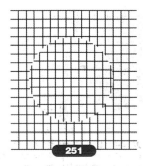

251

Illusory Circle

This is an illusory contour. Examine it closely. Although the edge of the circle appears to be very well defined, there is no actual edge.

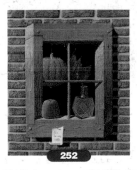

252

Still Life in an Impossible Window

The frames of the window twist in an impossible way. Belgian artist Jos De Mey created this impossible still life.

253

The Traffic Illusion

This is another variation of the effect seen in illusion # 154 by French artist Isia Leviant.

254

Legs of Entirely Different Genders

It is both. The contours of the legs are ambiguous in this figure/ground illusion by Japanese artist Shigeo Fukuda.

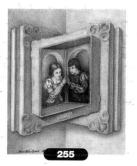

255

The Impossible Love of Romeo and Juliet

Carefully look at the picture's frame. It twists in an impossible way. Swiss artist Sandro Del Prete drew this impossible homage to the impossible love of Romeo and Juliet.

256

Homage to M. C. Escher

Escher was famous for creating tessellating images. Escher's portrait can be best repeated throughout the image in a tessellating pattern. The image still works when you turn it upside down. American artist Ken Landry created this tessellating topsy-turvy homage to Escher.

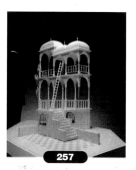

257

Belvedere

This impossible building only appears impossible from one specific viewing angle. In fact, the top portion of the structure is really at a right angle to the bottom structure, and they are not joined all the way around. Just from this specific angle do the columns appear joined together. Japanese artist Shigeo Fukuda created this three-dimensional model of M.C. Escher's print "Belvedere."

258

Beckoning Balusters

In order to see the standing figures, you must reverse figure and ground. The white areas in between the columns are the figures. Stanford psychologist Roger Shepard created this illusion.

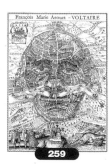

259

The Paris of Voltaire

Hungarian artist Istvan Orosz created this portrait of Voltaire.

260

A Crab in the Autumn

Japanese artist Akiyoshi Kitaoka created this variation of the Ouchi Illusion (see illusion #15).

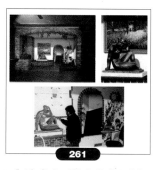

261

Art Imitates Life Imitating Art

Trompe l'oeil is French for "fool the eye" and refers to works of art designed to deceive the viewer, if only momentarily, into believing that the artist's fictitious representation is real. The art form of *trompe l'oeil* originated in ancient Greece, and was used widely by the Romans before becoming a lost art during the Dark Ages. It was revived during the Renaissance, and flourished again in the Baroque age, where it was used to enlarge and bring an element of fantasy to a room, incorporating invented hallways, objects and people. California artist John Pugh created this mural.

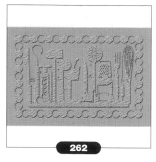

262

Kitchen Utensils

Reverse figure and ground to perceive all of the kitchen utensils.

263

Rokuyo

This is another variation of the perceptual drift illusion (see illusion #55) by Japanese vision scientist Akiyoshi Kitaoka.

264

Nob's Impossible Ledge

This wooden model, created by the late Japanese puzzle inventor Nob Yoshigahara, is impossible only from this one viewpoint. This time we won't reveal the solution. We want you to think about it! Compare with #95.

265

Different Shades of Green

The green area in the middle is the same shade of green as the outer area. If you were to remove both the black and white diagonal lines, the background would be a uniform green. In this particular case, black lines amidst the white lines form an illusory square at the center of the image. The dark diagonal lines that cross the middle square assimilate the dark color of the lines and the illusory square appears darker.

266

Cornsweet Illusion

The "dark" block is identical in gray value to the "light" block underneath it. The two dark and light blocks on either side of the foreground blocks really are darker and lighter blocks, although they appear identical to the blocks in the foreground. Vision scientists Dale Purves and R. B. Lotto created this illusion to show that illumination and context may influence the perception of brightness.

According to Purves and Lotto, the apparent brightness between two regions may be increased by the depiction of curvature.

In accordance with other brightness illusions, such as the Mach Band Illusion, Purves and Lotto considered the possible sources of the luminance gradients that give rise to the standard illusion. Luminance gradients are normally generated in one of two general ways: (1) from changes in the reflectance of surfaces (reflectance is the proportion of incident light that is *reflected from* a surface) or (2) from the illumination of surfaces (illumination is the amount of light incident *on* a surface).

They reasoned that the perception of the Craik-O'Brien Cornsweet Illusion (see illusion #245) would change in accordance with the relative probabilities of the underlying source of the stimulus. For example, if the elements in the scene coincided with the possibility that the

luminance of the Craik-O'Brien Cornsweet edge are reflectance features, and thus that the overall stimulus is uniformly illuminated, then the perceived difference in brightness of the two adjoining surfaces should be decreased (because, based on past experience, the equiluminance of the adjoining territories will generally have arisen from two surfaces with the same material properties under the same light). On the other hand, if it was more likely that the two equiluminant flanking surfaces are differently illuminated, then the perceived difference in brightness should increase (because in past experience the equiluminant adjoining territories will usually have arisen from surfaces with different material properties under different light; and brightness, or more properly lightness, is how the visual system represents the reflectivity of objects).

After experimenting along these lines, Lotto and Purves found that they could dramatically enhance the Craik-O'Brien Cornsweet Illusion by a factor more than tenfold. Lotto and Purves introduced visual cues that greatly increase the probability that the source of the stimulus is two differently reflecting surfaces illuminated by different amounts of light. The sky and ground, which surround the two surfaces, have the same average luminance. These mutually reinforcing cues, which suggest a normal viewing scene, greatly enhance the illusion by the object in the foreground. If you look at the same figure without the surround its effect is quite diminished.

267

Diamond Variation of the Craik-O'Brien Cornsweet Illusion

All the diamond shapes in this figure are identical in luminance, but when combined in a tessellating pattern, the diamonds near the bottom of the figure are perceived as darker than those near the top. There is a rapid change from the light to the dark on both sides of a border that is propagated and creates gray levels, the averages of which differ on the two sides of the border. Vision scientists Isao Watanabe, Patrick Cavanagh and Stuart Anstis described this very effective Craik O'Brien Cornsweet Illusion (see illusion #245) with diamond shapes for the first time in 1985.

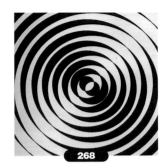

268

Ambiguous Rings

The rings have ambiguous depth cues. In one interpretation the rings point upward towards the upper left, and in the other interpretation, the rings point downwards towards the bottom right.

269

Outline Defines Shape

It is well known that shading can dramatically influence your perception of a figure's three-dimensional shape. In this case, Japanese vision scientist Isao Watanabe demonstrates how three figures can have the same luminance profiles, but be perceived as three very different and distinct shapes. The only difference between the three of them is their outlines. In other words, a figure's outline can also determine shape. See some interesting examples of this principle used in Bruno Ernst's impossible chess sets (see illusions #49 and #126).

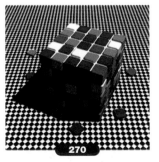

270

Rubik Cube Color Illusion

Unbelievable as it seems, the "brown" square on the top of the Rubik's cube is identical in color to the "yellow" square that is in the middle of the cube's side within the shadow. You can test this by covering everything except those two squares. This may be one of the most powerful color illusions known. Duke University neuroscientists

Dale Purves and R. Beau Lotto have used this new illusion to show that color perception can also be based on context and past experience. If you change the empirical meaning of the scene, for example, by removing the shadows, you not only change the brightness that people perceive, but also the colors as well.

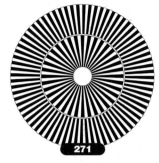

271

Wade's Hula Hoop Illusion

This illusion is similar to MacKay's Figure-Eight illusion (see illusion #24).

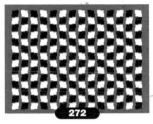

272

Kitaoka's Seaweed Illusion

The columns of "weeds" are all perfectly aligned. Look closely at each row of weeds. It is composed of alternating dark and light patterns (each pattern is made out of four joined squares, which are slightly offset from each other). The two different patterns repeat and switch their polarity. When the image is viewed globally, it appears to be wavy. Japanese vision scientist Akiyoshi Kitaoka created this illusion.

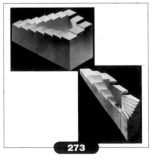

273

The Impossible Anamorphic Staircase

This is another clever way of making a physical object appear impossible. It only works from one special viewing angle.

Lattice Brightness Illusion

The white squares are all identical in brightness.

Hidden Jesus

For centuries, people have found the face of Jesus in all manner of things, but this undoctored photograph is quite remarkable in suggesting the face of a bearded man in profile. The child's white hat forms his forehead. Her elbow on the left forms his nose and her arm his moustache. Her mouth forms his eye. It is not known who took this image. The human visual/perceptual system is organized to see patterns and meaning in images – that is its primary purpose. Accordingly, it is also highly attuned to recognize faces. In this image, a curious coincidence creates meaning for those people who are already familiar with an iconic representation of what Jesus looks like. Compare this with illusion #19, 78, 87, and 113.

A King and His Queen

This gruff, bearded king, drawn by English muralist Rex Whistler, turns into his queen when you invert the image.

Anamorphic Stairs

This is another example of an anamorphic image, which is seen normally only from one specific viewing angle. Hungarian artist Istvan Orosz created this set of stairs.

Blakemore's Tilt-Induction Effect

Although the vertical bars appear to be tilted outward, they are parallel to each other. This is known as a tilt-induction effect, where the vertical line appears slanted in the direction opposite to the context lines. This illusion is thought to have some relationship to the classic Zöllner Illusion (see illusion #101). The tilt-induction effect is greater when the context lines are near vertical than when they are near horizontal. In the tilt-induction effect, visual cues (the oblique lines) cause errors in the perception of orientation, owing to mistakes in judging visual context. This illusion was first described by English visual psychologist Colin Blakemore.

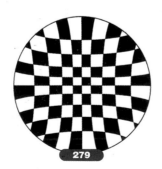

Fisheye

The curvature of the back of your retina introduces a distortion in the way you perceive the lines. You rarely, if ever, notice this distortion, because you normally do not use only one eye, where the image covers up most of the retina.

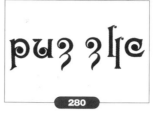

Puzzling End

Invert the word and it reads "The End."

Glossary

Accommodation

Accommodation is the process by which the lens of the eye varies its focus when looking at objects at different distances. Accommodation may serve as a weak depth cue over short distances.

Afterimage

An afterimage is the visual persistence of a retinal image after the eye stimulus is gone. It is due to either intense or prolonged stimulation with constant eye fixation. Most people are used to the experience of afterimages after briefly staring at the sun or a bright light source. Both positive and negative afterimages are possible.

Ambiguous Figure

Ambiguous figures are simple or complex figures that can give rise to two or more distinct perceptual interpretations. Most people find that one interpretation can switch to another readily, but they never can see both interpretations at once.

Attention

Attention is the concentration on a particular stimulus, sensation or thought to the exclusion of all others. Attention is a broad term that probably covers more than one type of brain mechanism.

Blind spot

The blind spot is a region of the retina in which there are no receptors because the axons of ganglion cells exit the eye and pass into the optic nerve. Therefore this is an area without photoreceptors and shows no response to light.

Brightness

Brightness is the perceived intensity of light coming from the image itself, rather than the surrounding scene. Brightness is sometimes defined as perceived luminance.

Cones

Cones are short, thick, tapering nerve cells in the photoreceptive layer of the retina which are specialized for bright-light and color vision. There are three types of cone-shaped photoreceptors that are responsible for the perception of color. Cones are heavily concentrated in the center of the retina (the fovea), but some are found throughout the periphery.

Contour

A contour is any place in the retinal image where the light intensity changes abruptly. It is the boundary of a region. Normally it is an edge that is assigned to the region of one side or the other, depending upon several factors influencing figure/ground organization.

Contrast

The contrast between two adjacent regions is their relative luminance levels.

Cues

Cues are features of visual stimuli which prompt the perception of depth or vision.

Filling-in

Filling-in is an action by the brain which "guesses" at the nature of absent information by assuming that it resembles related information.

Figure

Figure refers to an image region to which its contours have been assigned, producing the perception of being a perceptual element whose shape is defined by the contour and that 'stands out' in the center of attention.

Global

Global refers to the overall arrangement of parts of a figure, as opposed to the local details or parts that make up the overall figure.

Ground

Ground refers to regions to which contours have not been assigned producing the perception of being in the background and extending behind the figure.

Illusory Contours (Subjective Contours)

Illusory contours are visual experiences of edges where no corresponding physical luminance edges are present in the image.

Impossible Figure

Impossible figures are two-dimensional line drawings which initially suggest the perception of a coherent three-dimensional object that is physically impossible to construct in a straightforward way.

Impossible Object

Impossible objects are physical objects, as opposed to two-dimensional drawings, that suggest an impossible construction. These objects usually require a specialized viewing angle to see the paradox.

Lateral Inhibition

Lateral inhibition is the process of adjacent neurons inhibiting one another.

Lens Accommodation

See Accommodation

Lightness

Lightness is the perceived reflectance of a surface. It represents the visual system's attempt to extract reflectance based on the luminance in a scene.

Luminance

Luminance is the amount of visible light that comes to the eye from a surface.

Optic Nerve

The optic nerve is the collection of axons from retinal ganglion cells as they exit the eye.

Perception

Perception is the conscious experience of objects and object relationships.

Orientation

Orientation is the property of objects concerning their alignment with respect to some reference line, such as gravity or the medial axis of the head.

Reflectance

Reflectance is the proportion of incident light that is reflected from a surface.

Retina

The retina is the curved surface at the back of the eye that is densely covered with over 100 million light-sensitive photoreceptors plus other sensory neurons (amacrine, bipolar, ganglion, and horizontal cells), which process the output of the receptors. The photoreceptors are situated in the innermost layer while the ganglion cells, whose axons project to the brain, lie in the outermost layer, nearer to the lens of the eye. For this reason there has to be a gap in the retina through which the axons of ganglion cells can pass on their way to the brain. This gap in the photoreceptor layer produces a blind spot in each eye.

Rods

Rods are long, thin, cylindrical photoreceptors in the retina, used exclusively for vision at low levels of illumination. Rods are extremely sensitive to light and are located everywhere in the retina except at its very center (fovea).

Salient

An object is said to be salient if it attracts attention or stands out conspicuously.

Sensation

Sensation is the simple conscious experience associated with a stimulus.

Shape Constancy

Shape constancy is the process by which the apparent shape of an object remains constant despite changes in the shape of the retinal image.

Size Constancy

Size constancy is the stability of perceived size despite changes in objective distance and retinal image size.

Tessellation

A tessellation is a tiling (or repeated interlocking design) which can be extended infinitely in any direction.

Vestibular System

Your vestibular system monitors the motion of your body and head and provides you with an upright and stable perception of the world.

Visual Angle

Visual angle is a measure of image size on the retina, corresponding to the number of degrees the image subtends from its extremes to the focal point of the eye.

Visual Field

The visual field is comprised of all the stimuli you can see, even those a few degrees away from the center of your focus.

Further Reading

Baltrusaitis, Jurgis. *Anamorphic Art*. New York: Harry Abrams, 1977

Baltrusaitis, Jurgis. *Anamorphoses: les Perspectives Dépravées*. Montreal: Flammarion, 1984

Cobb, Vicki. *How to Really Fool Yourself: Illusions for all Your Senses*. Hoboken: John Wiley and Sons, Inc., 1999

Block, J. Richard. *Seeing Double*. New York: Routledge Books, 2002

Coren, Stanley and Girgus, J. S.. *Seeing is Deceiving: The Psychology of Visual Illusions*. Mahwah, N.J.: Lawrence Erlbaum Associates, 1978 (Advanced reading)

Dars, Célestine. *Images of Deception: The Art of Trompe-L'Oeil*. New York: Phaidon Press, 1979

Dawn Ades. *Dali's Optical Illusions*. New Haven: Yale University Press, 2000

Del-Prete, Sandro. *Illusoria*. Bentelli, 1987

Del-Prete, Sandro. *Illusorisme, Illusorismes, Illusorisms*. Bentelli, 1984

Enns, James. *The Thinking Eye, The Seeing Brain*. New York: Norton & Company, 2004

Emmer, Michele and Doris Schattschneider (eds). *The Legacy of M. C. Escher: A Centennial Celebration*. New York: Springer Verlag, 2003

Emmer, Michele. *The Visual Mind: Art and Mathematics*. Cambridge: The MIT Press, 1993

Ernst, Bruno. *The Eye Beguiled: Optical Illusions*. New York: Taschen, 1992

Ernst, Bruno. *The Magic Mirror of M.C. Escher*. Stradbroke: Tarquin Publications, 1985

Frisby, John. *Seeing: Illusion, Brain and Mind*. New York: Oxford University Press, 1980 (Advanced reading)

Gamboni, Dario. *Potential Images: Ambiguity and Indeterminacy in Modern Art*. Lexington, KY: Reaktion Books, 2002

Goldstein, E. Bruce. *Sensation and perception*: Fourth edition. Belmont: Wadsworth, 1997

Gonsalves, Robert. *Imagine a Night*. New York: Atheneum Books for Young Readers, Simon & Schuster, 2003

Gonsalves, Robert. *Imagine a Day*. New York: Simon & Schuster, 2004

Gregory, Richard. *Eye and Brain*: Fifth Edition. Princeton: Princeton University Press, 1997

Hoffman, Donald. *Visual Intelligence: How We Create What We See*. New York: W. W. Norton & Company, 1998

Hofstadter, Douglas. *Gödel, Escher, Bach: An Eternal Golden Braid*. New York: Vintage Books, 1979

Hofstadter, Douglas. *Metamagical Themas: Questing for the Essence of Mind and Pattern*. New York: Basic Books, 1985

Hughes, Patrick and Paul Hammond. *Upon the Pun: Dual Meanings in Words and Pictures*. New York: W. H. Allen, 1978

Hughes, Patrick and George Brecht. *Vicious Circles and Infinity: A Panoply of Paradoxes*. London: Jonathan Cape, 1975

Hulton, Pontus. *The Arcimboldo Effect*. New York: Abbeville Press, 1987

Kim, Scott. *Inversions: A Catalog of Calligraphic Cartwheels*. Emeryville: Key Curriculum Press, 1996

Kitaoka, Akiyoshi. *Trick Eyes: Magical Illusions that Will Activate the Brain*. New York: Barnes and Noble, 2005

Langdon, John. *Wordplay: Ambigrams and Reflections on the Art of Word Play*. New York: Harcourt Brace Jovanovich, 1992

Leeman, Fred. *Hidden Images: Games of Perception, Anamorphic Art, Illusion*. New York: Harry Abrams, 1975

Livingston, Margaret. *Vision and Art: The Biology of Seeing*. New York: Harry Abrams, 2002 (Advanced reading)

Locher, J. L. (ed.). *M. C. Escher; his Life and Complete Graphic Work*. New York: Abradale Press, 1992

Locher, J. L. *The Magic of M. C. Escher*. New York: Harry Abrams, 2000

Palmer, Stephen. *Vision Science: Photons to Phenomenology*. Cambridge: The MIT Press, 1999 (Advanced reading)

Robinson, J. O. *The Psychology of Visual Illusion*. Mineola: Dover Publications, 1998

Rock, Irvin. *Perception*. New York: Scientific American Library, W. H. Freeman, 1984

Rodgers, Nigel. *Incredible Optical Illusions*. New York: Barnes and Noble, 1998

Schattschneider, Doris. *Visions of Symmetry: Notebooks, Periodic Drawings, and Related Work of M.C. Escher*. New York: W. H. Freeman, 1990

Seckel, Al. *Ambiguous Optical Illusions*. New York: Sterling, 2005

Seckel, Action. *Optical Illusions*. New York: Sterling, 2005

Seckel, Al. *Geometrical Optical Illusions*. New York: Sterling, 2005

Seckel, Al. *Impossible Illusions*. New York: Sterling, 2005

Seckel, Al. *Masters of Deception: Escher, Dali, and the Artists of Optical Illusion*, Volume 1. New York: Sterling, 2004

Seckel, Al. *Masters of Deception: Escher, Dali, and the Artists of Optical Illusion*, Volume II. New York: Sterling, 2006

Seckel, Al. *Stereo Optical Illusions*. New York: Sterling, 2005

Seckel, Al. *Topsy-Turvy Optical Illusions*. New York: Sterling, 2005

Shepard, Roger. *Mind Sights*. New York: W. H. Freeman and Company, 1990

Spillman, Lothar and John Werner. *Visual Perception: The Neurophysiological Foundations*. San Diego: Academic Press, 1990 (Advanced reading)

Nicholas Wade. *Visual Allusions: Pictures of Perception*. Mahwah, N.J.: Lawrence Erlbaum Associates, 1990

Illusion Category Index

It is very difficult to categorize many of the illusions found in this book, as there are no clear lines in which to properly define them. Nevertheless, this subject index can be taken as a useful, but loose guide to explore similar examples in a various categories.

Image Credits

All images courtesy of IllusionWorks L.L.C. except:

Roger Shepard 10, 66, 76, 80, 96, 107, 133, 151, 258
Ted Adelson 13, 238
Bangio Pinna 14, 51, 58, 169, 177, 179
Jos De Mey 17, 82, 189, 193, 252
Jerry Andrus 18, 180, 191
Jerry Downs 20, 35, 197, 225
René Magritte, *The Human Condition,* 1934 and *Carte Blanche,* 1945 © 2006
 C. Herscovici, Brussels/Artists Rights Society (ARS), New York 100, 235
Salvador Dali, *The Mysterious Lips that Appeared on the Back of My Nurse, and*
 Paranoiac Visage, 1934 © 2006 Salvador Dali, Gala-Salvador Dali
 Foundation/Artists Rights Society (ARS), New York 28, 226
Oscar Reutersvärd 32, 53, 75, 99, 137, 145, 194, 228
Akiyoshi Kitaoka 33, 39, 47, 55, 101, 103, 108, 119, 129, 152, 157, 229, 260,
 263, 272
Nob Yoshigahara 264
R.B. Lotto and Dale Purves www.lottolab.org 34, 135, 166, 249, 266, 270
Stuart Anstis and Patrick Cavanagh 267
Bruno Ernst 44, 49, 126
Monika Buch 46
Ken Knowlton 50
Dick Termes 205, 222
Ryota Kanai 207
Susan Schwartzenberg, © Exploratorium www.exploratorium.edu 64
Sandro Del-Prete 69, 72, 109, 116, 120, 128, 134, 139, 160, 199, 213, 230,
 241, 246, 255
Shigeo Fukuda 71, 168, 182, 204, 250, 254, 257
Michael Lyons 183
John Pugh 74, 261
Tamas Farkas 77, 223
István Orosz 81, 111, 184, 215, 259, 277
David MacDonald 203
© Nicholas Wade, from *The Art and Science of Visual Illusions.* London:
 Routledge & Kegan Paul, 1982. 88, 105, 271
Andre Martins de Barros 248
Vic Muniz 106
Alice Klarke "Caravan" © 2003 A. Klarke 110
Matheau Haemaker 181, 224
Peter Tse 67, 112
Gene Levine 125, 141, 231, 232, 237
Octovio Ocampo 131, 208, 233
Philippe G. Schyns 146
Isia Leviant 154, 253
Pahwa Sinha 158
Rusty Rust 163, 172
Guido Moretti 164, 217
Ken Landry 221, 256
Hans Hamngren 170, 236
Joe Burull 218